the artist's manual

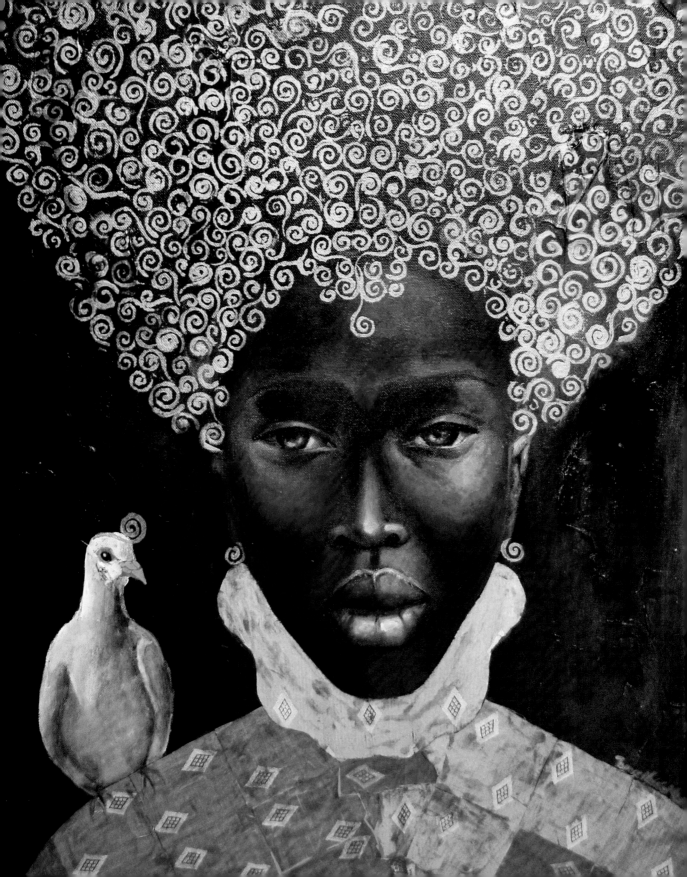

the artist's manual

The definitive art sourcebook— media, materials, tools, and techniques

CONSULTANT EDITOR
ROB PEPPER

CONTENTS

8 Consultant and authors

10 Foreword

IDEA TO ARTWORK

Where to begin?

16 Space to work

18 Research

20 Types of artwork

22 Developing ideas

24 Getting started

Art building blocks

28 Line

30 Color theory

32 How colors interact

34 Color attributes and tones

36 Shape and form

38 Composition and design

40 Perspective

42 Pattern

43 Texture

ART MATERIALS & EQUIPMENT

Supports

48 Paper
51 Canvas
54 Rigid supports

Drawing materials and equipment

60 Graphite
62 Colored pencils
64 Charcoal and chalk
66 Pastels
68 Pens
70 Ink
72 Erasers and fixatives

Painting materials and equipment

76 Pigments
78 Brushes
80 Acrylics
82 Oils
84 Watercolor and gouache
86 Spray paint
87 Airbrush
88 Nontraditional art paints
90 Knives and palettes
92 Gums, waxes, and resins
94 Mediums, varnishes, and cleaners

Sculpture materials and equipment

98 Clay
102 Wood and stone
104 Metal
106 Outdoor and synthetic materials

Printmaking, photography, and filming materials and equipment

110 Printmaking presses
112 Printmaking basics
114 Intaglio printing essentials
116 Photography
118 Filming

WAYS OF MAKING ART

Drawing
124 The act of drawing
126 Mark making and shading
128 Tonal drawings
130 Using color

Painting
134 Mark making
136 Washes and glazes
140 Wet-on-dry
142 Wet-in-wet
144 Encaustic and wax resist
146 Egg tempera
148 Color mixing
151 Alla prima
152 Blending, masking, and impasto
154 Grounds and underpainting
156 Textures
158 Mixed media

Observing and imagining
162 Still life
164 Figures
166 Portraits
168 Cartoon strips and comics
170 Landscapes
172 Cityscapes
174 Painting from photographs
176 Illustration

Sculpture
180 Armatures
182 Modeling
186 Molding and casting
188 Carving
190 Sculptural ceramics
192 Fabrication
196 Kinetic art
198 Readymades and assemblage
200 3D software and 3D printing

Printmaking
204 Intaglio: Engraving and drypoint
206 Intaglio: Etching
210 Intaglio: Making a print
212 Monoprints
214 Collagraph
215 Relief: Woodcuts
216 Relief: Linocuts
218 Lithography
220 Mokulito
222 Screen printing
224 Digital art prints

Photography and filming
228 Photography: Key elements
232 Photomontage
234 Filming: Key elements
236 Preproduction
238 Filming techniques
240 Editing film

Digital media
244 Working digitally
246 Color models: RGB and CMYK
248 Image types: Pixels and vectors
250 Working with vectors
252 Working with pixels

254 Working with layers
256 Digital painting tools
258 Image correction
260 2D animation

Applied arts
264 Gilding
266 Textile art
268 Embroidery
270 Collage
272 Paper arts

Nontraditional art forms
276 Installation art
278 Light art
280 Street art
282 Text art
284 Live and performance art
286 Book art
288 Environmental and land art

PRESENTING & PRESERVING YOUR WORK

292 Selling your work
294 Exhibiting and curation
296 Framing and hanging
298 Storage and cataloging

300 Index
308 Picture credits
311 Acknowledgments

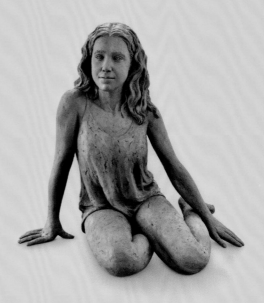

CONSULTANT AND AUTHORS

CONSULTANT

ROB PEPPER is a leading figure in art education. He divides his time between creating art in his Dorset studio, working as Principal of Art Academy London, and traveling to exhibit his work. He has undertaken many high-profile commissions, including an artwork that was given as a state gift by Britain to the President of China. His art features in galleries, museums, and private collections across the world.

Drawing is at the heart of all of Rob's art. He uses the simple act of pen on paper as a starting point for each project and is passionate about making art accessible to everyone, as he believes that it can be transformative.

AUTHORS

ALISON HAND is an artist whose practice spans painting, drawing, research, and site-specific art. She is a lecturer, writer, curator, and BA program leader at Art Academy London. Alison holds an MA from the Royal College of Art, London.

ANN KAY is a writer and editor specializing in the theory, practice, and history of the visual arts. Her numerous books include many DK titles, as well as collaborative projects with galleries, including the National Gallery and Royal Academy in London.

APHRA SHEMZA is a multimedia artist whose work explores Modernism, her Islamic heritage, and sustainable practice, fusing past methods with new technologies. She is Director and Curator at Art in Flux and manages the estate of Anwar Jalal Shemza.

CHRIS ROBINSON is a professional painter and an architect. He is a member of the Wapping Group of Artists, has won local and national awards for his watercolor paintings, and prefers to paint outdoors.

DANIELLE CREENAUNE is an Australian visual artist who focuses on printmaking and landscape, working primarily in traditional lithography. Her art is held in many public collections, and she has received numerous awards internationally.

JULIAN WILD is a sculptor, writer, and lecturer who was Vice President of The Royal Society of Sculptors from 2015 to 2019. His sculptures have won awards and been exhibited internationally. His clients include The University of Oxford and Canary Wharf.

KATIE HUGHES developed an enduring love of textiles and the creative arts from an early age; she went on to study Contextual Art and a PGCE at university. Her work includes needlepoint and exterior installations, one of which funded a well in India.

KATHERINE JONES is a printmaker and painter working in traditional forms of intaglio and relief print. She is the recipient of numerous awards, and her work is held in public collections, including The Ashmolean Museum and Yale University Library.

LUCY BAINBRIDGE is a printmaker working in screen print and photogravure and is Founding Director of Bainbridge Print Studios. Her prints—quiet reflections of everyday moments—are held in numerous private and public collections worldwide.

MICHELE ILLING is an award-winning watercolor artist with a background in illustration, advertising, and publishing. Her work features in many private collections, and she shares her passion for art in her classes, painting groups abroad, and online art courses.

NELSON GARCIA BERRIOS is a British Venezuelan preventive conservator working for Kensington Palace and HM Tower of London. He has a background in furniture finishes, fine art, and picture framing and holds an MA in Preventive Conservation.

PAUL S. BROWN is a classical realist oil painter from North Carolina. He works exclusively from life under natural light and makes his own paint by hand. His still life, landscape, and figurative paintings hang in public and private collections worldwide.

PETER DAY is an artist, writer, and educator. His art and Arts Council England projects analyze the banal and anonymity in the everyday. In 2014, the Higher Education Academy, UK, awarded him Senior Fellowship status for his contribution to education.

PETER LOIZOU is an award-winning stone carver with a background in fine art, stonemasonry, and draftsmanship. He ran Weymouth College stonemasonry program and has worked on many historic buildings and prestigious commissions.

SUE SPAULL is a figurative painter who works in oil, using neo-classical techniques. Her work has featured in the Royal Society of Portrait Painters' Annual Exhibition. Sue is Director of Programmes at Art Academy London, where she also teaches.

SUKY BEST is a visual artist, working with video, print, and installation. She teaches at Central Saint Martins College of Art and Design, London, and works as a freelance artworker for clients, including The British Museum. She has won many awards internationally.

TANYA RUSSELL is well known for her lifelike animal sculptures, but her practice also seeks to highlight our relationship with animals and their welfare. She founded Art Academy London, and her artwork is commissioned and sold internationally.

ZOE TOOLAN is an interdisciplinary artist and educator with a deep-rooted passion for drawing and everything that means. Her work centers around live art and social practices, and she has completed projects for Live Art Development Agency and Axis.

FOREWORD

There's a moment that occurs in an art studio when the silence arrives—the silence of creativity. This silence is very apparent when you give a child a pencil and their imagination runs wild. For adults, it's harder to access, often because we become frustrated as we struggle to reproduce what is in our heads.

As a professional artist of over 20 years, I've spent my career moving between making art for exhibitions and commissions and nurturing the artistic spirit in others. Art isn't the simplest of career choices. To be successful, you have to develop your ideas, learn about your materials, master your technique, market yourself and your work, and build your network. There are many challenges, and we learn continuously.

Schools of artists, from the great Italian artists of the Renaissance to those of the Bauhaus in Germany and the Black Mountain College in the US, have always learned, then happily passed knowledge on. Over the past two decades, I've been lucky enough to help develop and now lead one of London's foremost art schools, Art Academy London—developing courses for young artists and helping those emerging on their career paths.

Being asked to help create *The Artist's Manual* has given me a chance to share my knowledge and learning with a wider audience. I don't believe art is there just to be looked at passively in galleries. I believe it can be an active part of who we are, helping us create and express,

think and master, make mistakes and learn. There are many ways to create art and no one right way. Being passionate to try new things will help you find your own visual language.

The Artist's Manual is the book I'd love to have had as I developed my practice, and one that I hope many artists will use. With contributions from leading contemporary artists and packed full of inspiring artworks, it's designed to give beginners the confidence to get started and to help those further along their artistic paths to be more creative and knowledgeable.

This book is intended to be your studio assistant, offering practical guidance and giving you confidence to develop your art and access the creative silence that you found so easily as a child.

IDEA TO ARTWORK

WHERE TO BEGIN?

Becoming an artist is as much about preparation and research as execution. This section will help you explore and develop your ideas, choose a medium to work in, and translate your initial concept into a final art form.

SPACE TO WORK

Artists' studios are magical places. They are held in such high regard that many studios of famous artists are recreated in museums for the world to see. Yet not every artist can afford a studio, especially when starting out.

In the minds of many, the artist's studio is large and airy, with perfect light and ample space to work. In reality, most artists have to utilize whatever space they can. There are no hard rules, but there are some essentials to consider when creating your workspace.

The biggest expense can be your studio rent. If you don't require solitude to work, sharing a studio can be a helpful way to lower your rent, as well as being a great way of bouncing ideas. Many artists feed off the creativity of others—sharing ideas and asking for help can be part of an artist's life. Working in a studio complex or sharing a studio can also be a great way of fending off the potential loneliness of being an artist.

Working environment

Although many artworks have been created at the kitchen table or in the bedroom, ideally you need a dedicated space to work in. This should have enough room to accommodate the size of work you're creating, as well as space to store and use the materials you need.

Consistent, controllable lighting is also important. Light levels change throughout the day, and working in dim or fading light will ruin your eyes very quickly. LED daylight panels are ideal and reasonably priced.

It's also important to consider ventilation, especially if you are using materials that emit

AN INSPIRATIONAL SPACE

The artist Adebanji Alade has enjoyed this section of a shared studio space for 17 years. The well-established set-up provides a full and creative studio, with defined areas for storing, displaying, sketching, and painting. For Adebanji, an inspirational environment is key to motivation and creativity. Wall space is dedicated to well-loved paintings, and shelves house instructional art books and monographs of favorite artists, which inform and inspire him during his planning stages.

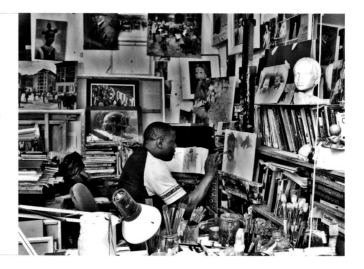

North-facing window gives consistent light

Focused ceiling spotlighting for showing work

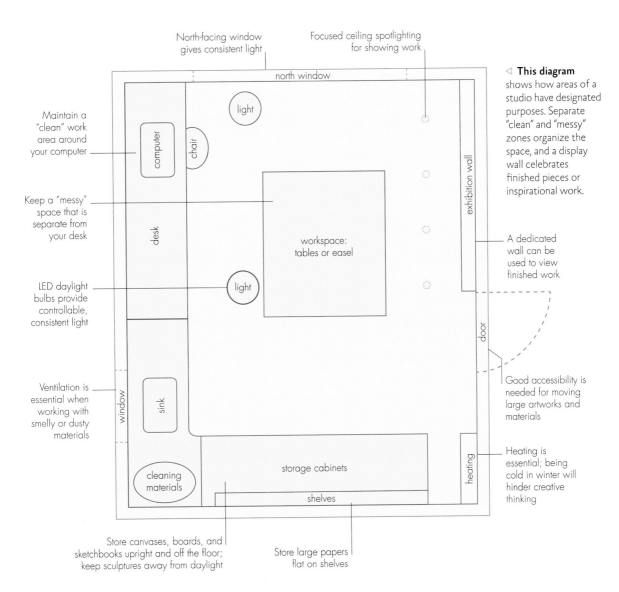

◁ **This diagram** shows how areas of a studio have designated purposes. Separate "clean" and "messy" zones organize the space, and a display wall celebrates finished pieces or inspirational work.

north window

light

computer

chair

Maintain a "clean" work area around your computer

Keep a "messy" space that is separate from your desk

desk

workspace: tables or easel

exhibition wall

A dedicated wall can be used to view finished work

LED daylight bulbs provide controllable, consistent light

light

door

Good accessibility is needed for moving large artworks and materials

Ventilation is essential when working with smelly or dusty materials

window

sink

cleaning materials

storage cabinets

shelves

heating

Heating is essential; being cold in winter will hinder creative thinking

Store canvases, boards, and sketchbooks upright and off the floor; keep sculptures away from daylight

Store large papers flat on shelves

smells or create dust. If you're using products that have high levels of chemicals or that create a lot of dust, then investing in a dust and fume extraction system is essential. If possible, work near a window, too. You may also need a dehumidifier to keep your studio free from moisture, which, left unchecked, can damage and ruin your work.

Storage

Equipment and materials should be stored in an accessible way. Units with wheels are great for fitting into tight spaces, and a plan chest is useful for storing artwork flat (see page 299).

Lock away chemicals and flammable substances—a metal cabinet and padlock is fine.

RESEARCH

Research is a fundamental element in all artistic practice, and there are three main areas that can be used as a starting point: studying other artists, formulating ideas, and deciding on which techniques to use.

INSPIRATION FROM OTHER ARTISTS

Begin by looking at other artists' work that you have strong feelings about. You might love their work, but equally you might struggle to understand it. Curiosity is an integral part of the creative process, and challenging yourself to learn about things you don't know will make you a better artist.

Keep a note of general information about the artist. When and where were they born and when did they die? Who were their friends? Look at what media they used and what their main style was. Take note of what influences they may have had

and whether they were a part of an art movement. Try to see how this is reflected in their work.

You can also do some formal analysis of a specific artwork. Think about what ideas the artist is trying to convey in the piece. When was it made, and can you determine what their inspiration might have been? All artwork also has some formal visual elements, so look at how they have used color, line, tone, pattern, texture, shape, and form (see Art Building Blocks, pages 26–43). Noting these elements in other works will make talking about and describing your own work much easier.

ENRICHING WITH RESEARCH

To create his tapestry series, *The Vanity of Small Differences*, the artist Grayson Perry interviewed people across the social spectrum, visiting their homes and examining their possessions, to explore the relationship between class and consumerism and how our tastes are formed. The resulting artworks are rich with cultural references and symbolism.

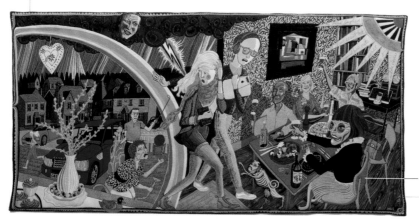

◁ **The tapestry** uses imagery from the Bible and morality tales to enhance its meaning.
Expulsion from Number 8 Eden Close (2012) Grayson Perry

Details such as decor and furniture have been used here to signify social classes

IDEAS

There should always be some kind of idea behind your work. It's important to stretch yourself in understanding the world—highly regarded artists tend to have inquiring minds. Try not to cling to the notion that you need to create completely original art; so much has already been made that every artist is influenced by others. However, researching an area that you are intrigued by will make your work more interesting. Explore the things that you love, whether it's 15th-century madrigal music, a contemporary dance form, or the plight of an endangered animal—if you're passionate about it, do your research to gain knowledge. Listen to podcasts, read books, and search the internet. The ideas don't have to be related to art, but being enthusiastic about them will infiltrate your work and make it full of life.

△ **Family, friends, and iconic figures** can make great "muses" or inspiration for your artwork. Many famous artists' portfolios are populated by the same character in different media and poses.

TECHNIQUES

There may be times when the technical aspect of making your art will become an obsession. There is craft in making art, so researching how others create similar work will help make your own art even better. In time, you will become so proficient in a technique that you will have full control of it and will be able to do things you didn't think were possible. However, it's always good to learn new methods, too, as it helps us be more creative. This book will open up new techniques to you, helping you become a more complete artist.

◁ **Experimenting** in different media by taking evening classes or short courses will help you find the one that suits your style, although many artists work in several media.

TYPES OF ARTWORK

In very broad terms, an easy-to-understand way of looking at art is
to split it into three general categories that sit across art movements,
which can help you see where your interests lie when you create art.

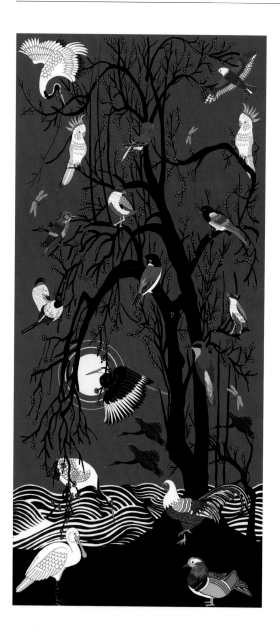

People love to classify art as a way to try to
understand where a piece of work sits in relationship
to other artists and history. Some art movements are
always given more importance than others, and one of
the roles of curators, galleries, and art critics is to try
to define what is significant at certain points in time.

An artist does not have to adhere to one way
of working or use one specific material throughout
their career, and it's good to learn about the different
styles and movements. Even if a work is challenging
to understand, try to find some things that resonate
with you. However, avoid labeling yourself as one
thing or another; instead, keep your options open
to new experiences and creative methods.

REPRESENTATIONAL ART

Also known as figurative art, representational art
depicts physical items in a familiar and realistic way.
The forms created by the artist will be identifiable as
existing in reality. This could be figures, portraits, still
life, nature, or architecture. The work doesn't need
to be a completely realistic depiction of an object
or scene, but recognizable as to what it represents.

◁ **Although all the birds** in this painting
are recognizable, their grouping in the tree
and its landscape setting are representative
rather than accurately realistic.
Tale of Daybreak (2019) Rob Pepper

ABSTRACT ART

Abstract art doesn't attempt to depict physical reality in any way at all. The focus is on the use of colors, shapes, and mark making to create the work. Often the forms have been simplified or stylized and importance is placed on the composition. Abstract art will often have a deeper meaning behind it, with the piece signifying an idea or virtue, such as chaos or tranquility.

Abstract art is mistakenly thought of as being a 20th-century invention, with artists Kandinsky and Picasso credited as the inventors. However, late J. M. W. Turner landscapes can also be seen as abstract, and even some early cave paintings would fit into the same category.

△ **These geometric forms** have a dynamic quality that explores the relationship of shapes and space.
Painterly Architectonic (1917) Lyubov Popova

CONCEPTUAL ART

Conceptual art is where the idea or concept is more important than the formal qualities of the work. The aesthetics, technique, and materials are of secondary concern to the idea behind the piece. Conceptual art emphasizes the idea, and the planning and decision-making are incredibly important, with this being done prior to the actual construction of the work.

Marcel Duchamp, a founder of the Dada movement, is often cited as one of the first conceptual artists with his artwork *Fountain* in 1917. Conceptual art became a mainstream art form in the late 20th century, with prominent artists including Joseph Kosuth, John Baldessari, Sol LeWitt, Yoko Ono, Tracey Emin, and Nancy Holt.

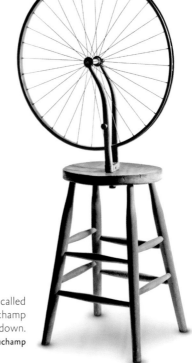

▷ **Using utilitarian objects** that he called "readymades" (see page 198), Marcel Duchamp aimed to turn the definition of art upside down.
Bicycle Wheel (1913) Marcel Duchamp

DEVELOPING IDEAS

Recording and developing your ideas is an essential part of any artist's practice and a fundamental stage in the process of creating a work of art. Find visual ways to document your thoughts and observations that are easy, accessible, and cost effective.

Be prepared to explore and try new materials to record your ideas. Rather than stick to one medium, think about the material that is most relevant to your idea and which will communicate it best. When inspiration strikes, a sketchbook can be the perfect place to capture the moment.

A camera is also a convenient tool that many artists use to help capture a passing scene or arresting composition. Smartphones have made taking photographs much simpler and are usually easily at hand. Many artists draw directly into tablets, which often also have cameras.

Software and small-scale models

Computers are useful for creating a digital record of observations, organizing your research and ideas, and trying different compositions. Many sculptors use 3D software to develop their ideas and also often create a small-scale replica or "maquette" of an intended artwork either with a 3D printer (see page 200) or in a less expensive medium than the intended finished piece. Whichever way you choose, it will give you a firm foundation to make successful art.

SKETCHING

A sketchbook is a versatile tool; keep one with you at all times. A small sketchbook is easy to carry around. If you are planning to sketch in watercolor, you'll need to consider the type of paper (see page 48). Use your sketchbook to write down ideas, thoughts, impressions, and details. Practice drawing what you see, either drawn accurately or as a quick sketch to record the moment. Draw from your imagination, doodle, make lists, practice techniques, and fill the pages with the richness of your experiences.

◁ **Sketching** in a colored medium such as pencils allows you to capture an expression or moment that may be lost.
Captain Tom Moore (2020) Adebanji Alade

MAQUETTES

A maquette is a scaled-down model or a rough draft of a sculpture. If you're working in 3D, then developing ideas in model form is integral to your final work, as it will help you understand materials and what approach to use on a large-scale version.

A maquette is a chance to play with composition and proportion. You don't have to use traditional materials; instead, use whatever is at hand to develop your thinking. As your idea takes shape, make another model in the same material, or one with the same characteristics, as the final piece to resolve any technical issues as you enlarge the work.

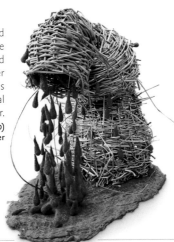

▷ **This model** allowed the artist to explore working with willow and silk before starting on her final artwork, which was inspired by the biblical story of Sarah and Hagar.
Maquette for *Being Seen* (2020)
Kate Crumpler

▷ **The intricate** composition of this sculpture was mapped out in miniature by the artist in preparation for working on the full-scale piece.
Maquette for *History of Creek* (2020)
Tanya Russell

DIGITAL IDEAS

Many artists use photo-editing software to create quick montages of potential ideas. Use photographs or scanned images from sketchbooks or found objects and explore the software options for editing and visualizing new concepts (see page 254). By cropping, changing scale, and placing images on layers in new configurations, you can very quickly think through and record an idea. Remember to save your files in an orderly way to find them again.

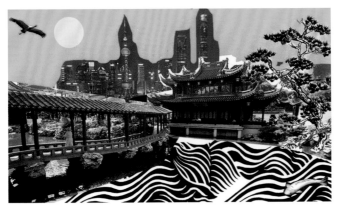

◁ **This photomontage** of different elements helped the artist conceptualize the finished work.
Bridge of Nine Turns, Shanghai (2020) Rob Pepper

GETTING STARTED

Once you have developed your idea through sketches or maquettes, you can start to execute your vision to transform your idea into a final artwork that expresses your individual style.

Today, the boundaries of art have been pushed well beyond the traditions of painting, drawing, and sculpture, and art is made in a wide variety of media and forms. As you prepare to make your final piece, your key considerations are the materials that you will use, your method of working and the techniques this requires, the scale of your work and practicality of its construction, and where it will be displayed.

Materials

Meaning is often attached to what an artwork is made from, so think carefully about every aspect of your piece. Is the material or medium relevant to your idea and will your subject benefit from its use? Will you stick with your usual materials or try new ones? There's no need to try experimental materials unnecessarily, but, equally, trying new media and exploring different possibilities can help you develop as an artist and keep your ideas fresh and challenged. Chapter 2 on pages 44–119 explores the options for different materials, ranging from traditional painting and drawing media to tools and equipment for photography, filming, and printing.

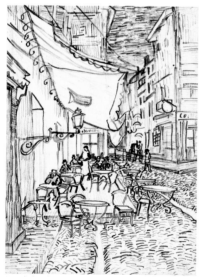

Initial sketch

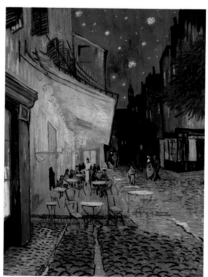

Final painting

◁ **A preparatory sketch** of this famous café scene illustrates how van Gogh mapped out his work. The boldly contrasting oil colors in the final piece show how he used this medium to create depth, texture, and atmosphere.
Terrace of a Café at Night (1888) **Vincent van Gogh**

Honing your technique and style

There will be a variety of ways in which you can use your chosen material and an artistry to the techniques you select. Observing how other artists have worked with materials can help you decide how you want to approach your piece. Once you have chosen a method, it's important to spend time honing your craft so that you can develop the ability and skill to execute the techniques.

Allow yourself time to develop your own unique style. The more you produce, the more accomplished you will become and the more you will be able to critique yourself. Knowing what works and what doesn't gives you control over your design and style.

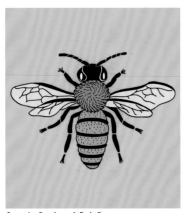

Save the Bee (2019) Rob Pepper

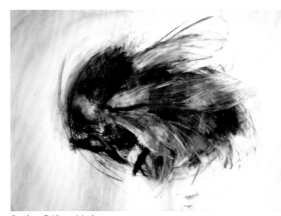

Bee (2016) Kinga Markus

◁ **Your design** and the style you choose has the ability to communicate the same subject in a very different way, as shown here with these contrasting pictures of a bee.

SCALE

The size of your work is integral to your decision-making. Size creates a focus on certain elements and impacts the meaning. On a practical level, will you be able to lift and move it; fit it in a vehicle; hang it easily; and be able to afford to make it at a certain scale?

A particular scale may suit your work. Don't be afraid to experiment. A piece can take on a different character when it's 10 times the size or reduced down to the size of a postage stamp.

Mass (2017) Ron Mueck

ART BUILDING BLOCKS

Even before you have an idea for your artwork, it's important to learn about and practice the fundamental principles of art covered in this section—line, color, tone, shape, form, design, composition, perspective, pattern, and texture.

LINE

Most artworks begin their life as line drawings, which can be used as a framework to build upon. In art, lines provide outlines, describe physical appearance and features, add detail and texture, and suggest light and shade.

Lines can be made clearly using pencils, pens, and brushes and can also be implied by the way in which objects and colors are juxtaposed. At their most basic, lines join two points together. As well as being used to describe an object or form, lines can also be expressive, helping to create a mood or suggest emotion.

Lines can lead the eye of the viewer, helping create movement and a sense of direction. In some artworks, lines are invisible and implied through object placement, which helps guide the eye through a piece. Lines can create texture, for example, moving from smooth to rough. A line also has "weight," which refers to the visual lightness, darkness, or heaviness within a work. The lines you produce can be as important in three-dimensional works as in two-dimensional ones. In sculpture, a line is often made where two planes meet.

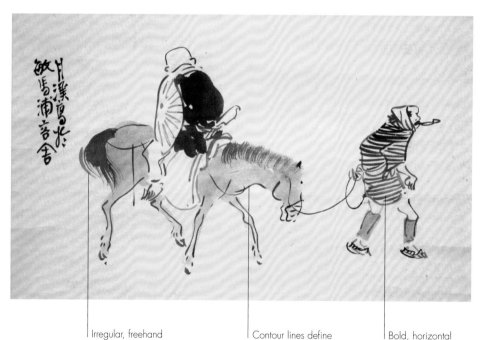

◁ **Soft outlines** and gentle curves depict simple but expressive forms.
Monk Renshō Riding His Horse Backwards (c.1784) Matsumura Goshun

Irregular, freehand lines add movement

Contour lines define the horse's shape

Bold, horizontal lines draw the eye

TYPES OF LINES

Understanding the versatility of lines and how to create them allows you to achieve a range of effects, from simple lines to depict an outline, to expressive or flowing lines that convey emotion, to mechanical ones that can be used for technical drawings and design.

△ **Contour lines** define outline, showing where an object ends and sometimes its interior structure. A simple contour creates a form with minimal adornment.

△ **A continuous line** is one that is unbroken from beginning to end. It is created using an implement that gives a free-flowing mark.

△ **Descriptive lines** add light, shade, and texture. Hatching (lines drawn in one direction) and cross-hatching (lines at an angle across the top) are examples.

△ **A freehand line** can convey the energy and mood of the artist. It may be natural and imperfect and change quickly, adding character to a work.

△ **Mechanical lines** have a rigid, uniform nature and may suggest perfect mathematical shapes. They can be straight or curved and imply restraint.

△ **Expressive lines** give feeling. A thin, gently curved line suggests calm; short, angular lines, anger. A dark keyline can change mood from calm to intense.

△ **A silhouette** is created with one solid keyline that is filled in. This simplifies the form and shape of the subject.

△ **Orientation lines**—whether horizontal, vertical, diagonal, zigzag, or curved—create a focal point. They can give depth and a sense of perspective.

△ **Implied lines** use positioning of shapes, color, and tone to lead the eye. For example, objects placed at regular intervals can lead to a focal point.

COLOR THEORY

Color is one of the most enticing, exciting, and dynamic visual elements of art. Understanding how to use color in an artwork to convey a mood, express an emotion, and create form and shape will develop your craft.

Color is a science and an art. Some artists' use of color is determined by instinct and feeling, their connection with color invoking an emotional reaction to their work. For others, a fascination with the science of color informs them, and they use technical data and color planning in their art.

However you choose to handle color, understanding the basics—the principles of color theory and how colors work together—will help you achieve the effects you desire. Knowing, for example, how certain color combinations intensify one another or which colors cancel each other out is key to your art practice.

The color wheel

In 1704, Sir Isaac Newton published the first color wheel in his work *Opticks*. His observation that light separated into its constituent colors as it passed through a triangular prism demonstrated that white light was composed of the seven colors— red, orange, yellow, green, blue, indigo, and violet (ROYGBIV)—that make up the visible spectrum. His color wheel promoted the theory that red, yellow, and blue are the primary colors from which all other colors are derived. Although his theory is not entirely accurate, the wheel's circular arrangement, showing the relationships between primary, secondary, and tertiary colors in the order of the color spectrum, has become a convenient tool for artists.

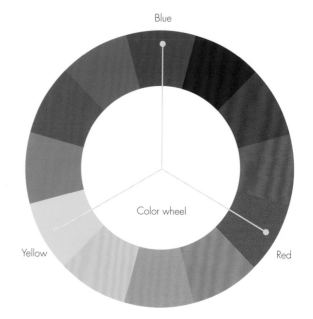

Blue

Color wheel

Yellow

Red

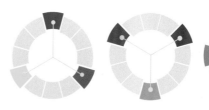

△ **The primary colors** yellow, red, and blue form the wheel's three main spokes. They cannot be made by mixing other colors.

△ **Secondary colors** arise from mixing primaries. Red and yellow make orange; blue and yellow make green; blue and red make purple.

△ **Tertiary colors** are a mix of primary and secondary ones. Adjusting mixes forms a blend of colors, making a complete wheel.

Warm and cool colors

Colors are termed "warm" or "cool." Warm colors are vivid and dynamic and tend to jump out at the viewer. They sit in the red, orange, and yellow section of the wheel. Cool colors comprise the green, blue, and purple section. They have a soothing and reassuring effect and tend to recede. Juxtaposing warm and cool colors creates depth in a composition, because warm colors appear to come forward while cool colors fall back.

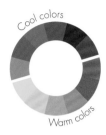

Cool colors

Warm colors

◁ **Understanding** color temperature can help inform the composition of your artwork.

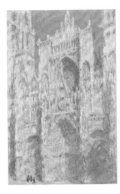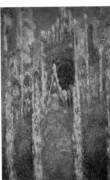

◁ **In his series** of paintings on Rouen Cathedral, Monet used warm and cool hues to show how changes in light altered the atmosphere.
Rouen Cathedral Paintings (1892–1893) Claude Monet

COLOR NAMING SYSTEMS

PIGMENTS
In traditional painting, color names are based on the pigments (see page 76) that are mixed with binders (linseed oil, polymer, gum arabic, and egg tempera). Names such as "yellow ocher" and "cobalt blue" refer to the compounds that form pigments.

CMYK COLOR
Digital and predigital print color mixes cyan, magenta, yellow, and black, called CMYK (see page 247). Layers of dots of each color are mixed to make a new color. Each layer has a percentage, 100 percent indicating complete saturation.

DIGITAL RGB COLOR
Electronic devices such as computers project red, green, and blue beams to create different colors, described as RGB. By varying the amounts of light sent out, a huge range of colors and shades can be created (see page 246).

Pigment for paint

CMYK color book

Digital color spectrum

HOW COLORS INTERACT

Using the color wheel to mix colors and explore how they interact can help you understand the relationships between them. The effect of color interactions on the viewer can be used to create different impacts.

Throughout the centuries, there has been debate about how colors can affect our psyche, and artists have explored the effects that different color combinations can have on the observer. Individual responses to color combinations can be personal and subjective. How people understand color is not always the same, and one color can appear altered depending on the context in which the perceived color is presented. Despite this subjectivity, artists can use color interactions to create an effect. While a single color has hue, chroma, and value (see page 35), the interactions of multiple colors are regarded as having harmony, where there is an orderly arrangement of similar colors; or contrast, when there is a high level of difference between them. Changing the colors around a single color can change how it looks.

Contrast

Juxtaposing contrasting colors in an artwork can have a powerful impact. For example, placing a lightly saturated color next to a highly saturated

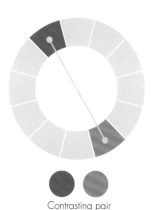

Contrasting pair

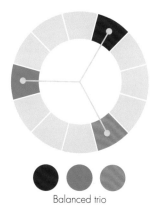

Balanced trio

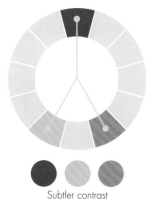

Subtler contrast

△ **Complementary colors** sit directly across from each other on the color wheel, as with the shades of green and orange shown here. When two complementary colors interact, they intensify, causing visual tension, which can create a sense of drama.

△ **A color triad** consists of three colors that are equally spaced around the color wheel. These harmonious color interactions tend to be vibrant and can create a lively feeling in a painting, even when using a color triad made up of pale shades.

△ **Split complementary** is similar to complementary color interactions. However, here, one color interacts with a pair of colors (known as analogous colors, see right) that sit close to the first color's opposite complementary color.

one can alter the perception of the lighter color, giving it a slight hue of the richer one. A harmonious use of yellows, greens, and blues may be contrasted with a strong red to add vibrancy and to emphasize the red's dominance. More subtle contrasts, for example, with a warm orange and gentle blue, can create a sense of calm.

Harmony

Harmony refers to the combining of certain colors to create pleasing combinations. Harmonious combinations fall into four categories: complementary, split complementary, analogous, and color triads, as shown below.

▷ **In this painting**, the artist has blended harmonious colors into each other, creating a luminosity and sense of purity.
Being There (2020) Artswati London

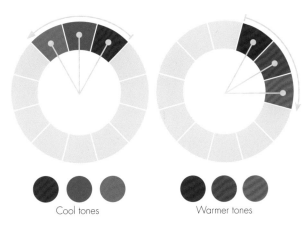

Cool tones Warmer tones

△ **Analogous colors** are adjacent to each other on the color wheel, making them harmoniously balanced and easy on the viewer's eye. They can be shades of one color or encompass both a primary and a secondary color.

OPTICAL ILLUSIONS

No color is static, but is transformed depending on its surroundings. In the picture below, the left circle appears to be magenta and the right looks orange, although physically they are both magenta. Laying the blue lines over the top creates this visual illusion.

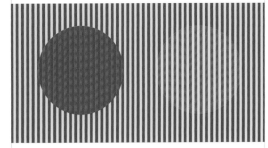

Munker Illusion or Chromatic Whites Illusion

COLOR ATTRIBUTES AND TONES

The attributes of a color refer to its hue, intensity—or saturation—and brightness, known as its value. Tone refers to the lightness and darkness of a color; artists use the term to refer to the scale between light and dark.

As well as a color's hue, saturation, and value (see opposite), colors have tints, shades, and tones. White and black are used to adjust pure colors, creating tints or shades of a particular hue, while combining a pure color with gray creates a tone, or tonal contrast, of that color (see below).

Understanding tonal range

Every color can have a wide variety of tones, known as a "tonal range" or "scale." Tone operates separately from color; if the color is removed from an image so that it is transformed to black and white, the different tones will remain, as shown in the paintings opposite.

A tonal range, or scale, moves from black through to white. It can be useful to make a nine-stage tonal scale as a reference aid when creating an artwork. This can help you see the lightest values for showing highlighted area and the darkest values for showing darker shadow, as well as identify the middle tone, so that you can balance tones in your composition.

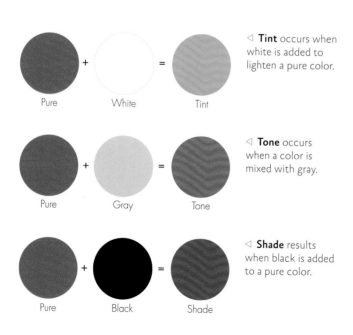

◁ **Tint** occurs when white is added to lighten a pure color.

Pure + White = Tint

◁ **Tone** occurs when a color is mixed with gray.

Pure + Gray = Tone

◁ **Shade** results when black is added to a pure color.

Pure + Black = Shade

DESCRIBING FORM

Color attributes can be used to give an object a 3D form by describing its position in relation to a light source. Here, a tint is used for the highlight; a shade is used for the core shadow; and a midtone is used to show the side of the cube that receives some light.

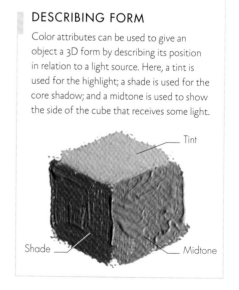

Tint

Shade

Midtone

A helpful exercise for understanding tone is to observe what happens when a light is shone on a ball (see page 129). Where the light is shining directly, the color of the ball will be uniform and the tone will be light. As the surface moves away from the light source, midtones will appear that are darker; the other side of the ball, which is completely removed from the light, will have even darker tones.

Tone vs. color

Not all colors have the same tonal range. Lighter hues have a smaller tonal range than darker hues. For example, yellow has a smaller range than blue. In addition, different colors can have the same tones, while the same color can have many tones. Like color, tone is subject to the perception of the viewer and is relative to what lies around it. For example, the same midtone can appear darker when surrounded by lighter tones than it does if it is placed next to darker tones.

Too many similar tones can produce a dull artwork. A successful piece will have a variety of tones that add visual interest and a dynamic feeling.

△ **Low-intensity colors,** shown here, have a light tonal contrast when the color is removed; the highly saturated colors in the image below have stronger tonal contrasts.

Undiluted paint

◁ **Hue** is the dominant color you see. It includes all primary, secondary, and tertiary colors, but not black, white, or gray.

Diluted paint

◁ **Saturation,** also referred to as "chroma" or intensity, refers to the vividness of a color. Strong colors are highly saturated. Diluted colors have a lower saturation.

Diluted further

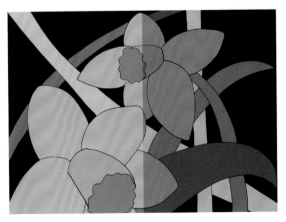

△ **Value** is the lightness or darkness of a hue. A hue's value can be adjusted by adding white to lighten it or black to darken it.

SHAPE AND FORM

Shape defines the composition and balance of a two-dimensional work, while form creates a framework for a three-dimensional piece. The size, structure, and relationships between shapes and forms in an artwork will define how visually successful it is.

SHAPE

A shape is created in two dimensions; it is a defined area confined by an actual or implied line and has width and height but no depth. You can make shapes by using an edge to suggest a contrast and by a change in color, tone, or texture.

Artists use many types of shapes: organic shapes give an artwork a natural quality; geometric shapes create a sense of balance and order. Shapes formed from negative and positive space can transform a piece, creating balance and rhythm or discord.

▷ **Organic shapes**, prevalent in nature and seen in clouds and flowers, are neither perfect nor symmetrical; they have curved edges and irregular angles. They tend to be unique, with subtle differences in size.
Irises (2019) Rob Pepper

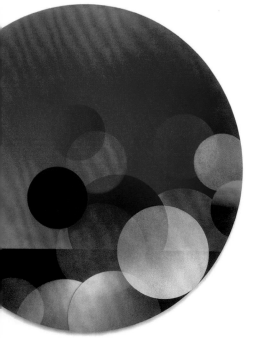

◁ **Painted on a circular plywood panel**, this piece plays with illusions of space using overlapping circles—some painted with hard lines and others transparent—giving the image depth and perspective.
Chroma Sphere Red Green (2019) Caroline List

POSITIVE AND NEGATIVE SHAPES

Positive and negative space is essential to composition. Positive shapes are the enclosed area of the object, such as the structure of a chair. The area around or between objects is the negative shape, such as between the chair legs.

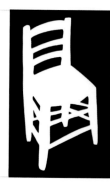

FORM

Form has two meanings in art. It is used to describe the physical nature of the artwork, as in watercolor painting. It also refers to a shape in three dimensions: an enclosed volume, having length, depth, and height. A closed form is used in sculpture to describe an enclosed or contained space or a solid mass with a sense of volume that is isolated from ambient space.

△ **An open form** is where a sculpture is transparent and reveals its inner structure. It uses lines and planes to create an integrated relationship with the surrounding space.
Encompass (2016) Mike Speller

▽ **Irregular and free-flowing** natural forms, whether animate or inanimate, occur throughout the natural world.
Spider (1999) Louise Bourgeois

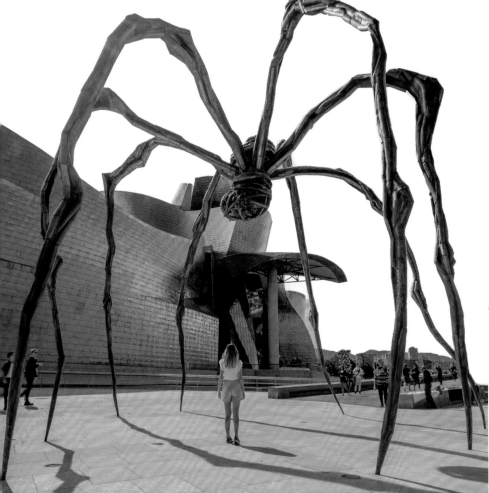

△ **Geometric forms**, based on mathematical principles, create a sense of balance and order and suggest the mechanical and artificial.
Man with Mandolin (1916) Jacques Lipchitz

COMPOSITION AND DESIGN

Simply put, composition is the way in which elements are arranged in a 2D image, or a 3D space in sculpture. Designing your artwork goes into further detail, involving planning, construction, and execution.

COMPOSITION

It is worth studying some basic rules of composition and taking time to assess how other artists have used those rules (or broken them) to great effect. Some key terms you may hear within composition are the "rule of thirds" and "The Golden Mean" (or "Golden Ratio").

Rule of thirds

This involves dividing your canvas into nine sections and placing key items, such as the horizon, tall objects, and focal points, on or near where lines intersect. It can be seen in many famous paintings.

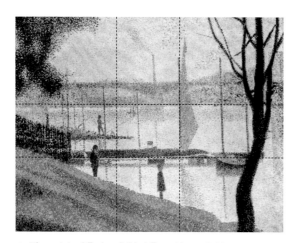

△ **The original "rule of thirds"** used here divides the canvas based on Fibonacci's sequence (right), but artists often draw nine squares of equal sizes.
Bridge at Courbevoie (1887) Georges Seurat

The Golden Mean

The Golden Mean is a ratio often seen in nature that can be applied to art, architecture, and design to create aesthetically pleasing compositions. The basis of this ratio is the "Golden Rectangle," which is created by stacking squares with ever-increasing sides. It can be applied to any artwork composition.

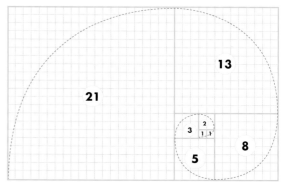

△ **Fibonacci's** sequence (0, 1, 1, 2, 3, 5, 8, 13, 21, 34...) shows how the sides of each larger square are equal to the sides of the two smaller squares beside it.

◁ **By drawing a line** spiraling through the blocks of the Golden Rectangle (above), it creates a shape that is commonly seen throughout nature.

THE KEY PRINCIPLES OF DESIGN

There are seven principles of design that you can use when creating an artwork. They are ways in which you can use the key elements of art (line, shape, form, color, space, texture, and value) within your work to grab the viewer's attention or communicate your ideas.

Repeated elements in an artwork create rhythm

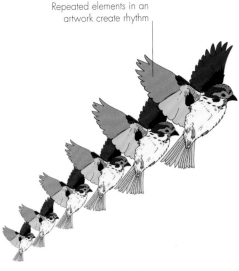

The size of this bird implies it is nearer and more important

Perfect symmetry is when elements are mirrored across an axis

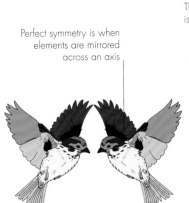

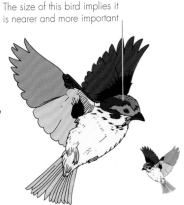

△ **A balanced image** gives stability; an unbalanced one is disturbing. Compositions do not need to be completely symmetrical to be pleasing.

△ **Proportion** is the size of different elements within a composition and how they relate to one another, as well as the size of the parts within each element.

△ **Use movement and rhythm** to lead the viewer's eye through an artwork via elements such as line, color, or form. Rhythm can be regular or chaotic.

Work in a consistent style

The viewer's eye is drawn to the bright "pop" of color

Contrasting ordinary and extraordinary creates a focus

△ **Unity** is created by the interaction of the elements in an artwork, such as using harmonious colors or tonal ranges and repeating shapes.

△ **Use emphasis** to draw attention to an element. This can be created through spacial emphasis, placement at a focal point, or contrast.

△ **Variety and juxtaposition** bring life and complexity. Variety is about difference; juxtaposition contrasts the unexpected to draw attention.

PERSPECTIVE

Giving an illusion of depth on a flat surface, perspective is a technique that artists use to depict a three-dimensional object or space in two dimensions, based on natural effects and the principles of geometry.

Artists from different cultures have used various types of perspective to create a sense of realistic depth. In most, it is assumed that the viewer is looking at the work from a certain distance and therefore objects change scale accordingly.

Linear perspective uses converging lines that lead to either one or several vanishing points to help the artist create the illusion of depth or height within an artwork. The vanishing points usually fall outside the frame of the drawing. There are three main types of linear perspective: one-point, two-point, and three-point (see below and opposite), which help in drawing geometric subjects, such as architecture; interiors; and boxlike, still-life objects. In landscape paintings, aerial perspective is often used (see page 171).

BREAKING THE RULES

Creating perspective is a visual trick based on certain rules, but the rules are there to be broken. Abstract artists, such as Picasso in his Cubist paintings, often give multiple views of objects at the same time and show objects from different perspectives in the same artwork.

Sputnik House 2 (2018) Gail Seres-Woolfson

One-point perspective

This is the simplest form of linear perspective, with a single point on the horizon and all lines converging toward it. The actual drawing often finishes before the vanishing point, but the overall effect is to make the image appear to recede away from the viewer.

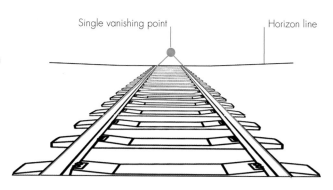

Single vanishing point Horizon line

Two-point perspective

This occurs where converging lines appears to meet at two points on the horizon line. Both points need not be within the confines of the image but remain on the notional horizon line that continues beyond the picture frame. Useful for drawing low buildings and interiors.

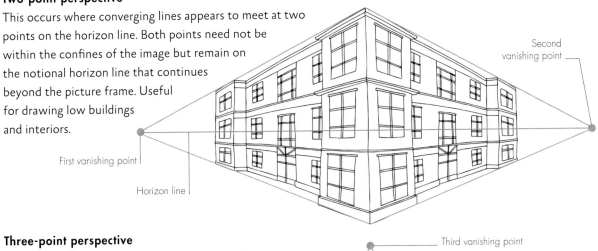

Second vanishing point

First vanishing point

Horizon line

Three-point perspective

This has an additional vanishing point, giving the illusion of height; two remain on the horizon and a third is added either above, called the "zenith," or below, the "nadir." In three-point perspective, all lines recede toward one of the vanishing points. The three points create a triangle with the observer's viewpoint in the middle.

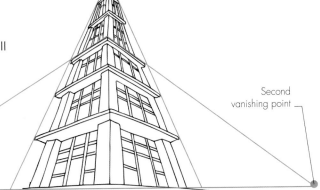

Third vanishing point

Second vanishing point

Horizon line

First vanishing point

ISOMETRIC DRAWING

When an object is viewed from one corner, all the lines begin from this point, and there are no vanishing points. Instead, the lines are created at a 30-degree angle. Unlike linear perspective, isometric lines are parallel, and all objects the same size.

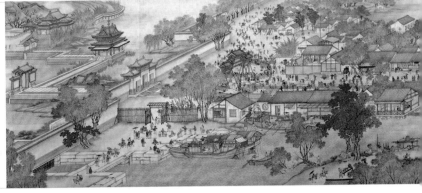

Along the River During the Qingming Festival
(1085-1145) Zhang Zeduan

PATTERN

Pattern is the order, arrangement, and repetition of shapes in an artwork. The way shapes are placed and the interactions between them can create a pattern or add a sense of rhythm and movement to a work.

The eye determines patterns by seeing shapes, forms, lines, and colors and how they interact with one another. A pattern's complexity is determined by how an object is repeated and the manner in which it is repeated. In art, natural pattern is inspired by nature—the shape of a shell or the outline of a leaf. Artificial pattern, such as geometric elements or nonorganic shapes, is used in art for structure and decoration. Patterns can be regular, irregular, structural, decorative, organic, geometric, repeating, or random.

OP ART

Pattern can be a subject matter in itself. Employed by artists such as Bridget Riley, Op Art uses geometric forms to create optical effects that suggest movement.

Shadow Rhythm (1989) Bridget Riley

PATTERN DESIGN GLOSSARY

A visual motif is a recurring element in a pattern, such as a form, shape, or figure. In art and design, decorations and visual motifs can be combined and repeated to form patterns.

△ **In gradation pattern**, a motif changes gradually as each step is repeated.

△ **For a mirrored pattern**, the motif can be mirrored horizontally or vertically.

△ **A radiating pattern** extends in all directions from a central point.

△ **An irregular pattern** is made by repeating a motif in an unpredictable way.

△ **A repeat pattern** is formed with a motif spaced in a uniform way.

△ **For a rotating pattern**, turn the motif clockwise or counterclockwise repeatedly.

TEXTURE

Texture refers to the physical qualities of an artwork and the implied surfaces within an image. The surface quality of an artwork gives an extra dimension of visual stimulation and can change the way objects are understood.

Artists use textures to add interest to their work. Physical texture refers to the surface of an artwork. Painters can play with the amount of paint on the canvas or add other substances such as sand, wood, and cloth to create unique textures (see page 266).

Playing with perception

Optical texture is how an artist uses their skills to give an illusion of texture. Photorealistic painters attempt to create works that appear real, known as "verisimilitude" (see page 174). Ephemeral texture refers to objects whose texture changes constantly, such as clouds, moving water, smoke, and flames. Artists can spend years honing their painting skills

△ **Sculptors can create texture** in many ways, incorporating found objects or using them as their sole material. Here, the sculptor has carefully placed swirls of dentalium shells to highlight their beauty and structure. *Pithváva Praegressus* (2017) Rowan Mersh

to portray real textures, such as the sumptuous textiles seen in Jan van Eyck's works. Other artists aim to break down barriers or create a reaction by incorporating unusual textures in their work, such as Chris Ofili's use of elephant dung in the 1990s or Meret Oppenheim's fur-covered cup and saucer.

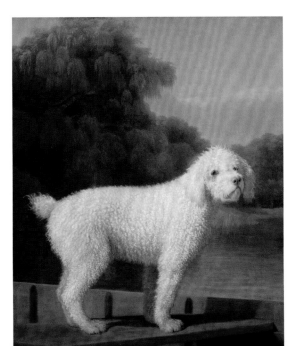

◁ **To paint animal fur** that makes the viewer want to touch it requires observational skill and patience. *White Poodle in a Punt* (c.1780) George Stubbs

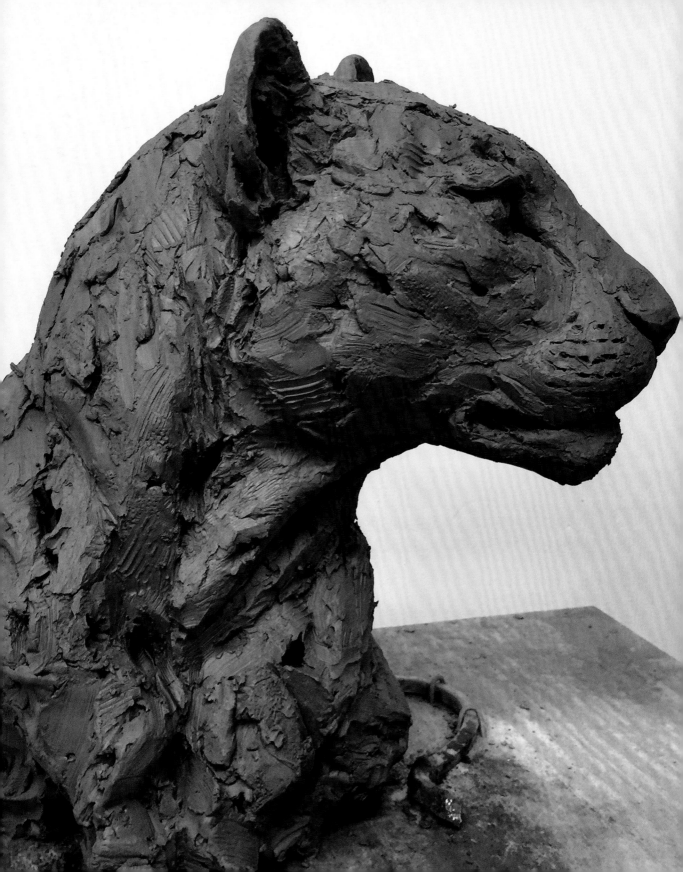

ART MATERIALS
& EQUIPMENT

SUPPORTS
MATERIALS AND EQUIPMENT

What you draw or paint on is as important
as your choice of subject matter. Almost
any material can be used, from newsprint
to a second-hand tin, as long as you prepare it
correctly to ensure the longevity of your work.

PAPER

Paper comes in an array of surfaces, textures, and colors and can be made from wood pulp and numerous plant fibers. Each medium works differently according to the paper's weight, absorbency, and texture.

Plants and trees have cell walls made of cellulose, a substance that makes their stems, leaves, and branches strong. In papermaking, the greater the cellulose content of the raw materials, the stronger the paper will be. To make paper, the plant tissues are mixed with water and then beaten to a pulp to expose the cellulose fibers. These form strong physical and chemical bonds to hold the sheets of paper together.

Paper weight
Paper weight is measured in pounds per ream (lb) or grams per square meter (gsm). The lightest papers, such as newsprint, tracing paper, and some Japanese washi, are 22–34lb (35–55gsm), while the paper in sketchpads is often 50–60lb (75–90gsm). Paper of 166lb (300gsm) is heavy enough to stand up to wet media, such as watercolor.

Archival paper
Papers that are resistant to deterioration and discoloration are termed "archival." They are usually acid-free (with a neutral pH of 7 or above) and free from optical brighteners (chemical agents added to make the paper brighter). The natural substance lignin, found in wood, will discolor paper over time, so archival paper should contain no lignin or unbleached pulp. Paper made of 100 percent cotton is naturally archival.

PAPER TYPES AND TEXTURES
Whether handmade or machine-made, a paper's texture (tooth) is key when choosing a support. Many dry media need a rough texture to grab pigment, while others require a smooth surface.

△ **Handmade** paper is made in a mold and deckle (mesh frame). Its heavy texture suits mediums that need tooth, such as pastels.

△ **Mold-made** paper is created on a cylinder mold. It has an irregular felt side, preferred by artists, and a wire-imprinted mold side.

▽ **Laid** paper has visible texture lines. It has a light tooth and is often used for word art. Can cause puddling in wet media.

▽ **Wove** is made on a wire mold like laid, but wove paper has a smooth, uniform surface with no visible pattern.

△ **Cotton** paper, made from cotton linters (fibers around cotton seeds) or rags, is strong enough to hold wet media, such as ink.

△ **Wood-free** paper is machine-made from wood with all the lignin removed, so it retains its color. Mainly for printing.

△ **Vellum** is now made from plant or tree fibers, not animal skin. Weight affects transparency; tracing paper is lightweight vellum.

△ **Cartridge** paper has a light grain and is often made from cotton. Lightweight suits dry media; heavyweight suits wet media.

△ **Newsprint** is an inexpensive, smooth paper that's good for sketching. It's not acid-free, so it will discolor over time.

△ **Sugar paper** is inexpensive and with a tooth to take pastels and charcoal, but dye colors will fade over time.

△ **Hot press (HP) watercolor** paper is pressed with hot rollers and is smooth. Often used with pen and ink.

△ **Cold press (CP) watercolor** paper, also called "NOT," is absorbent, with a slight tooth. Good for use with many media.

▽ **Rough watercolor** paper has a heavy tooth and is useful for granulated washes and bold brushwork. Not ideal for detailed work.

▽ **Kozo** (from the kozo plant) is the most common Japanese paper (washi). It is very strong and absorbent, even when wet.

▽ **Mitsumata** is a smooth, shiny paper with a soft, tissuelike texture. Good for many wet and dry media, including printing.

▽ **Gampi** is a strong, translucent paper with no visible fibers. Used in many art applications, including chine collé.

PREPARING PAPER

Sizing is a substance added to paper to strengthen it and prevent dry paper from absorbing liquid, so that ink and paint sit on the surface instead of being absorbed into the paper. Sizing affects the application feel, finish, and tooth. Unsized paper, such as blotting paper, is known as waterleaf, which is porous and allows wet mediums to soak into it quickly, often causing "bleed-through." This isn't always a negative point, with untreated paper often being used for relief printing (see pages 215–217).

Internal and external sizing

Most machine-made papers now have internal sizing added into the pulp during manufacture. Surface sizing is applied after paper has been formed and dried, usually by soaking in a bath. High-grade "bond," "ledger," and writing papers have both types applied. Gelatin is still the traditional agent used, especially for watercolor papers, and even some synthetic sizings aren't entirely free of animal ingredients, so always check individual paper specifications for vegetarian and vegan products.

Acrylics and oils

There are preprepared oil painting papers available for oil paint or acrylic, or you can use heavyweight watercolor paper (300lb/640gsm), which will need priming with an acrylic or oil primer so that the layers of paint glide over the surface. If using a watercolor technique with diluted acrylics, this is not necessary, but the paper may need stretching.

STRETCHING PAPER

Lightweight papers—140lb (300gsm) or under—will need stretching before you apply wet mediums, such as watercolor, to prevent the paper from buckling when the paint is applied or as it dries.

EQUIPMENT

- Sheet of paper
- Bath or sponge
- Water and towel
- Flat board
- Gummed paper tape
- Dry sponge

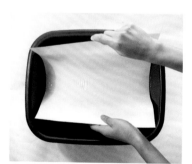

1 Soak the whole sheet in a bath or bowl of water so that it expands. For 140lb (300gsm) paper, soak for 15 minutes; less for lighter papers. Drain.

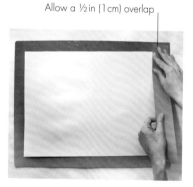

Allow a ½in (1cm) overlap

2 Towel-dry the excess water from the edges and place the paper on a board. Dampen some gummed paper tape and place it around the edge.

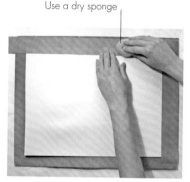

Use a dry sponge

3 Rub a sponge over the edges to press them down. Leave in a horizontal position for a few hours until the paper has dried and contracted. Remove tape.

CANVAS

Canvas is material stretched over a frame made of stretcher bars to create a springy but taut surface on which to paint. Canvases are commonly made from either linen or cotton in a variety of different weights.

TYPES OF CANVAS

Cotton is cheaper, while linen is regarded as having a more "natural" woven finish. Your choice of weight and texture of canvas will depend on the subject matter and your painting style.

Linen canvas

Linen canvas is both strong and durable, made from good-quality flax. It is often used by professional artists, as it is long-lasting, but it can be expensive. It is less likely to expand or contract due to moisture than cotton, because its warp and weft threads are of equal weight. This makes it good for applying paint thickly. It also retains its natural oils, helping preserve the fibers' flexibility.

Cotton canvas

The surface of a cotton canvas is more uniform and can be stretched more tightly than linen. Heavy-weight cotton will last as long as linen, but cotton is less suitable for very large paintings, as the fibers are shorter than linen and may relax over time.

△ **Fine linen canvas** is suitable for precise, detailed paintings, such as a still life or portrait. *Three Apples Reflection* (2020) Sue Spaull

▷ **The smooth surface** of the fine canvas enhances the shine of the fruit and their reflections.

▷ **Linen and cotton** canvases come in a range of weights and textures.

Fine-grain linen

Coarse-grain linen

12oz (410gsm) cotton

15oz (510gsm) cotton

STRETCHING CANVAS

You can buy ready-made canvases, in both linen and cotton and in a variety of textures and weights, but it is also straightforward to make your own from rolls of unprimed or primed canvas. You will need commercially prepared stretcher bars and a pair of canvas pliers for this job.

EQUIPMENT

- Stretcher bars
- Hammer or mallet
- Tape measure
- Roll of linen or cotton canvas
- Scissors
- Canvas pliers
- Staple gun and staple remover
- Canvas wedges
- Crossbar(s) for larger canvases

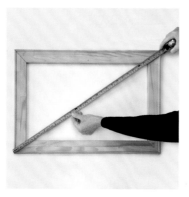

1 Slot the bars together, ensuring the flat edges meet to make a frame. Gently knock with a hammer. Measure the diagonals to check they are equal.

Leave plenty of overlap

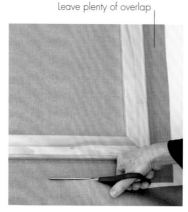

2 Lay the frame on the underside of the canvas. Cut around it, leaving an extra 2in (5cm) of canvas on each side of the frame. Turn the frame over.

Canvas pliers

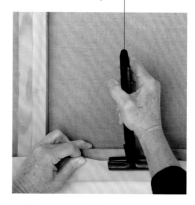

3 Using canvas pliers, pull one of the short edges of the canvas, starting at its center, tight over the stretcher bar. Hold it in place and staple it to the bar.

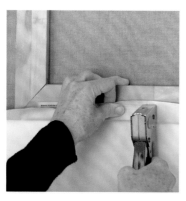

4 Repeat on the opposite side, then on the long sides. Next, add staples at ¾in (2cm) intervals on alternate sides, leaving a 4in (10cm) gap at the corners.

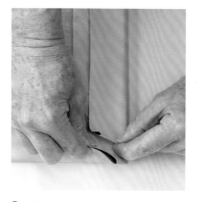

5 Fold the excess canvas at the corners into a neat triangle and tuck it underneath the canvas on either side. Secure with one or more staples.

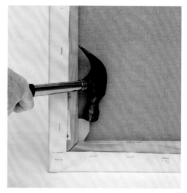

6 Insert the wedges into the holes in the corners to stretch the canvas, with long edges against the stretcher bars. Knock them in firmly with a hammer.

SIZING AND PRIMING CANVAS

Supports for oil painting must be sized to seal the pores between the fibers and prevent the oil binder in the primer and paint from sinking in. If you are buying a ready-made canvas, ask if it is presized, especially if working in acrylics, as the size will prevent acrylic paint from sticking to the canvas.

Traditionally, rabbit-skin glue is used for sizing for oil painting (but not acrylics). Alternatives to rabbit-skin glue include PVA, or wood glue, and can be used for both oils and acrylics.

Priming a canvas further seals it and provides a grip or "bite" for the paint. Acrylic primer or gesso can be used for either acrylic or oil painting but can't be used over canvas sized with rabbit-skin glue. You need at least two coats (up to seven). It will provide a rougher surface than oil primer. You should lightly sand the surface between coats. Oil primer takes longer to dry than acrylic primer—at least 24 hours—and it has a slightly yellow tinge.

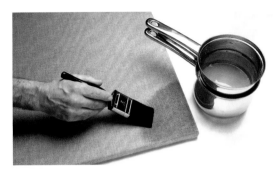

△ **When sizing a canvas**, prepare the size as directed and apply it with a flat hog hair varnish brush, working in one direction only.

WORKING ON UNSTRETCHED CANVAS

It is possible to paint on unstretched canvas, but you will need to tack it to a wall or flat surface to do this. Some artists prefer the loose effect that an unstretched surface creates.

Untitled (undated) Vivian Suter

△ **For large, stretched canvases,** you may need to insert a center bar or crossbar across the width to add support and stabilize the frame.

Crossbar

RIGID SUPPORTS

The main advantages of wood or metal supports over flexible ones (like paper or canvas) are that they are rigid and won't cause the paint to crack through movement. They are also less prone to denting or tearing.

You can make your own rigid support by buying a sheet of wood, composite wood, or metal from a hardware supplier and cutting it to size. You will then need to prepare the surface for painting. Alternatively, you can buy preprepared wooden or metal panels. Priming a large board and cutting and sanding it to size as needed is another option.

PAINTING ON WOODEN BOARD

The smooth surface of a wooden board means that oil paint will glide on more readily than on canvas, allowing you to move and layer paint easily to give solid transitions and to block in color.

Smooth blocks of color stay in position

Thick impasto layers remain solid without cracking

Bearded Man (2020) Tim Benson

WOOD AND COMPOSITE WOOD

While wood has the advantage of being rigid, its disadvantage is that it tends to shrink, expand, or distort as it absorbs and loses moisture. Wood needs to be prepared carefully for painting by sealing every side with glue size or gesso to keep it dry and prevent lignin in the wood from turning the paint yellow. Sanding the wood grain in between each layer of primer will create an even surface. Some artists like to incorporate the grain into their work; look for hardwoods with a fine or coarse grain to suit your style.

When preparing large or thin wooden panels, you may need to attach a "cradle" to the back to prevent them from bowing or warping. Solid wood is also heavy, so it may be not be suitable for a large painting; consider lighter options or metal instead.

◁ **Canvas boards** are made by sticking canvas onto cardboard or board using gesso or archival glue. They are cheap and light but are prone to warping and can be difficult to paint on, because the surface tends to resist the paint.

TYPES OF WOOD AND COMPOSITE SUPPORT

Hardwoods have been used for centuries by painters and are more suitable than soft woods, such as pine, which tend to crack. Composite panels can be more stable and usually less costly.

◁ **Oak** boards should be primed with gesso or linseed oil if you wish to incorporate the grain into your work. Ensure the whole board is sealed to prevent rot and woodworm.

▷ **Plywood** is made of a central wooden core sandwiched between thin layers of wood that are glued at right angles to the one beneath. Plywood is reasonably stable and rigid and unlikely to split.

◁ **Mahogany** is traditionally the best wood for oil painting. Dark woods, such as mahogany, will need more coats of gesso or primer unless you are happy for the deep color to change the hue or tonal value of the applied paints.

▷ **Hardboard** is made by hot pressing steam-exploded wood fibers and impregnated with resin to make it moisture-resistant and less prone to warping or distortion. You can paint on either the smooth or rough side.

◁ **Chestnut** is a hardwood (slightly lighter in color and weight than oak) with a defined, attractive, wide grain. If chestnut is used in multiple panels, the grain should align where the panels join to prevent splits.

▷ **Chipboard** is made by mixing small wood particles with resin, then compressing them together under intense heat to produce a rigid board, typically with a smooth surface.

◁ **Poplar wood** was favored by Italian Renaissance artists. It is a lighter-colored hardwood with a relatively straight grain and a natural, smooth texture. It is generally less expensive than other hardwoods.

▷ **MDF** is a stable, smooth support formed from compressed wood fibers, wax, and a resin binder. Be aware that thicker pieces are heavy and can chip at the edges, while very thin pieces may warp after painting.

PREPARING WOOD AND COMPOSITE SUPPORTS

You will need to size or prime a wood or composite wood panel for painting in order to seal it and prevent warping. It is advisable to size, or size and prime, all six sides of the panel—front, back, and edges—to prevent distortion. You can use rabbit-skin glue, acrylic primer, oil primer, gesso, or household paint for this purpose, as with canvas (see page 53).

<div>

EQUIPMENT
- Hardboard or MDF
- Paintbrush
- Primer
- 220-grit sandpaper

</div>

1 Load the brush with primer and apply horizontal strokes to cover the entire surface of the support, working evenly in one direction. Allow to dry.

2 Sand the surface lightly with fine sandpaper, then apply a second coat using vertical brushstrokes to ensure an even coating. Allow to dry before painting.

FOUND OBJECTS

Artists paint on a wide variety of different surfaces, including "found" objects. This can be for economy, or it might contribute to the meaning of an artwork. It is more difficult to judge the durability of the surface of a found object, because you may not know exactly what material it is made from. Prepare the surface according to its make-up by degreasing it if metal, as well as sizing and priming it, especially for oil and acrylic. Spraying with varnish will improve its longevity.

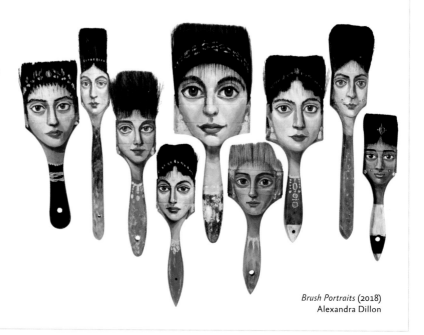

Brush Portraits (2018)
Alexandra Dillon

METAL SUPPORTS

Rigid, lightweight, and ultra smooth, metal panels are a great alternative to wood. They are not sensitive to humidity and, although likely to be expensive, they are more durable as a support for painting than canvas or wood panels. Copper was historically used for miniature paintings, and aluminum has been used by artists since the 1940s. It is important to think about attaching any fittings for hanging a metal support before you start to paint.

△ **Honeycomb aluminum** is available as sheets that can be joined. These panels are ideal for working on a large scale.

△ **Copper's** luminosity can give paintings an added vibrancy. The surface is very smooth and slick, so your paint will flow easily.

△ **Sheet aluminum** has a smooth surface that aids paint application; it can also be used as a drawing surface to aid fluid marks.

PREPARING AND PAINTING ON METAL

Before painting on metal, you need to prepare the surface. Both copper and aluminum panels should be degreased with isopropyl alcohol. Copper is soft and prone to corrosion, so prepare the surface carefully to prevent oxidation (where the copper turns green from exposure to air). If you leave any of the copper or aluminum surface exposed, varnish it after you finish your painting to prevent corrosion. A final consideration when using copper is size. Anything larger than an 8½×11in plate will be very heavy, making it less suited to large paintings.

▷ **In this multimedia work,** the blue cabin of the title is painted into a found metal tin that is integral to the whole composition.
The Blue Cabin (2020) Jayne Stokes

DRAWING
MATERIALS AND EQUIPMENT

From a quick sketch in graphite pencil to
an oil-pastel study or a pen-and-ink seascape,
putting your observations down on paper is
made so much easier by having the correct
materials and equipment.

GRAPHITE

The humble graphite pencil is the first art tool most of us encounter and an essential item for your pencil case. But don't be fooled by its humility: the scope of graphite as a drawing medium is extensive.

GRAPHITE PENCILS

Graphite is a natural form of carbon found in the ground. It was first discovered in England in the 16th century, when it was mistakenly called "plumbago," the Latin for lead ore. This is why the pencil core became known as "lead," despite the fact there has never been any actual lead in pencils.

The method of making graphite pencils varies by manufacturer, but the ingredients are the same: a blend of graphite powder and clay is fired and then encased in wood. The proportion of graphite to clay determines the hardness of the lead: hard leads are labeled with an H (hard) and soft pencils are labeled B (black). The higher the number accompanying the H or B, the harder or softer (and blacker) the pencil lead.

Choosing your pencil

Each brand of graphite pencil is slightly different, so experiment to find your favorite. "Feedback" is the resistance you feel from a mark-making tool as you work on a support. If a pencil feels scratchy (more common in H pencils), it has high feedback. B pencils have lower feedback and tend to move over paper more smoothly. Every medium and support combination will feel different in terms of ease of application and grip control, so always test a pencil on your support before you start drawing.

▽ **In the pencil grading system**, standard 6mm drawing pencils range from 9B to 9H, with HB and F (firm) pencils in the middle. Artists mainly draw with B pencils.

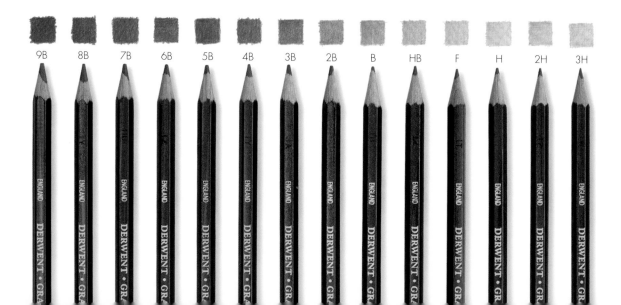

9B 8B 7B 6B 5B 4B 3B 2B B HB F H 2H 3H

0.9mm clutch pencil

6mm clutch pencil

Jumbo pencil

Woodless pencil

Water-soluble pencil

Carpenter's pencil

△ **As well as the standard** 6mm pencils shown opposite, there is a vast array of delivery systems and widths.

▽ **As with many** drawing media, pencil marks can be blended easily with paper stumps or tortillons.

Tortillon

Paper blending stick

OTHER FORMS OF GRAPHITE

Graphite is available in other forms besides wood-encased pencils. Graphite sticks come in a variety of widths, while graphite blocks are often water-soluble. Powdered graphite is useful for applying large tonal areas with a brush and can easily be erased.

Water-soluble graphite block

Powdered graphite

USING A KNIFE-SHARPENED PENCIL

Using a knife to sharpen your pencil reveals more of the lead for shading or making different marks, as shown below. The softer the pencil lead, the more often you will need to sharpen it.

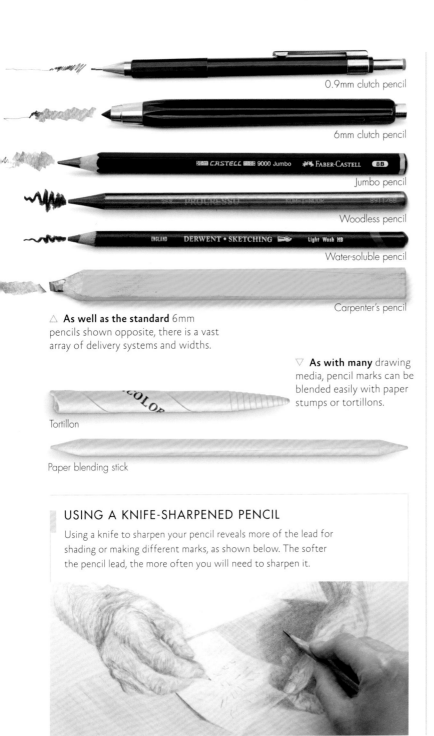

Graphite stick

Colored graphite blocks

△ **Graphite sticks and blocks** offer a wider range of mark-making options, as you can use the side as well as the tip in your drawings.

COLORED PENCILS

Interest in colored pencils as a serious art medium is comparatively new. Available as wax-based, oil-based, or water-soluble in up to 120 shades, they are a relatively inexpensive way of injecting color into your art.

All colored pencils can be used with other media, such as ink or paint, and wax- and oil-based pencils can be used together. The quality varies, with professional-grade pencils having a much higher percentage of pigment and a greater resistance to the sun's UV rays (called lightfastness). You can also buy individual colors (known as buying "open stock") in some brands.

WAX-BASED PENCILS

Wax-based colored pencils are the most common type. Their leads are primarily made from colored pigment and a wax binder, which acts as a delivery vehicle for the pigment.

Wax-based pencils can be applied and erased easily. On the downside, their leads are prone to breaking, and they may shed pigment debris. Another drawback is wax bloom, when the binder migrates to the surface of the drawing, resulting in a hazy white residue on the paper.

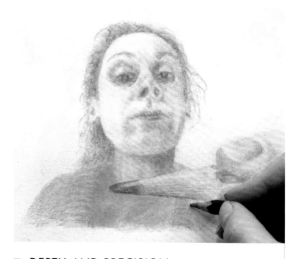

DEPTH AND PRECISION

The fine tip of the lead in colored pencils means they are great for precision and detail, with the option to layer colors lightly for a soft finish or work up lots of layers for depth. You can even employ a burnishing technique (see page 130) for a richer, more painterly feel.

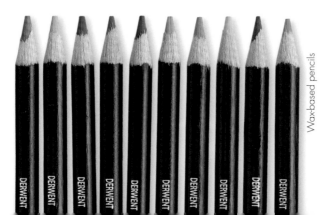

Wax-based pencils

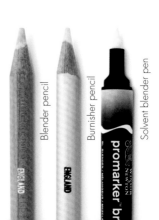

▷ **Blending tools** such as a colorless wax blender pencil, a burnisher pencil (see page 130), or a liquid solvent can be used to blend wax- and oil-based pencils.

Blender pencil

Burnisher pencil

Solvent blender pen

OIL-BASED PENCILS

Oil-based colored pencils are more expensive and less common than wax-based ones. As with their wax-based counterparts, leads are made of colored pigment and binder, but the binder is mainly oil (though some also contain a small amount of wax).

Oil pencil leads break less easily than wax-based pencils and retain their sharp point for longer. They dispense lots of color at once, which can make light layering and erasing more difficult, but a major advantage is the lack of pigment debris and wax bloom.

SHARPENING TOOLS

Whatever kind of colored pencil you use, you'll need to keep them sharp.

Manual blade sharpeners are best for colored pencils, as the binders in the lead can build up inside electric and hand-crank sharpeners. Turn the sharpener instead of the pencil to prevent breakages.

Sanding blocks also work well for colored pencils.

Craft knives can be used, but practice first with old pencils or you'll risk wasting lead.

Craft knife

WATERCOLOR PENCILS

Also known as water-soluble or aquarelle pencils, these have a water-soluble binder, usually gum arabic, that is neither wax- nor oil-based. You can use them dry, but the leads are harder than other colored pencils, as they are designed to be activated by brushing with water for a wash effect. This means you can employ the same wet-on-dry or wet-in-wet techniques as with watercolor paints (see pages 140 and 142). You can also combine watercolor pencils with many other media, including graphite, pen and ink, wax-based pencils, pigment pens or brushes, and watercolor paint.

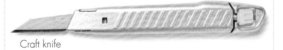

Fine, round-tipped water brush

Thick, round-tipped water brush

Flat-tipped water brush

△ **Water brushes** can be used alongside watercolor pencils to wet specific areas for a watercolor effect. They hold a reservoir of water in the handle.

Watercolor pencils

CHARCOAL AND CHALK

Charcoal and chalk are two of the oldest known drawing materials. They are often used together by artists, especially in tonal drawings and gestural sketches, due to similarities in their mark-making qualities.

NATURAL CHARCOAL

Like graphite, natural charcoal is a form of carbon and is produced by firing wooden twigs—usually willow, but sometimes vine—at high temperatures in airtight containers. The natural variations in the wood create differences in each twig's texture, handling, and tone, so if you need to use a new stick halfway through a drawing, it's a good idea to test it out first on a separate piece of paper.

Natural charcoal is tactile and expressive—great for immediate gestural drawings, applying large areas for shading, and creating a sketch before painting. It is fairly unstable, which can be both a blessing and a curse: its appearance can be adapted easily, but if you accidentally lean on the paper, your work can vanish. Using fixatives—both workable and permanent—will protect your charcoal drawings (see page 73).

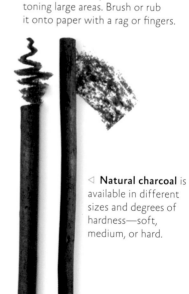

△ **Use charcoal powder** for toning large areas. Brush or rub it onto paper with a rag or fingers.

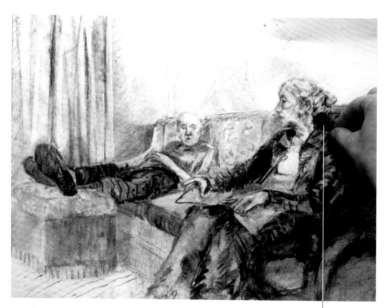

△ **Charcoal is a versatile medium**. A single stick can both shade large areas and create fine detail. Snap long sticks to a shorter length to give you more control.

Use the side of the stick for shading in areas of shadow

◁ **Natural charcoal** is available in different sizes and degrees of hardness—soft, medium, or hard.

COMPRESSED CHARCOAL

This man-made charcoal is created from charcoal powder mixed with a binder, then compressed into sticks or encased in wood as pencils. You can use it in the same way as natural charcoal, but the effect will be bolder and darker, producing marks that aren't as easily changed or erased.

Square, round, and rectangular sticks are available, allowing a wide range of marks. There are even sticks and pencils with colored pigments added, and some compressed charcoal can also be used with water. Due to the addition of a binder, compressed charcoal sticks are less brittle and therefore less likely to break than natural charcoal.

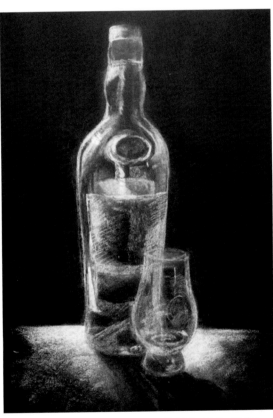

Sketch (2020) Zoe Toolan

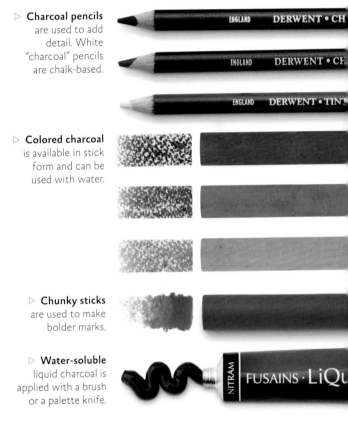

▷ **Charcoal pencils** are used to add detail. White "charcoal" pencils are chalk-based.

▷ **Colored charcoal** is available in stick form and can be used with water.

▷ **Chunky sticks** are used to make bolder marks.

▷ **Water-soluble** liquid charcoal is applied with a brush or a palette knife.

CHALK

Chalk has many of the same properties as charcoal. It is useful for creating highlights on a charcoal drawing but can also be very effective when used on its own with a dark support, as in this still-life drawing on black pastel paper (above). Like charcoal, chalk drawings require fixatives.

△ **A sandpaper block** is usually made of fine and coarse sandpaper sheets. It can be used to sharpen charcoal and chalk, as well as paper stumps.

PASTELS

There are three types of pastels—soft, oil, and hard—each with unique qualities that suit different styles of drawing. Working with pastels is often known as "painting," but colors are mixed directly on the support.

△ **Soft pastels** have a dry, dusty texture that can create both bold and subtle marks. Many types can be used with water.

Pastels are made by mixing pure pigment with a base material (binder). The mixture is then cut to shape and allowed to harden. Sticks can be round or square and vary in length. Soft pastels are made using gum as a binder; oil pastels are made by combining pigment with nondrying oil and wax.

Pastels work best on a textured support, with a tooth (raised surface) that "grabs" the pigment as you apply color. Many pastel artists prefer to work on warmer, mid- or dark-toned supports instead of white.

SOFT PASTELS

The high pigment content of soft pastels produces rich, vibrant hues, and a huge range of colors is available. They are easy to work with, especially for blending and layering, and their soft texture allows you to quickly fill areas with color.

Soft pastels have a dusty, matte finish that gives an appealing soft, painterly effect. However, this quality can also make your work fragile; you will need to treat your work with a fixative to prevent smudging and lifting (see page 73).

◁ **Pastel pencils** are thin sticks of soft pastel encased in wood. The core is harder than sticks and is useful for creating fine lines.

▽ **Soft pastels are versatile:** create broader strokes with the sides or make thin lines and crisp marks with edges and tips.

OIL PASTELS

Oil pastels are a tactile, buttery medium: their intense application of color lends itself to a bold, direct style of working. They can be softened in the palm of your hand so they work better and blended in many ways, including with a solvent (see page 131). Oil pastels adhere well to many surfaces, making them well suited to mixed-media working.

▷ **Oil pastels** should be stored in a cool place with their paper wrappings on.

▷ **To blend with layers**, apply the darkest color first and gradually add layers of lighter shades.
Talya (2020) Madeleine Hartley Salim

The lightest color—pure white—forms the uppermost layer

HARD PASTELS

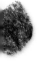

A high proportion of binder to pigment gives hard pastels a firm feel. This means they're better for detail than soft pastels and break less. The creators of the first hard pastels now produce many colors, but the original Conté carré (square) sticks were created from natural pigments in white, black, gray, and red (sanguine). Many artists still enjoy working with this traditional palette.

Layers can be blended with a finger or soft rag

▷ **A mid-tone support** enhances the earthy tones of the traditional color range of Conté crayons.
Ralph (2021) Zoe Toolan

PENS

Pens make permanent marks that can be created spontaneously or used for precise work, showing thought and control. The pen nib and ink will determine the best choice for your project and the effect you achieve.

TYPES OF PENS

Pens differ greatly in terms of construction and nib style, as well as their ink quality and color. There are two types of pens: the simplest has a tip to be dipped into ink; others have a reservoir of ink that flows to the nib. From highly engineered technical pens to ballpoints, choose the pen to suit your purpose.

Technical pens and fineliners

Technical pens require practice and skill. They are available in a range of nib widths, and the nib construction allows them to run along the edge of a ruler without coating it in ink. Fineliners are closely related, but they are cheaper and require no special knowledge to use. They can be held at any angle, making them good for sketching.

Gel pens

Gel pens have an opaque ink made from pigment suspended in a water-based gel, which makes for a very smooth drawing experience. They come in lots of vibrant colors, which are great for working on darker supports. However, on some surfaces, they can "skip" their ink flow—which means they create partial strokes—more than other pens with a "ball" delivery system.

Rollerballs

Rollerballs generally use a water-based liquid ink dispensed by a tiny, smooth ball at the tip. The ink flows as soon as the tip touches the paper. The result is a relatively broad line, similar to that produced by a fountain pen.

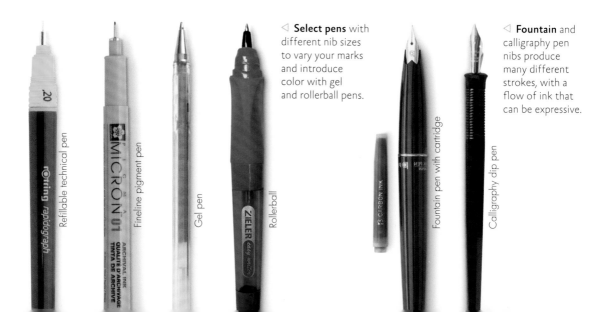

◁ **Select pens** with different nib sizes to vary your marks and introduce color with gel and rollerball pens.

◁ **Fountain** and calligraphy pen nibs produce many different strokes, with a flow of ink that can be expressive.

Refillable technical pen

Fineline pigment pen

Gel pen

Rollerball

Fountain pen with cartridge

Calligraphy dip pen

Brush pens

Often used for modern calligraphy or drawing, brush pens combine the feel of a brush tip with the convenience of an internal reservoir ink pen. They come in different tip sizes and shapes, as well as ink flows: wet, medium, and dry.

Art markers

These can be oil, acrylic, or water-based. Oil-based art markers dry fast and are permanent; some are refillable. They have rich color saturation and a smooth ink flow and can be blended. Work in a well-ventilated area, as they have a strong smell. Water-based art markers aren't permanent but are odorless. Acrylic markers, often used by street artists and signwriters, create a dense, opaque mark that can be used on glass, plastic, or board.

Ballpoint pens

These are an immediate tool. Ballpoint ink is thick and oily, made with a mixture of dye, alcohols, and fatty acids, and the ink delivery comes via a small, rough ball at the tip. The combination of the ink and the small tip can produce a gloopy effect.

SKETCHING IN BALLPOINT

The humble ballpoint pen is a more versatile tool than many realize. The drawn line is directly proportional to the amount of pressure applied, which means that delicate shading, as well as dark marks, are possible.

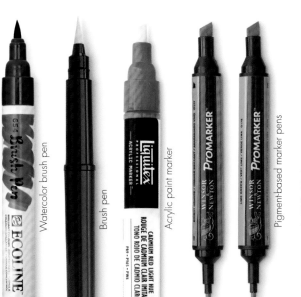

Watercolor brush pen

Brush pen

Acrylic paint marker

Pigment-based marker pens

Ballpoint pen

Erasable pen

◁ **Brush pens** and art markers have a range of tip and nib shapes. Art markers can have a bullet for fine lines and chisel for coloring on the same pen.

△ **Ballpoints** have permanent ink. Erasable pen ink has liquid eraser. Rubbing creates friction that dissolves this ink.

INK

"Drawing ink" generally describes a colored, fluid medium used with pens or brushes to draw or write with. The versatile medium of ink has been used for millennia, and its popularity endures today.

Ink is usually made of water and a coloring agent, plus a binderlike gum. Colors are either pigments or dyes. Pigments don't fully dissolve, whereas dyes do, so if the bottle says "shake before use," the ink is probably pigment-based.

The lightfast quality of your ink is important if you are selling your work and want it to endure. This is dependent on a range of factors, so check product labels. Consider, too, the compatibility of paper and ink, as well as tool and ink. For instance, thicker papers are good for heavy ink applications; pigment-based ink can clog fountain pens (see page 68); thinner inks can be too thin for dip pens.

PIGMENT-BASED INK

Pigment-based inks have tiny particles of pigment that are suspended instead of dissolved in the solution. The most well-known pigment ink is India ink (also known as Indian ink or Chinese ink). Traditionally made from lampblack, this black ink is now industrially made by burning creosote, tar, naphthalene, or other petroleum products.

The binder in India ink is frequently gum-based (check labels for vegan options), which means the ink is often waterproof when dry yet can be diluted further when wet to give tonal gradients. This makes it a great ink for creating outlines and then applying other wet media on top without fear of smudging.

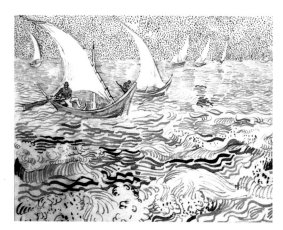

△ **In this drawing**, Vincent van Gogh used a pencil and black ink with a reed pen and quill on wove paper to achieve a descriptive range of marks.
Fishing Boats in Saintes Maries de la Mer (1888) Vincent van Gogh

▷ **India ink** can be applied with a nib or a brush and becomes shiny when dry.

DYE-BASED INK

Unlike pigments, dyes dissolve in fluid to give a different type of ink. Containing man-made chemicals, they offer a vast color range. A thinner, slightly sheer consistency means ink flows rapidly and dries quickly; avoid flexible or thin nibs to control flow.

◁ **Dye-based inks** are favored by book illustrators, as the colors scan and print well.

DIP PENS

The simplest form of writing tool, a dip pen has a carved or steel nib. Originally used for calligraphy, it is ideal for drawing or creating ink washes. Use pigment-based inks that won't clog the nib.

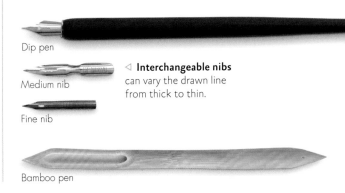

Dip pen

Medium nib

◁ **Interchangeable nibs** can vary the drawn line from thick to thin.

Fine nib

Bamboo pen

OTHER TYPES OF INK

It is worth exploring other inks to match their qualities to your drawing style, from the traditional calligraphy inks, to water-resistant acrylics that can build color, to watercolor inks that can be rewetted and worked on again.

◁ **Chinese ink sticks** are a compressed mixture of pigment and glue that is ground with water on a special stone to produce ink.

△ **Acrylic ink** has a very fine pigment mixed with a binder. Use with a brush or refillable marker pen.

△ **Watercolor ink** is dye-based. It is not lightfast, but it is still favored by many illustrators.

△ **Calligraphy** ink is a thick pigment ink made with a binder; it's usually used with dip pens or brushes.

△ **Alcohol-based** ink, a dye-based colorant dissolved in alcohol, is a thin ink used mostly in pens.

△ **Oil-based** ink is found in ballpoint pens but generally is only used for printing (see page 112).

ERASERS AND FIXATIVES

Two essential tools in any artist's toolkit are erasers and fixatives. Erasers can be used during the drawing process to correct errors or lighten areas, while fixatives preserve and enhance many different drawing media.

ERASERS

Erasers not only get rid of unwanted marks, but are also a useful tool in their own right, drawing lighter marks into darker expanses or creating interesting effects. Although erasers are primarily designed to lift off marks, you can employ their specific qualities to smudge or blend tones, add highlights, and draw defined edges. Instead of just having one eraser in your toolkit, find one that works best for your current project.

Mechanical eraser pencil

Retractable eraser pencil

△ **Eraser pencils** are very useful for accurate removal of small marks or for drawing precise lines.

SUBTRACTIVE DRAWING

For tonal drawings, an eraser is invaluable for subtracting tone or "lifting off" loose pigment, such as graphite or charcoal, by gently rubbing. Cover your paper with a mid-tone of willow charcoal by rubbing it into the surface with your finger or a rag. Then work further into this mid-tone ground with charcoal for darker tones and subtract pigment with an eraser to achieve lighter tones.

△ **Gum erasers** crumble easily, so they won't damage paper. Good for natural charcoal and graphite.

△ **Vinyl erasers** remove most mediums, but their firmness can damage thinner papers.

△ **Sand erasers** have an abrasive in them; one side can erase ink, the other pencil. May damage paper.

△ **Kneadable erasers**, as they absorb pigment, can be folded in to reveal a cleaner area.

FIXATIVES

Fixatives can be applied to a finished artwork to protect it and prevent smudging, but are also useful for a work-in-progress. Available in spray form, they are made up of fast-drying solutions of colorless acrylic or vinyl resin in a solvent, such as alcohol, that bond the particles to the paper. Their low resin content helps preserve the detail of fragile dry media such as pastel, graphite, and charcoal. Most fixatives are acid-free and archival. They should be used in a well-ventilated area or outside, ideally with a mask, to protect against toxic or irritant fumes.

Workable fixative

This type of fixative can be used *during* the drawing process. When working with most drawing media, the tooth of the drawing surface eventually becomes saturated with pigment. Spraying with a workable fixative adds tooth to the surface, so more pigment or graphite can be added. Fixative can also reduce wax bloom in colored pencils (see page 62).

The slightest accidental touch to a charcoal, chalk, soft pastel, or hard pastel drawing can change the piece forever. Spraying a workable fixative between layers will counter this. For water-soluble mediums, such as water-soluble pencils, using workable fixative between applications prevents the layer beneath from running. Use workable fixative to protect unfinished drawings that you aren't working on.

Workable fixative

Permanent fixative

This type of fixative is used to protect finished work and is essential with some media, such as oil pastels, which never fully dry (see page 67).

Choose your finish—gloss or matte—according to your medium. Absorbent media, such as soft pastels and charcoal, will be dulled by a matte fixative, reducing clarity and making the work appear hazy. Using a gloss finish over such materials counteracts any visual haze. However, most fixatives alter an artwork's appearance to some degree, so always test before using on your finished piece.

APPLYING FIXATIVE

Hold the can around 8in (20cm) from the work. Spray lightly in one movement across the entire work. Don't spray back over; instead, let the surface thoroughly dry, then apply another coat. Oversaturating the surface can dissolve pigments.

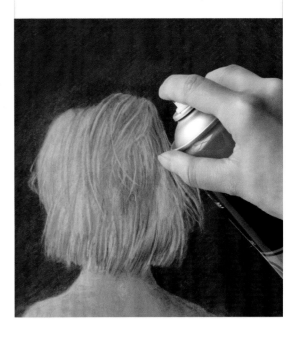

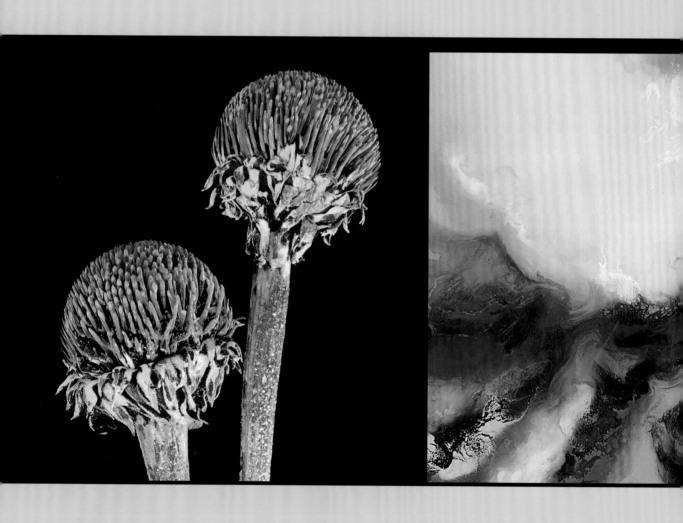

PAINTING
MATERIALS AND EQUIPMENT

The vast range of painting materials and
equipment can be baffling, but with a little
knowledge about what's available and a
willingness to experiment, you can build
a collection that meets all your needs.

PIGMENTS

Pigments are the source of color in all paints. They are used to create the variety of colors we see every day in the subtle hues of house paint, the bright colors of car paints, and on artists' canvases and papers.

△ **Red vermilion** is created from the natural mineral cinnabar.

Pigments are small insoluble particles that provide color and are made either from natural sources or by synthetic means. The first known use of pigments was by early humans spraying iron oxide and water onto cave walls 64,000 years ago.

Natural pigments are either organic or inorganic, have been used for centuries, and come from all over the world: ultramarine from the semiprecious stone lapis lazuli of Afghanistan and carmine red lake from crushed shells of cochineal beetles in South America. Most pigments used in paints today are either inorganic (not of animal or plant origin) or synthetic organic (created in a laboratory), even many of those still available naturally. For use in art, the pigments are usually mixed with an oil- or water-based binder, according to the medium, before being packaged into tubes or pans.

◁ **The cueva de las manos** takes its name from the stenciled outlines of hands created with mineral pigments over 9,000 years ago.

Organic pigments

Organic pigments are carbon-based and made from animal or plant matter. They are used in paints, dyes, and stains. Historic colors include sepia brown from cuttlefish and red madder from plant sources. Synthetic organic pigments began to be made on an industrial scale in the mid-19th century and are very stable, high-tinting, brighter, and more transparent than nonsynthetic organic pigments.

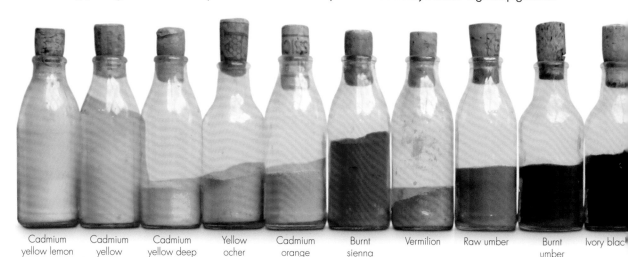

Cadmium yellow lemon | Cadmium yellow | Cadmium yellow deep | Yellow ocher | Cadmium orange | Burnt sienna | Vermilion | Raw umber | Burnt umber | Ivory black

Inorganic pigments

Inorganic pigments are either natural salts and minerals extracted directly from the earth or rocks that are ground to powder, washed, and sifted to make them into pigment, or they are synthesized from salts and minerals. These pigments are long-lasting and available in many colors. They include warm, earthy reds and yellows from natural inorganic pigments containing iron oxides and the bright reds and yellows of synthetic inorganic pigments like cadmium, the rich ultramarine and cobalt blues, and chrome greens.

Some of these pigments can be used in their natural "raw" state or heated to change color completely. Raw sienna is a light brownish yellow that, when heated, becomes the rich rustlike red called burnt sienna. The same can be done with umber.

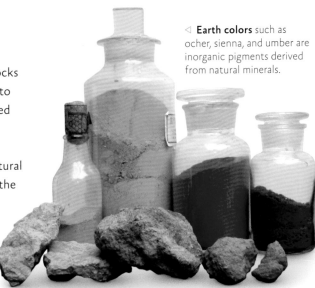

◁ **Earth colors** such as ocher, sienna, and umber are inorganic pigments derived from natural minerals.

▷ **Some pigments** begin as raw rock, such as yellow ocher (right), which is pulverized into powder. Oil is added and then ground into the pigment with a glass muller, in a traditional method of creating oil paint.

◁ **There is a greater** range of hues available in inorganic pigments compared to organic options, with long-lasting, stable color rendition.

balt blue Cerulean Veridian
 blue

CAUTION!

Safety is paramount when handling dry pigments, as inhaling dust can cause serious health problems. In the past, some pigments contained lead (cremnitz white), arsenic (emerald green), or mercury (red vermilion). Nontoxic versions exist today, but always read the label and wear a particulate-filtering face mask and gloves.

BRUSHES

Brushes for painting come in many shapes and sizes, with both natural and synthetic fibers or bristles available. Your choice of brushes will be guided by your art medium and style of painting, as well as your budget.

European cave paintings dated to the Upper Paleolithic period, before 30,000 BCE, show that humans have been making marks with brushes for tens of thousands of years. The Ancient Egyptians used bound palm fibers; American Indians used an array of materials, including bone, hide, and porcupine guard hair. In 14th-century Italy, artist Cennino Cennini recommended plucking cooked minever (squirrel) tail hairs and fitting them into feather quills of different sizes: vulture, goose, and hen or dove.

Natural or synthetic?

While animal hair and quills are still widely available, there is now also the choice of synthetic brushes, which may suit those on a budget or with concerns for animal welfare. Traditionally, sable-hair brushes from the kolinsky weasel are the favored choice for watercolorists, because the hairs are soft and springy, keep their shape, and hold lots of wash. Similarly, oil and acrylic painters often favor hog-hair bristle brushes, because they are stiff enough to manipulate thick paint well and, if

TYPES OF BRUSHES

There are many brush shapes available—each suited to its purpose—in different bristle fibers. Size is denoted by number, with 000 being the smallest and finest. Buy the best brushes you can afford.

▷ **"Bright" flat brushes** have shorter, stiffer bristles that afford greater control for more detailed work when oil painting.

◁ **Round brushes** are versatile for all painted media, as they hold paint well and have a pointed tip for detailed work.

▷ **Flat brushes** are square-ended and hold a lot of paint for impasto. They lend themselves to bold marks when laid flat, or use the edge for detail.

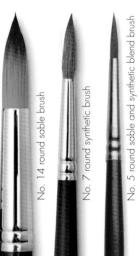

No. 14 round sable brush

No. 7 round synthetic brush

No. 5 round sable and synthetic blend brush

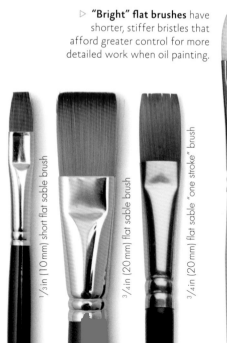

⅜in (10 mm) short flat sable brush

¾in (20 mm) flat sable brush

¾in (20 mm) flat sable "one stroke" brush

No. 8 short flat hog-hair brush

cleaned properly after use (see page 95), will keep their shape for years. There are no hard-and-fast rules, and purely synthetic or mixed brushes are long-lasting and well-suited to all roles.

Choosing brushes

For beginners, start with a small selection of the most useful brushes and extend the collection as you become more proficient. For watercolor, three different-sized round brushes (No. 3, 5, and 8), two large wash brushes (square or oval mop), and a liner for fine details is plenty to start with. For acrylic, you can achieve a lot with six brushes (two large, two medium, and two small) in a mixture of flat and round shapes depending on painting style. A basic brush collection for oils is two round, two flat, and two filbert in different sizes. Many painters keep duplicate brushes—one for light paint and one for dark—to avoid cleaning brushes while painting.

EARLY PAINTBRUSHES

Humans have always been creative in their methods of applying paint, and our use of tools extended to improvised paintbrushes. Strands of horse hair bound to a wooden shaft with plant fiber have been found, and plant materials, such as moss, were also used to apply pigment. Ancient Egyptians used palm-fiber brushes.

Ancient Egyptian brush

Cut fibers form the tip

Remnants of red pigment on brush tip

Palm fibers are bound together with string

▽ **Use wash brushes** to achieve broad stripes of watercolor. A round wash brush is called a mop. These suit both large washes of color and detailed work.

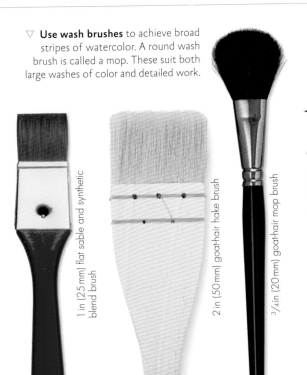

1 in (25 mm) flat sable and synthetic blend brush

2 in (50 mm) goat-hair hake brush

³/4 in (20 mm) goat-hair mop brush

▷ **Filbert brushes** are round with flattened ferrules. They give a broad stroke used flat or a sharp line using the edge.

No. 4 filbert synthetic brush

Sable rigger brush

Synthetic liner brush

△ **Liners and riggers** are long and narrow, with long, pointed tips that are ideal for painting very fine lines. Riggers hold a lot of paint.

▷ **Fan brush fibers**, arranged in a fan shape, are usually kept dry to use for softening and blending.

Sable fan brush

Synthetic fan brush

ACRYLICS

Fast-drying, durable, and versatile, classic acrylic paint is water-soluble and capable of producing effects from thick, opaque, oil-like impasto to transparent, watercolorlike washes—and many more.

Acrylic paints came from 20th-century industrial origins. By the 1960s, they were popular with artists partly because they lacked the unhealthy fumes of contemporary oil-painting processes and dried more rapidly. Pop artists exploited their ability to produce flat, hard-edged areas of even, bold color with no visible brushmarks. They can be used straight (right from the tube) or diluted to create watercolorlike washes, but they are water-resistant when dry. Their stability and lightfastness compares well with watercolors or oils, creating a tough but flexible surface with good permanence.

Working with acrylics

Because they are fast-drying, you can layer acrylic colors quickly and easily, but you can't keep working the paint surface as readily as with oils. For beginners, acrylics' versatility and ease of preparation are ideal and, while the rapid drying can be awkward, it's useful for overpainting errors.

Supports and additives

Acrylics can be used on many surfaces, from cardstock, canvas, and board to wood, plastic, and metal. Priming may be unnecessary, although an acrylic gesso primer will often be invaluable. Numerous gels and mediums can be added, such as "extenders" or retardants to delay drying and so make blending easier and gels to add translucence (see page 95).

△ **Bold, flat color** is a hallmark of acrylic style, used here to create the block pattern of the tiles and solid shapes of the dresses.
The Zar II (1992) Laila Shawa

Even finish mixed on the palette

Open, loose blend with a brush

Impasto blend with a palette knife

△ **Mix colors in different ways** for a variety of effects: on the palette for flat color or with a brush or palette knife directly on the canvas.

TYPES OF ACRYLIC PAINT

Acrylic paint typically consists of an emulsion of synthetic plastic resin, water, and pigment. Paint types range from thick and buttery to very thin and suitable for airbrushing. There are basic or "student" grades and superior "professional" grades, and paints are sold in an array of containers, from tubes to bottles. For a long life and good permanency and lightfastness on the painted surface, certain pigments and paint qualities are better than others. Look for the permanence rating information given on many products. Good acrylics should last around 10 years if their containers are kept at room temperature, ideally 60–80°F (16–26°C), away from moisture and direct light—possibly in an airtight, lidded plastic box.

SAFE AND SUSTAINABLE SUPPLIES

Classic acrylics do contain some VOCs (Volatile Organic Compounds). Some pigments, such as cadmium and cobalt, are also poisonous if they are consumed or enter the bloodstream via open cuts. A mask, gloves, and ventilation system are therefore advisable (especially with airbrushes and spray paints). Non-VOC paint ranges are available.

△ **Markers and pens** have multiple uses, including outlining a mural or for cartoons.

△ **"Open" or "interactive"** paints let you control drying speed, so they remain workable for longer.

△ **Heavy-bodied or thick paints** are good for textural effects and retaining brushwork.

△ **Soft-bodied or flowing** acrylic can be painted or poured, gives even coverage, and is good for detail.

△ **Acrylic gouache** has an opaque, matte finish but is waterproof, unlike traditional gouache.

△ **Special effects** such as metallic, glitter, and fluorescent paints may prove "fugitive," or prone to change and fading.

OILS

Typical oil paints are composed of ground pigment bound in linseed oil. They offer rich, lustrous color, and their buttery, slow-drying texture makes them easy to apply and rework.

Using oil paints, you can achieve expressive, textured effects and smooth blends; thick opacity; thin scumbles; and even transparent glazes. Oil paints are made with "drying" or "semidrying" oil—especially linseed oil—which hardens on exposure to air. It is the oil that slows the drying time—water-soluble paints are dry once the water has evaporated; classic oils harden through oxidation. Because oils are slow-drying, unlike watercolor and acrylics, the paint remains workable over time.

Paint quality

Most ready-made oil paints are graded from low to high as student, artist, or professional quality. The more costly artist and professional quality paints generally contain better-quality pigment and have more vibrant, longer-lasting, and fade-resistant color. Lower grades may use a pigment blend (called "hue" on the tube) for certain colors that would traditionally use expensive single pigments. Student quality paints may also contain fillers and driers for a more uniform performance across all colors, ensuring easier usage for beginners.

Color name: check pigment

Permanence rating

Series number: the lower the number, the lower the quality

Approximated paint color

Pigment number

Lightfastness rating

Opacity rating

Front of tube Back of tube

△ **Oil paint labels** provide important information about the properties of the pigments used. See above for some useful things to look out for.

Titanium white Naples yellow Lemon yellow Cadmium yellow

▷ **Tubes** are the most common format for oil paint and are sold in various sizes. They are sold individually or in sets of colors.

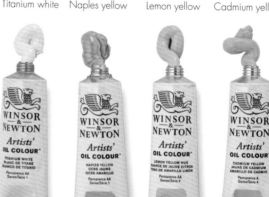

△ **Alkyd oil paint** contains synthetic alkyd resin, so it is faster drying—more like acrylics.

Supports and mediums

You can paint on canvas, board, wood, or even metal. For thinners and tool cleaners, you can use solvents or a low fume/toxicity alternative with good environmental credentials—or choose paints you can use with water (see right).

Adding mediums is useful for changing how the paint performs in some way—alkyd mediums that speed the drying process are much loved by some oil painters. Wearing gloves and a mask can be wise if handling paints and thinners or painting large areas. Spaces must always be well-ventilated, and remember that solvents may be highly flammable.

△ **Water-mixable oil paint** is formulated so it can be thinned with water instead of a chemical solvent.

Pigment properties

When selecting your paint colors, look for the opacity rating, which is a guide to the paint's transparency. Some pigments tend to be more opaque (such as cerulean blue) and some more transparent (such as viridian). Drying times also vary between colors; permanent rose is usually a slow drier, while cobalt blue dries quickly. Permanence also differs: zinc and titanium whites are among the most permanent, and alizarin crimson among the least.

△ **Oil sticks and bars** are made of compressed oil paint and wax in a range of colors and special effects, such as iridescence.

◁ **Cans** are available for larger amounts of paint and are useful for foundation colors.

| Cadmium orange | Cadmium red | Alizarin crimson | French ultramarine | Cobalt blue | Cerulean blue | Viridian | Burnt sienna |

WATERCOLOR AND GOUACHE

Unlike any other medium, watercolor can create finished paintings within a short space of time. There is little drying time and few materials involved, and it is an excellent way to satisfy those creative urges.

Watercolor pans

WATERCOLOR

Watercolor paints—or to be more precise, pigments—behave in different ways. The pure watercolor range varies between transparent and opaque, from smooth to granular, from permanent to fugitive. It is always best to choose the type that suits your style or subject. Try to avoid student quality, as it has less pigment and will give your paintings less impact. If you can keep to a few trusted colors instead of the whole rainbow, then you are more likely to control your painting.

Tubes of paint

Watercolor tubes are moister than pans (see right) and are ready for use once you have topped up your wells. You can load a brush more easily from tubes, as the paint is thick and creamy. Because of this, tubes tend to be used for larger watercolor paintings that require a lot of paint.

Pans

Pans are ideal for smaller paintings and details. They are also good for artists who do not paint at regular intervals, as the paint is easily pliable with just a drop of water—this is useful if you are traveling and require a quick response to a view that you like.

Watercolor pens

Watercolor pens are particularly effective for graphic art styles and for sketching ideas in the fashion world where color is as important as detail. They are very quick and easy to use and can be a great tool for creating or adding detail on top of a complementary wash.

Watercolor pens

◁ **Watercolor tubes** are generally available in a greater variety of colors than pans. The moist paint makes mixing color washes very quick and easy.

Lemon yellow

Yellow ocher

Quinacridone magenta

Cadmium red

Prussian blue

Sap green

Watercolor crayons

Watercolor crayons, like watercolor pencils (see page 63), are excellent for adding texture and extra color to a painting. They can also be used to highlight where needed, for example, in architectural details where the texture of a surface needs to be brought to life by laying an underlying watercolor wash.

Watercolor crayons

Inks and liquid watercolors

Particularly effective if allowed to run freely without labored brushwork, inks and liquid watercolors can be used to achieve abstract patterns and shapes.

GOUACHE

Gouache is a water-based paint that can be diluted to become transparent like watercolor. As its opacity varies depending on the amount of water it is mixed with, gouache can straddle both watercolor and more opaque media such as oils and acrylics.

Gouache is often used in watercolor to add opaque highlights as an alternative to masking out, such as for snow, stars, or highlights on objects. It can also be mixed with pure watercolor and applied in glazes to provide an alternative to acrylics.

Gouache tube

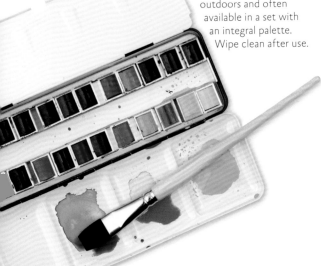

◁ **Pans of paint** are perfect for working outdoors and often available in a set with an integral palette. Wipe clean after use.

WORKING WITH OTHER MEDIA

Try using watercolor with other media, such as ink, wax, and charcoal, so you can further your understanding of its qualities and limitations.

Mixed with ink, pigments can granulate when water is added. If left to run on rough paper, it creates an ethereal effect.

When overlaid on wax, watercolors separate, giving a painting a sense of spontaneity and looseness.

Add color and tone to a charcoal sketch with watercolors without destroying the marks beneath.

SPRAY PAINT

Spray painting is an effective way of creating intense color, exciting mark-making, and a sense of street culture. The soft edge created by spray paint is unique, and colors dry fast and keep their vibrancy as they dry.

Ideal for outdoor use, such as creating a mural, spray paints can also be applied on top of a range of media, such as acrylic and oil paints. They can be sprayed directly onto metal, wood, canvas, plastic, and outdoor masonry, covering large areas quickly. The paint can be blended and shaded freehand or with stencils. If using on canvas or board, priming the surface with gesso will intensify the paint color.

Choosing your spray paint

There is an extensive range of spray paints. Water-based ones with a low odor are the least toxic. Graffiti or fine-art brands are high quality and come in over 100 colors. Some professional brands distinguish between high-pressure spray paints that cover areas rapidly and low-pressure ones that are easier to control—check the label or ask before buying. Always work in a well-ventilated area and wear a mask when using spray paint.

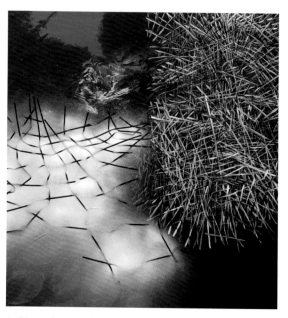

△ **Here, the mixed media** of acrylic and spray paint creates depth and drama. *All That Is Solid...* (2019) Alison Hand

Montana graffiti

Liquitex acrylic paint

Hammerite metal paint

Water-based acrylic paint

AIRBRUSH

An airbrush is a handheld device that uses compressed air to spray paint onto a surface with a very fine level of detail and control. Airbrushes draw paint from a bottle, then release it with a trigger.

You can use ink and most types of paint with an airbrush, including acrylics, watercolors, textile paints, and even oils and enamels, if thinned. There are also special airbrush paints, which are ideal for beginners. All airbrushes need pressurized air to atomize the paint; this is supplied by attaching either an air compressor or a can of propellant. Different sizes and air capacity offer options for paint coverage. A can is cheaper and more portable.

Controlling the airbrush

Learning to control the airbrush takes practice. With a dual-action airbrush, you press the trigger for air, and pull back for paint; the farther you pull, the more paint is released, allowing you to control the spray. With a single-action airbrush, the trigger releases both air and a fixed amount of paint at the same time, making it simpler to use but not as precise.

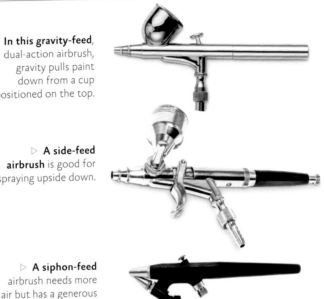

▷ **In this gravity-feed**, dual-action airbrush, gravity pulls paint down from a cup positioned on the top.

▷ **A side-feed airbrush** is good for spraying upside down.

▷ **A siphon-feed** airbrush needs more air but has a generous paint capacity.

△ **Select** the nozzle size according to the coverage required.

Acrylic airbrush paints

◁ **A cleaner** for the airbrush also prevents the nozzle from clogging.

△ **A hose** connects the airbrush to the compressor.

NONTRADITIONAL ART PAINTS

Many artists use commercial paints that are not traditionally made for fine art. Inexpensive household paints are useful for covering large areas, while neon and black light paints offer vibrant and luminous effects.

Household and other everyday paints allow you to explore new finishes and textures, from chalky and matte to reflective or luminescent. As with traditional media, the properties of each paint determine the application methods and supports you can use; there are numerous possibilities with these paints. A vast array of colors is also available, although the names will not be comparable to fine art paints. If you mix paints with the same base, they should blend together easily. Mixing paints with different bases can cause them to separate, which some artists utilize as a special effect.

◁ **Black light and neon paints** are bright in daylight but seem to come alive under UV lights, creating glowing, luminous, and magical effects.

EMULSION

- **Properties:** Water-based. Colors muted. A chalky, matte finish, but satin has a subtle sheen. Use to create texture.
- **Supports:** Suitable for any surface, including canvas, MDF, wood, or metal. If using MDF, work on a primed surface.
- **Art methods:** Pour, layer, drip, sponge, or apply with a brush or roller.
- **Notes:** Covers large areas fast. If mixed with gloss, it can partially separate.

GLOSS

- **Properties:** Water- or solvent-based. Bold color. Sheen. Dries to impenetrable, hard finish. Viscous and easy to control.
- **Supports:** As for emulsion (left). On nonabsorbent or metallic surfaces, has a reflective finish.
- **Art methods:** Pour, layer, drip, sponge, or apply with a brush or roller.
- **Notes:** Stir well before using. If applied to a nondry surface, it may wrinkle.

VARNISH

- **Properties:** Water- or solvent-based. Can be clear or tinted. Marine/spar varnish creates a thick, semitransparent resinlike layer. Acrylic varnishes unify a surface.
- **Supports:** As for emulsion and gloss.
- **Art methods:** Pour, layer, drip, sponge, or apply with a brush or roller.
- **Notes:** Thick varnishes can hold parts of a collage. Can crack if too thick. Apply painted layers between varnish for depth.

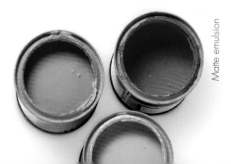

Matte emulsion

Gloss

Varnish

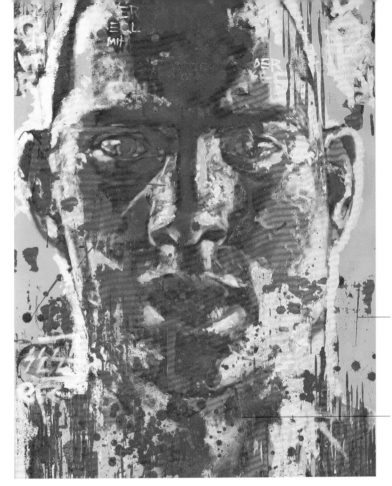

◁ **Neon paint** was dripped from a spray paint can nozzle directly onto the propped-up canvas in this painting. The artist also smeared the paint-covered can across the canvas in places.
Zeste (2017) Egon von Euwens

The drops of paint fell randomly onto the canvas

Red and blue neon paints beside each other can create a flickering effect

ENAMEL

- **Properties:** Solvent-based. Glossy, glasslike finish; semitransparent to opaque. Runnier than gloss paint.

- **Supports:** Suitable for glass, metal, plastic, canvas, and wood.

- **Art methods:** Pour, layer, drip, sponge, or apply with a brush or roller.

- **Notes:** Used for painting model trains and airplanes, floors, and signage, so it is hard-wearing. Good for adding in detail.

NEON PAINTS

- **Properties:** Water- or solvent-based. Fluorescent pigment is vivid in daylight and, under UV light, luminescent. Available in heavy- and soft-bodied acrylic paints and in spray paints.

- **Supports:** As for emulsion and gloss (see opposite).

- **Art methods:** Pour, layer, drip, sponge, spray, or apply with a brush or roller.

- **Notes:** Great for large-scale artworks.

BLACK LIGHT PAINTS

- **Properties:** Water- or solvent-based. They react to ultraviolet light, also called black light, to produce photoluminescence.

- **Supports:** As for emulsion and gloss (see opposite).

- **Art methods:** Pour, layer, drip, sponge, or apply with a brush or roller.

- **Notes:** "Visible" black light paint can be seen in daylight, while "invisible" is visible under black light only.

Enamel paint

Neon paints

Black light paint

KNIVES AND PALETTES

Both painting and palette knives are used to mix and apply paint, while a palette holds the artist's choice of colors ready for mixing or applying directly. Painting knives can also be used to create texture in an artwork.

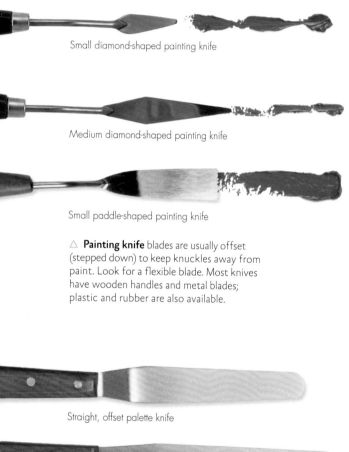

Small diamond-shaped painting knife

Medium diamond-shaped painting knife

Small paddle-shaped painting knife

△ **Painting knife** blades are usually offset (stepped down) to keep knuckles away from paint. Look for a flexible blade. Most knives have wooden handles and metal blades; plastic and rubber are also available.

Straight, offset palette knife

Straight, flat palette knife

△ **Palette knives** have flat, round-ended blades, making them ideal for mixing paints.

PAINTING AND PALETTE KNIVES

Painting knives, most of which have tapered blades, are flexible and designed to apply paint. Also called palette knife painting, this method became popular in the 19th century, when artists such as Gustave Courbet (1819–1877) used knives to create impasto images (see below and page 153). The method is best suited to heavier paints such as oil and acrylic, although some watercolorists use it, too. Rounded palette knives are used to mix paint on a palette.

△ **Using a painting knife** allowed Gustave Courbet to build up layers of paint (impasto), adding texture and a sense of drama.
Marine: The Waterspout (1870) **Gustave Courbet**

Layered paint reflects light

PALETTES

A palette is a vehicle for paint. It allows easy access to colors, enables artists to keep colors separate, and provides a space for mixing. Before the arrival of palettes, artists would work with paints from shells or pots. The traditional wooden arm palette dates back to the 15th century. These are still favored by many artists today, particularly when using oil, but there are other types of palettes available that may suit your needs.

△ **Porcelain palettes** with raised partitions are practical for keeping watercolors separate.

△ **White plastic palettes** are helpful if using white paper.

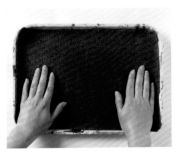

△ **Dipper pots**, for oil-painting mediums (see page 94), can be clipped onto a wooden palette for convenience.

Wooden palette

△ **Paper palettes** work for both oils and acrylics.

MAKING A STAY-WET PALETTE

This home-made palette can be useful for painting with acrylics. The paints are kept on a water-soaked membrane to stop them from drying out, allowing you to keep using them over long periods of time, sometimes weeks, without waste.

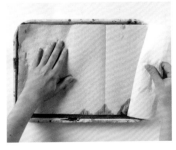

Parchment paper

1 Fit a capillary mat (from a florist or nursery) over a shallow plastic tray. Wet the mat and press it down.

2 Place two layers of paper towel on top of the mat. Put a layer of parchment paper or wax paper on top.

3 Add and mix your paints. When finished, cover with a plastic wrap to keep paints moist until needed again.

GUMS, WAXES, AND RESINS

Gums and resins are natural sticky liquids that are produced by trees and plants in response to injury. Waxes are natural substances made by some animals and plants. Gums, waxes, and resins have many uses within art.

GUMS

Water-soluble gums are a major ingredient used in the making of paint. They are also used as adhesives in printing and as a sizing for paper. At the source, they have a thick, sticky consistency between solid and liquid and are produced by the bark of certain trees and plants. The hardened sap is dissolved in water.

Gum arabic

Also used by printmakers, this is the favored gum for use as a binder in watercolor paints, but it can also be bought as a medium to increase the paint's color brilliance, gloss, and transparency. It can be added to a watercolor wash or straight to the water pot, which will affect all the colors used, making them more brilliant and luminous. It also aids in the correction of mistakes, as it reduces the staining of pigments and helps slow drying time, giving more time to work with washes.

Other gums

Gum tragacanth is the binder used for making soft pastels, because it doesn't adhere to itself in the same way that gum arabic does, thus creating the desired soft, powdery texture of this medium.

Gum ammoniac is used by calligraphers and artists as a glue to add detailed illuminated (gilded) areas to paper, parchment, and vellum.

△ **Gum arabic** is the binder in watercolor paints and can be used as a sealant on finished watercolor art.

△ **Gum tragacanth** is used as a binder for pastels and to thicken natural dyes for painting and printing.

△ **Gum ammoniac** is applied with a fine brush or dip pen. It dries quickly, but it can be reactivated by hot breath.

△ **Drawing gum** is used for masking. It is actually latex rubber, also produced by plants when injured.

WAXES

Natural waxes are insoluble in water and therefore repel water-based paints to great effect (see page 144). The best known is beeswax, which is the traditional wax used, with damar resin, to make encaustic paints—although microcrystalline wax, synthesized from petroleum, can also be used. The plant-derived waxes, carnauba and candelilla, are common ingredients in oil-painting mediums and varnishes.

Wax sticks, crayons, and candles

The simple technique of drawing with clear wax sticks or candles and then washing over the paper with watercolor paints is a great way of retaining background colors or white areas in a painting, as well as fine underpainting details.

Wax crayons are a cheap, readily available option for creating large areas of colored wax resist or for adding strong color accents and finishing touches to a watercolor painting.

▷ **Encaustic wax** comes in clear or colored blocks to be melted.

▷ **Beeswax** can be mixed with pigment and damar resin to make your own encaustic paints.

▷ **Some crayons** are water-soluble to create less intense color.

Wax candle

◁ **Brushable wax** is a versatile mask and can be applied with a brush or sponge or thinned with solvent to use with a pen.

RESINS

Resins are more gluey and liquid than gums and can be either natural or synthetic—most natural resins darken and can become brittle over time, making them a less durable option. Synthetic resins are used to make some paints, inks, and etching grounds and in 3D printing.

Many resins are used as transparent varnishes (see page 94), and some artists now paint with resin, using acrylic paint, metallic powders, or other items and a heat gun to move pigment around the canvas. Resins have a distinctive smell and should be used with a mask.

Glimmer of Hope (2020) Tamsin Pearse

MEDIUMS, VARNISHES, AND CLEANERS

A medium is a substance added to paint to increase its workability or to achieve an effect. A varnish protects a finished painting. Many mediums can be used as cleaners, although specialty cleaning products also exist.

OIL PAINT MEDIUMS AND VARNISHES

Adding a medium to oil paint can affect both how the paint behaves and its appearance. A medium can also be used to shorten or increase the slow drying time of oils. Available as solvents and oils that thin paint and enhance flow or as prepared mediums that have specific properties, you can either add mediums to the paint or dip into them. Low-odor, eco-friendly alternatives that are nontoxic are available. Care needs to be taken when using mediums, because a build-up of one in the base layers will create cracks as it tries to dry through the faster-drying layers on top.

Applying gloss or matte varnish to dry oil paint helps deepen colors and even out the surface.

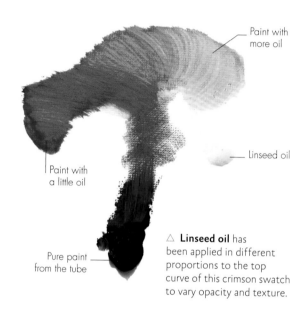

Paint with more oil

Linseed oil

Paint with a little oil

Pure paint from the tube

△ **Linseed oil** has been applied in different proportions to the top curve of this crimson swatch to vary opacity and texture.

◁ **Alkyd impasto medium** is crack-resistant, preserving thickness and brushmarks. Its gloss finish resists yellowing.

△ **Linseed oil** increases the flow of oil paint and gives a gloss finish but slows down the drying time of the paint to about three to four days.

△ **Varnish** is applied when a painting is completely dry. It provides a protective layer to repel dust and UV damage.

ACRYLIC MEDIUMS

These are less complex in their application than oil mediums, because they are made with the same emulsion as acrylic paints. This makes drying times consistent, unless a retarder is used to slow drying time for wet-in-wet techniques. Experiment with different gels and pastes to add texture or impasto effects, improve flow, or alter transparency.

Sand texture gel Glass beads Black lava
 texture gel texture gel

WATERCOLOR MEDIUMS

Ox gall (or a vegan substitute) improves the flow of a watercolor wash, for greater coverage and to avoiding puddling. A gum arabic binder solution increases gloss and transparency and slows drying times; impasto gels add thickness.

To retain whites or add highlights, use masking fluid or a thin layer of gum arabic; let these dry to form a barrier from washes, then lift them off.

Apply masking fluid Peel to reveal area

CLEANERS

A natural cleaning choice for artists working with water-soluble media such as watercolor or acrylics would be water and mild household or special artists' soap. Some water-soluble artists' soaps or soaplike products clean across most media. Oils, such as safflower oil or vegetable oil, can be effective natural cleaners for oil paints (especially for wooden palettes). Spike lavender oil can act as a cleaner (and a thinner), although this is costly. Solvents such as artists' white spirit or citrus turpentine make good cleaners for enamel and oil-based paints and certain acrylics.

△ **Artists' soap** removes oil and acrylic from brushes.

△ **Liquid brush cleaner** can be used for cleaning and thinning paint.

△ **Brush cleaner-preservative** removes all paint media and helps condition brushes.

USING PRODUCTS SAFELY

Many solvents are flammable and potentially toxic, so it's essential to follow safety guidelines.

- **Read product safety notes** and never ingest anything.

- **Use protective measures:** barrier creams, masks, and nitrile gloves. Always ventilate your working area.

- **Store products** securely in their original container.

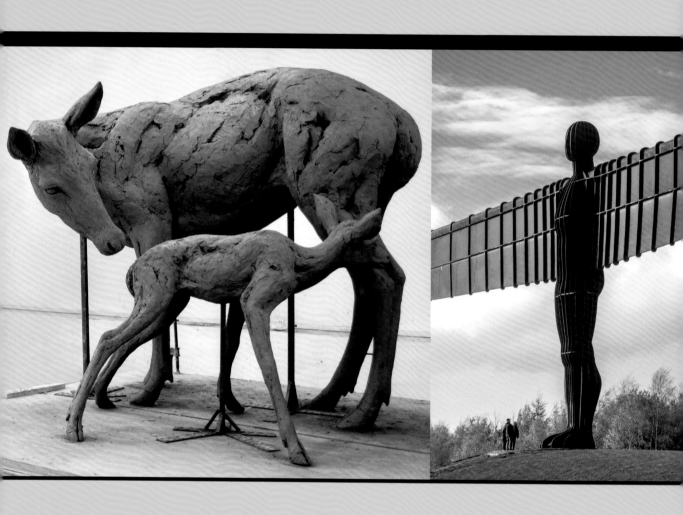

SCULPTURE
MATERIALS AND EQUIPMENT

From clay animals and metal figures to stone
reliefs and clear acrylic tunnels, modern sculpture
can be made in many materials, each with its own
unique properties and requiring specific tools and
equipment, which are covered here.

CLAY

There are two main types of clay available for sculpting—natural and synthetic—and within these two categories, there is much variation in handling and drying properties, as well as final finishes.

WATER-BASED CLAY

Water-based clay is the natural type dug from the ground and is one of the oldest and most common of all artists' modeling materials. It is best known for creating pottery, but it can be used for modeling sculptures to be cast in metals such as bronze. It is also used for making ceramic sculptures (see page 190), which are fired in a kiln to make them stronger and then often glazed for decorative reasons or to make the final piece nonporous.

Coarse and fine clay

Clay used to make sculptures that are to be fired in a kiln is often coarse and contains "grog" (particles of crushed brick or ceramic) to reduce cracking in the firing process. On the other hand, clay used for molding and casting a sculpture in another material such as metal, plaster, or resin (see page 186) is usually finer and smoother in consistency.

Air-dry clay

The jury is still out on this relatively new water-based clay to the market. Its main advantage is that the clay dries or "cures" in the air at normal temperature with no kiln firing required. It also contains more additives than normal clay, which means the sculpture won't crack as it dries out, but this can have the disadvantage of making the clay less pliable and therefore harder to take texture.

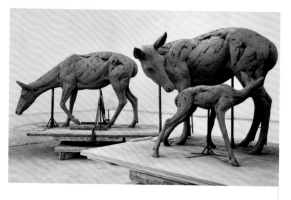

USING ARMATURES

Unlike sculptures to be fired, those created for molding and casting can have an armature (see page 180), because they aren't going into a kiln, which would overheat the metal, causing the clay to crack or explode.

△ **Water-based clay** has plasticity due to its very small particle size, making it easy to manipulate using just your hands or any type of modeling tool.

△ **Naturally air-drying,** water-based clay must be kept damp with a spray bottle while working. Keep clay in plastic bags and wrap partly completed sculptures.

OIL-BASED CLAY

These are synthetic clays made from various combinations of oils, waxes, and clay minerals or other additives that prevent them from drying out like water-based clays if left exposed to the air. This means the clay remains malleable at normal temperatures, but they come at a higher price than water-based clay. Oil-based clays can even be made to order, with the exact malleability and color required.

Smaller and more detailed sculptures are especially prone to drying out, so oil-based clays can be a better material in these instances. Most models created in oil-based clays will require a metal armature inside for support, although firmer oil-based clay is less reliant on armature support. Stripped from the armature, these clays can be recycled and reused if stored carefully and kept clean.

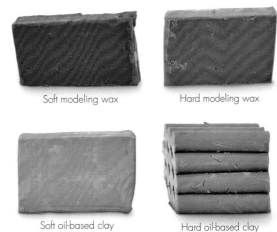

Soft modeling wax Hard modeling wax

Soft oil-based clay Hard oil-based clay

△ **The properties of oil-based clays** vary between brands and according to the mixture of wax, oil, and other additives, so experiment to find the one you like best and that suits your style.

POLYMER CLAY

Polymer clay is a fairly new synthetic modeling material best used for smaller, more detailed work and is frequently used by restorers and animators. It has the properties of oil-based clay, in that it generally maintains its malleability at room temperature and does not dry out in the air.

It has the huge advantage that it can be hardened into a finished material by baking in a domestic oven at a much lower temperature than a kiln. Alternatively, use a two-part epoxy clay, which hardens when mixed. It can be tough to manipulate, and you only have a few hours before it sets to a rock-hard finish. It can be further shaped by sanding.

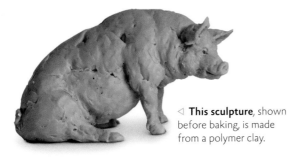

◁ **This sculpture**, shown before baking, is made from a polymer clay.

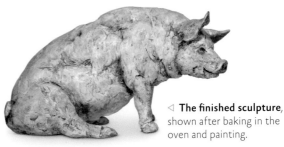

◁ **The finished sculpture**, shown after baking in the oven and painting.

CLAYS FOR MODELING

Only water-based clay can be modeled and then
fired in a kiln to become a ceramic sculpture. It
can also be modeled and used to create a mold for
casting in other materials, such as bronze, plaster,
resin, or concrete. Oil- and wax-based clay needs to
be modeled and then molded and cast—it cannot
be fired, as it would simply melt in the kiln. Polymer
clay and air-dry clay are used for modeling and then
either oven baked or left to self-dry in the air.

The clay in which you choose to model your
sculpture, as well as your sculptural style and
how detailed you wish your final piece to be, will
determine the type of modeling tools you use. Your
hands are, of course, your most responsive tool.

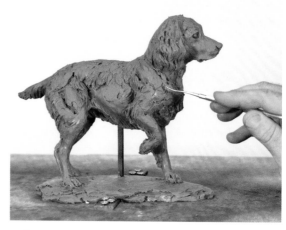

△ **Stronger metal tools** are used with oil-based and
polymer clay, although wooden tools can be used if care
is taken that they don't break when using harder clays.

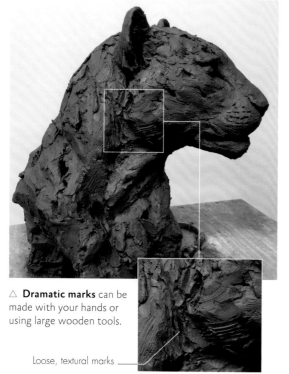

△ **Dramatic marks** can be
made with your hands or
using large wooden tools.

Loose, textural marks

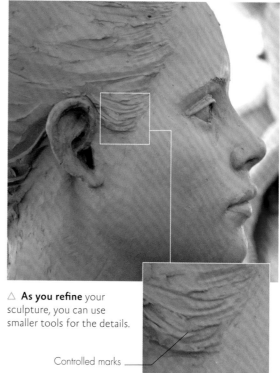

△ **As you refine** your
sculpture, you can use
smaller tools for the details.

Controlled marks

TOOLS FOR MODELING

Modeling tools come in all shapes and sizes, and you can even make your own bespoke set. Small wood or metal tools are useful for detailing, while larger wooden tools are helpful in creating form, contour, and texture. Metal tools are generally used to model polymer clay. Loop tools can be used for both sculpting and adding texture.

Calipers

△ **Use calipers and dividers** for measuring your model and artwork.

▷ **Stainless-steel tools** are excellent for working in hard wax or for fine detail.

Small stainless-steel modeling tool

Curved stainless-steel modeling tool

▷ **Use metal wire tools** for cutting away, shaping, and texturing clay.

Metal loop tool

6 in hardwood tool with flat end

8 in curved hardwood tool

7 in hardwood tool for fine detail

8 in student hardwood tool for shaping

△ **Hardwood tools** come in a variety of shapes and sizes depending on the scale of your work. Tools with a curved profile allow for more control.

Small tip for fine detail

Straight end for smoothing

Shaped end for detail

Sharp end for controlled detail

Serrated end for texture

△ **A basic modeling tool set** includes a selection of shaped and serrated ends for creating texture in soft to medium-hard materials.

WOOD AND STONE

Natural materials such as stone or wood provide the artist with an enormous choice of materials to work with, especially when carving a sculpture using hand-held tools to cut, gouge, or scrape the surface.

To transform natural materials such as stone and wood into sculptural forms involves using hand-held tools that connect you directly to your material. The many different qualities of stone and wood and ease of carving should be taken into consideration depending on your skill level.

For working with stone and wood, you need protective equipment, such as safety glasses, an FFP3-grade dust mask, and steel-toe work boots.

CARVING TOOLS

Many carving tools can be used for either wood or metal. A hammer is paired with other tools that pulverize, penetrate, or split the stone or wood. Mallets reduce the force driving the cutting edge and give better control. Chisels are used to penetrate, split away, and remove larger chunks or to mark your design. The smaller the width of the chisel, the less is removed and the finer the carving.

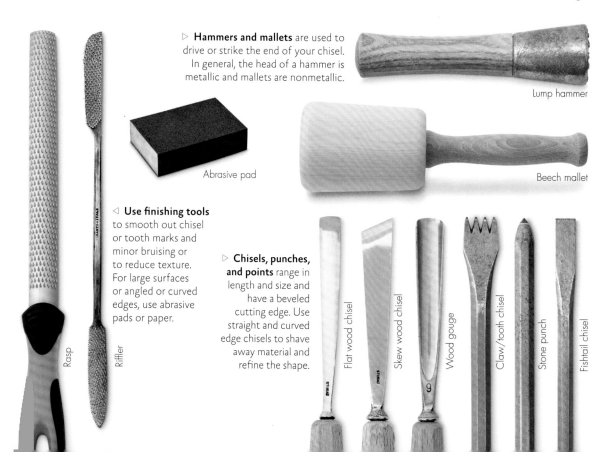

▷ **Hammers and mallets** are used to drive or strike the end of your chisel. In general, the head of a hammer is metallic and mallets are nonmetallic.

Lump hammer

Abrasive pad

Beech mallet

◁ **Use finishing tools** to smooth out chisel or tooth marks and minor bruising or to reduce texture. For large surfaces or angled or curved edges, use abrasive pads or paper.

▷ **Chisels, punches, and points** range in length and size and have a beveled cutting edge. Use straight and curved edge chisels to shave away material and refine the shape.

Rasp

Riffler

Flat wood chisel

Skew wood chisel

Wood gouge

Claw/tooth chisel

Stone punch

Fishtail chisel

TYPES OF WOOD

The species of tree—whether it is a broad-leaved hardwood or a softwood variety—and how long since the wood was cut will determine whether it has a closer grain and is harder to carve, although this allows for more detail. Greenwood that hasn't been dried is easier for whittling, but dried wood is used for carving. Here are a few types of wood, but there are many other species that can be used.

OTHER TYPES OF WOOD

HARDWOODS	SOFTWOODS
▪ Aspen	▪ Butternut
▪ Cherry	▪ Balsa
▪ Maple	▪ Cedar
▪ Oak	▪ Redwood

SOFTWOODS

HARDWOODS

△ **Lime or basswood** is soft, so making or correcting complicated cuts is easy.

△ **Pine** is soft and easy to shape but dents easily. Knots and rings can hinder carving.

△ **Mahogany** is fairly easy to carve and polishes well, to a dark reddish brown.

△ **Walnut** carves well and takes detail and polish. It is dark brown in color.

TYPES OF STONE

Stones are categorized depending on the way the rock was originally formed (by sedimentary, metamorphic, and igneous processes) and how long since extraction. For example, some stones are extremely hard and require specialist chisels to be worked, and others have very distinct patterning.

OTHER TYPES OF STONE

METAMORPHIC	SEDIMENTARY
▪ Slate	▪ Limestone
▪ Marble	**IGNEOUS**
	▪ Onyx

METAMORPHIC **SEDIMENTARY** **IGNEOUS**

△ **Soapstone** is the easiest to carve (even with a knife). It holds fine detail, polishes well, but scratches easily.

△ **Alabaster** is easy to carve but can flake. It is lightly colored and translucent, with colored veining.

△ **Sandstone** is a medium to hard stone, often red-hued. It is easy to carve along the natural bedding.

△ **Granite** suits advanced carvers, as it's the hardest to work. It has a crystalline pattern and many colors.

METAL

There are a number of different metals commonly used in sculpture. Some have been used for centuries and others are relative newcomers. Metal sculptures can be made by either casting or fabrication—and each method of working with metal requires different skills and equipment.

Casting—pouring molten metal into a mold and allowing it to set solid—has been used for millennia (see page 186). Bronze was the most common metal used in ancient times for casting statues and remains the favorite metal today due to its strength. Fabrication describes the cutting, drilling, welding, and assembling of different materials to make sculptures in a variety of metals, each with their own unique properties (see page 192).

Working with metal

Metals such as bronze and aluminum require a foundry for casting, but there are lower-melt alloys (a mixture of metals), such as pewter, that you can cast in your own home or studio—you will need a melting pot with a spout and a gas or electric ring stove. For fabrication, you will need a welder and an angle grinder with disks for cutting and shaping.

WEATHERING STEEL

Corten, also known as weathering steel, was invented in the 1930s to form a stable rust that avoids the need for a protective coat of paint. It quickly develops a red color, making its rust an attractive feature in outdoor artworks.

Angel of the North (1998) Antony Gormley

PROTECTIVE EQUIPMENT

It is essential that you wear personal protective equipment (PPE), such as thick leather gloves, fire retardant overalls, steel toe–capped boots, and a clear visor. If you are welding, it's vital to wear a visor. For drilling or grinding, also use ear protection, such as ear muffs or ear plugs.

▽ **Ensure you** have the appropriate headgear for the task at hand.

Ear muffs (sound muffling)

Clear visor

Welding visor

TYPES OF METAL

A metal's properties determine whether it suits casting, fabrication, or both. The type of metal also indicates the type of welding that should be used. The most straightforward welder to use is a MIG (manual inert gas) welder. This is suitable for welding steel and stainless steel. TIG (tungsten inert gas) welding is also used on steels and is ideal for welding bronze and aluminum, as the amperage can be controlled while you weld, thus lessening the chance of melting the metal away. Alloys that have a very low melting point can be soldered.

△ **Steel or mild steel**, an alloy of iron and carbon, is great for fabrication, as it can be easily cut, forged, and MIG-welded.

△ **Stainless steel** is iron combined with chromium and nickel to prevent rusting. This material can be MIG- or TIG-welded.

△ **Corten**, a steel alloy of chromium and copper, can be fabricated like steel and oxidizes quickly into a bright red color.

△ **Iron** is used for decorative applications. It can be forged but is difficult to weld and is brittle, so it can easily break.

△ **Bronze** is an alloy of copper with some tin and additives such as silicon. It is mostly used for casting but can be TIG-welded.

△ **Bronze with patina** is when bronze oxidizes, forming a protective film. Chemicals create patinas of different colors.

△ **Aluminum**, a soft metal, can be drilled and cut easily. TIG-welding is preferable, but you can MIG-weld with difficulty.

△ **Pewter** is an alloy of tin, with antimony. (Historically, it contained lead.) It is ideal for home casting due to its low melting point.

OUTDOOR AND SYNTHETIC MATERIALS

When installing a sculpture outside, weather-resistant materials are a key consideration. For sculptures both inside and outside, fabricating your material from synthetic substances opens up more creative options.

PRESERVING OUTDOOR SCULPTURES

Exposure to the elements contributes to the disintegration of outside sculptures. The location of a sculpture can also speed up surface damage. For example, a sculpture may age in a marine environment or be affected by sap if positioned under trees, and polluted urban areas can cause damage.

Choosing and maintaining materials

Most types of stone last indefinitely outside, and resins designed for outside use are available (see right). Fired clay can crack in frost; using a grogged clay (see page 98) fired to a stoneware temperature (2,300°F/1,260°C) avoids this. If using wood, choose a hardy variety—oak, larch, cedar, and teak all last well and can be coated with an exterior-grade varnish or oil. Metals such as bronze and corten form a protective patina. Mild steel will rust and degrade over time, so you can have the steel galvanized or powder-coated. Stainless steel rarely corrodes outside.

Regular maintenance and cleaning help sculptures last. Consider, too, a design that free-drains so that water runs off a surface without collecting.

◁ **Galvanized steel and larch wood** were chosen to create this outdoor sculpture, ensuring its resistance to the elements.
Swift Tower (2020) Will Nash

Fiberglass matting

Quadriaxial matting

SYNTHETIC MATERIALS

Synthetic polymers are liquids and materials that can be used when making sculptures—to create the actual material or to reinforce it. These materials are often petroleum-based, though eco-friendly versions are also available.

△ **Fiberglass matting** is made of randomly arranged glass fibers. Quadriaxial matting comprises uniform layers of fiberglass.

Using resin

A resin is a liquid material that can be used for bonding, laminating with fiberglass matting, encapsulating objects, mixing with powders such as bronze and marble, and as a decorative transparent material. Resin is usually activated with another chemical or catalyst, causing a reaction to take place that allows the resin to harden. When handling all polymers, you should wear protective equipment (see below). Polyester resin is toxic; epoxy is less toxic but slower to set; and jesmonite is a nontoxic mineral and acrylic powder mixture that can be used as an alternative to plaster or fiberglass.

Using fiberglass

Lightweight, hollow sculptures can be reinforced with different types of fiberglass matting in a silicone rubber mold. The fiberglass matting is used after you have brushed in a layer of polyester resin mixed with a powder such as bronze or marble, which creates a sculpture that looks like bronze or marble at a fraction of the cost. The same process can be applied with jesmonite (see left), in conjunction with "Quadriaxial" layered matting.

△ **Combining fiberglass matting** with a resin or mixing it with a powder allows you to fabricate shapes using a mold.

△ **Bronze powder** can be mixed with resin or painted onto a surface to create a bronzelike effect.

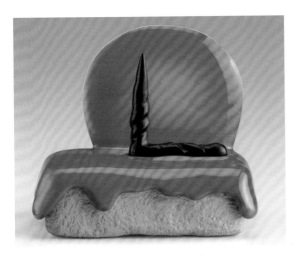

△ **In this miniature sculpture**, the artist has combined ceramic, epoxy resin, and catalyzed polyurethane to create a smooth, durable surface.
Handsome Drifter (2015) Ron Nagle

SAFETY

- **When working with polymers and fiberglass**, always use personal protective equipment. Wear an organic vapor mask and latex or other protective gloves, and work in a well-ventilated area.

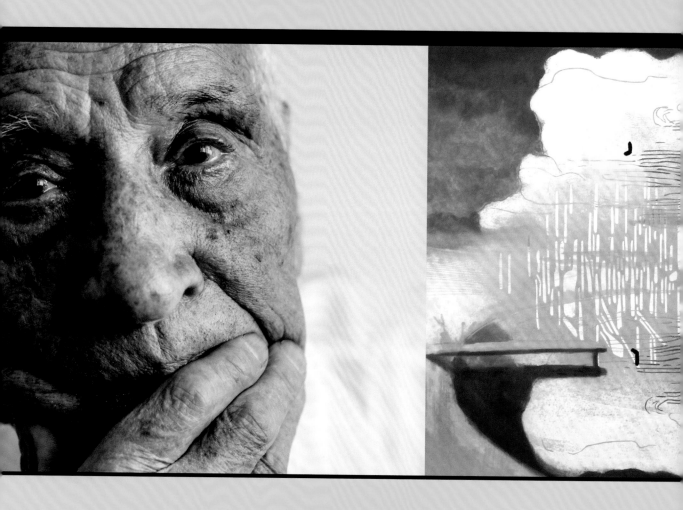

PRINTMAKING, PHOTOGRAPHY, AND FILMING
MATERIALS AND EQUIPMENT

Printmaking, photography, and filming are exciting art forms in their own right, but they are also relevant to many other areas of art. The equipment for each is unique and well worth exploring for your specific purposes.

PRINTMAKING PRESSES

Traditional printmaking techniques are etching; lithography; relief printing; screen printing; and, more recently, digital printmaking. Each involves a different type of press to transfer the image onto the support.

TYPES OF PRESSES

Printmaking falls into two main categories: intaglio (see pages 204–211) and relief (see pages 215–217). In intaglio, the ink sits in grooves or pits beneath the surface of the plate. In relief printing, the print is taken from ink applied to the raised surface of the plate. Due to this fundamental difference, the presses used for each type are noticeably distinct in their design. Lithography, screen printing, and digital printmaking transfer the ink in slightly different ways (see pages 218–225).

Etching press

A mangle-style press is used when printing an intaglio etching. The artist creates an image on a thin etching plate, usually made of metal such as

copper or zinc, which is inked and covered with a piece of softened, damp paper and three blankets. These are forced between two high-pressure rollers, which push the paper into ink-filled grooves on the etched plate, transferring the image onto the paper. Etching blankets or "felts"—normally one thick, one medium, and one thin—are usually made from wool felt. Swanskin, a closely woven cloth that is softer than wool, is used for fine-printing and editioning.

Lithography press

The offset lithography process is used for most high-volume, commercial printing. It comprises two or three ink-covered rollers that continually revolve. The plate passes through the rollers, which transfer a thin, even layer of ink onto it. A dry piece of paper is laid on the plate and pressed down to transfer the image from the plate onto its surface. Artists and print studios tend to use smaller artisan presses, called direct litho presses, on which a range of plates are inked by large, wide rollers operated manually.

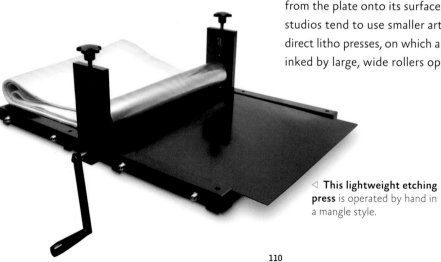

◁ **This lightweight etching press** is operated by hand in a mangle style.

A MINIATURE PRESS

Etching presses don't need to be huge. This tiny press design is available online from the Open Press Project. For those with access to a 3D printer, it can be downloaded and printed.

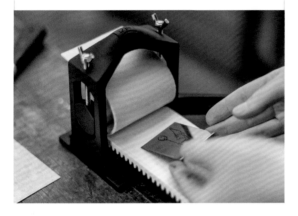

Relief press

One of the oldest types of press is the hand-operated relief press. Mainly used for letterpress, woodcut, and linocut, it works by applying pressure to paper placed on an inked plate. Although relief presses come in many forms, their basic structure has stayed true to their earliest design (see below).

A relief press is effective for simple designs and color can be added in successive layers by reinking the plate. Pressure is applied consistently and evenly, and the amount of pressure applied can be varied to create lighter or darker prints.

Screen-printing bed

Screen-printing beds, used for printing onto fabrics and paper, are large tables often with small holes cut into the surface and a suction pump below that creates a vacuum to hold the paper in position while the print is in progress. The table is padded for fabric printing. The stenciled screen is fastened to a hinged frame that is raised and lowered for each application of ink, which is pushed through the mesh screen using a squeegee (see page 222).

Digital printers

The most popular digital printers are inkjet or laser printers, which deposit pigment or toner onto a variety of surfaces, including paper, canvas, glass, metal, and stone. They are increasingly used as a way of circumventing the need for the costly offset plate preparation used in lithography and to avoid transporting the physical artwork, by sending digital images directly to be printed at their destination.

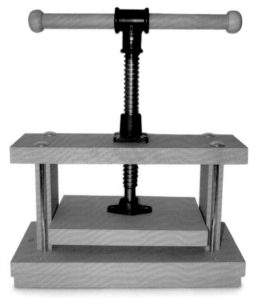

▷ **This table-top relief press**, a wooden, hand-operated machine, is based on the same principle as the first printing press designed by Johannes Gutenberg in the mid-1400s.

PRINTMAKING BASICS

Many relief and direct printing techniques can be accomplished with traditional tools. To print your work, choose ink that is suited to your printmaking method and a paper that will receive the image well.

Both linocuts and woodcuts require tools to carve into the surface of the block. The most useful are a set of small, medium, and large U- and V-shaped gouges and, for woodcut, a flat hangito knife.

For lithography, the image is drawn onto the prepared stone or grained aluminium plate using an oil-based medium and stabilized with gum arabic etch. The chemical processes for intaglio require specialist equipment (see page 114).

Ensure that you have a supply of ink mixing pots, along with plenty of rags, sponges, and cleaning equipment as printmaking can be messy.

INKS

The type of printing ink you use will depend on the process. Intaglio and lithography inks are oil-based, viscous, and highly saturated with fine pigment. Relief inks tend to be stiffer so that the ink remains on the surface of a block or plate during printing. Both relief and intaglio ink can be mixed with plate oil, extender base, or easy-wipe compound to reduce viscosity, or to make lighter tones. Screen-printing ink for printing on paper and fabric tends to be acrylic or oil-based but washable with water.

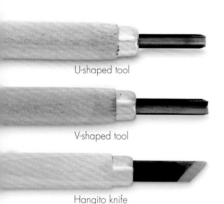

U-shaped tool

V-shaped tool

Hangito knife

△ **To carve wood or lino** use a selection of U- and V-shaped tools or a hangito knife. Sharpen tools regularly using a whetstone.

△ **Use a squeegee** to distribute ink across and push it through the screen mesh when screen printing.

△ **A baren** is a small, bamboo-covered disc used for relief prints to rub over the paper placed on top of the inked block.

◁ **Use rollers** in various hardnesses to ink relief plates and monoprints.

BLOCKS, SHEETS, AND PLATES

Wooden blocks for wood engraving use the end grain of hardwoods, such as maple and sometimes lemon or boxwood. Side grain woodblocks and Japanese soft plywood, regular ply, and MDF can be used for woodblock printing. Use traditional linoleum, soft vinyl, or rubber for linocuts.

A lithographic stone is usually made from a smooth, flat limestone slab. Pre-prepared, ball-grained aluminium and zinc plates can also be bought. More recently, polyester plates, traditionally used in commercial lithographic printing, have been made available for artisan use. Additionally, plywood plates can be used for mokulito (lithography on wood – see page 220).

PAPER

Relief prints need paper with a fine, smooth surface rather than textured, where the image may not print evenly. Paper for intaglio prints needs to be strong enough to be pre-soaked to make it soft enough to pick up the maximum amount of information from the etched line, and to withstand the high pressure of the press. Use a heavy cartridge paper to take the first proofs, and tissue for wiping the plate and protecting the press bed.

Smooth relief paper

Cotton rag intaglio paper

Blotting paper

▷ **Printmaking paper** comes in an array of surfaces and colours. Papers made from cotton or "rag" tend to be strong and naturally acid-free. Use blotting paper to dry finished prints under boards.

△ **A lithographic stone** is traditionally made from polished limestone. You draw directly onto the surface with oil-based ink or crayon.

▷ **Lithographic crayons** are available in different hardnesses to vary the line, from soft and velvety to fine and precise.

12 CRAYONS LITHOGRAPHIQUES
CHARBONNEL
FONDÉ EN 1862

▽ **Other printing surfaces** include lino and vinyl or rubber for linocuts and wood for carving. Japanese plywood suits the traditional Japanese-style woodcut method (see page 215).

Linoleum

Japanese vinyl

Japanese plywood

Silkscreen for fabric

INTAGLIO PRINTING ESSENTIALS

Intaglio is a term for any print where the ink sits below the surface of the plate, including etching, drypoint, collagraph, and most copperplate engraving. Etching in particular requires specific tools and materials.

The process of making and printing an etching requires a dedicated studio where equipment can be used and stored safely. In addition to a press, you may need a fume hood for using chemicals such as nitric acid, a supply of running water, space for acid and water trays, and hotplates for applying grounds or warming ink.

An aquatint box has an internal rotating paddle that creates a cloud of fine rosin dust which, once settled on a plate and heated, creates an irregular dot resist for tonal etching. UV light units are used for exposing photo-sensitive screens and plates.

ACIDS AND MORDANTS

Etching solutions, or mordants, "bite" or etch metal. Zinc and steel can be etched in nitric acid, which should be used beneath a fume hood. Etch copper in ferric chloride with the plate face down to prevent the sediment from blocking the etching process. Edinburgh etch (citric acid added to ferric chloride) can be used on aluminum, copper, steel, zinc, and brass to speed up etching and keep the plate free of sediment. Saline sulfate, an equal mix of copper sulfate crystals and table salt dissolved in water, is a safe alternative to nitric acid.

△ **Your studio** will need a place for acid trays. Here, a bath of saline sulfate has been prepared; it can be used in rooms with basic ventilation.

SAFETY

- **Wear protective** gloves, goggles, and an apron whenever you are using acid or other mordants.

- **Remember to keep acids** separate and do not use any prepared mordant for more than one metal.

- **Always add acid to water** and not water to acid; otherwise, it will bubble and splash out of the tray.

- **Mordants should always be stored** and disposed of safely and not poured directly into the water system.

- **Always work** in a well-ventilated area.

Copper Zinc Mild steel Aluminum

△ **The most common metals for etching** are copper, zinc, steel, and aluminum. Copper is the finest with a clear line, while steel holds more tone and, unlike other metals, does not tint the ink.

PLATES FOR INTAGLIO PROCESSES

Any metal can be used for etching depending on the mordant or acid used. The edges of metal plates need to be prepared before use—filed, beveled, and smoothed to remove sharp edges, then polished to eliminate any residual texture. Collagraphs can be created on any surface that is thin enough to pass through the press. For mezzotints, copper is soft enough for texturing and strong enough to hold the texture through the printing process. Copper can also be steel-faced, which increases the longevity of the plate, allowing for a larger edition to be printed.

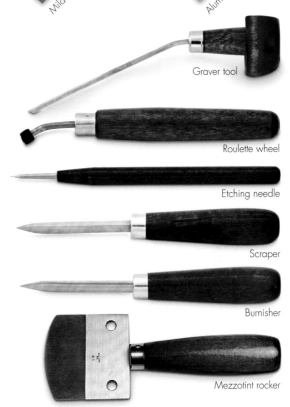

Graver tool

Roulette wheel

Etching needle

Scraper

Burnisher

Mezzotint rocker

△ **Engraving and etching tools** include scrapers and burnishers to prepare the plate and needles to draw and incise marks. A mezzotint rocker creates a textured surface.

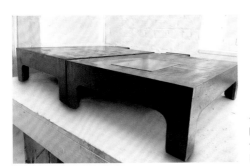

◁ **Use separate hotplates** at different temperatures to melt hard and soft ground.

▷ **Tarlatan** is used for wiping the plates in the intaglio process.

Photopolymer

◁ **A photopolymer** plate is coated with light-sensitive emulsion that reacts when exposed to UV.

▷ **For drypoint**, use any thin, rigid material with a smooth surface, such as sheets of acetate or laminated cardstock.

Acetate Paper drypoint plate

PHOTOGRAPHY

Photography is used as a reference tool and as an art form. Digital imaging technology has opened up the medium for both film (analog) and digital photography. Even the most basic camera can be used creatively.

Traditional analog cameras work by loading a reel of film into a camera, exposing it to light via an aperture, then processing it. With a digital or smartphone camera, the image hits a sensor chip, which breaks it up into millions of pixels (tiny picture elements), termed "megapixels."

Many artists are returning to the hands-on craft of film and analog processes, while others embrace new technology in the form of 360-degree, mirrorless, or drone cameras.

SMARTPHONE

The portability of smartphones means you are always "image ready." Improvements in sensors and lenses means that images now have higher pixel counts, or resolution, than earlier models, and focal lengths and apertures are greater, resulting in high-quality images. Smartphones can be used for most

purposes nowadays and are great for uploading images online. The aperture on a smartphone is fixed, but some apps allows for manual exposure and white balance adjustment. With an SLR (single lens reflex) camera, either digital or analog, you have the benefit of using different lenses, although some smartphones now offer add-on lenses.

▷ **High-definition** photos, such as this one, can be achieved with a megapixel count of 12MP or higher.

△ **A selfie stick** holds your camera on an extending arm to achieve hard-to-reach shots or selfies.

△ **Flexible camera tripods** are available for smartphones and standard cameras. Adjust the feet to achieve the exact angle and crop you require.

SINGLE LENS REFLEX CAMERAS

Single lens reflex (SLR) cameras, both digital and film, use a mirror behind the lens to reflect an image. An SLR camera is bigger and heavier than a smartphone but has a better-quality image and allows the photographer greater control over the look. Most SLR cameras allow you to turn off autofocus and other settings to shoot totally manually (adjusting exposure, shutter speed, and aperture), thus having complete control over the key aspects of image-making. For a digital SLR (DSLR), always consider file storage and battery life, especially on location.

Lenses, filters, and flash

You can change lenses and add other features to your SLR to give you even greater control over an image. You can choose from wide-angle lenses for landscapes and cityscapes, to super-telephotos for wildlife, to macro lenses for close-up natural and environment images or object photography. Filters can be placed over a lens to add effects and color.

Portable or off-camera flashes can be used as a creative tool to control lighting in both daylight and low-light conditions, in landscape or portrait photography. Tripods stabilize cameras when using heavy telephoto lenses or low exposures; many are portable and lightweight.

DSLR camera

Lenses are interchangeable, according to your subject matter

△ **Battery-powered** portable flashes are lightweight and help control lighting.

△ **Mirrorless cameras** don't have an internal mirror to reflect light. They are smaller, faster, and lighter than standard SLR cameras.

△ **A professional tripod** that stabilizes a camera to stop it from shaking during exposure is invaluable for landscape, nighttime, close-up, and studio photography.

△ **Lens filters** control light input, enhance colors, or add special effects.

FILMING

Video functions on smartphones and cameras mean that high-quality filmmaking is no longer an expensive art. For more creative options, consider investing in a video camera and sound and lighting equipment.

Professional video camera

RECORDING EQUIPMENT

The type of equipment you require for filmmaking will be guided by the type of recording you intend to make. Image and sound quality; recording time; control over focus, exposure, and color balance; and the immediacy of viewing the action will all play a part. There are many options, from smartphones to professional video cameras or drone cams, with accessories to help enhance sound and lighting.

Digital cameras

All digital cameras now have film functions that allow you to shoot in ultra high definition in various digital formats and file sizes. Compact cameras, DSLRs, or smartphones (see page 116) are ideal for creating exciting films in the moment.

Video cameras and camcorders

Designed for filmmaking, camcorders and professional video cameras give you more control and enhanced resolution quality, with better sound recording quality, or options for adding sound and light equipment, than a digital camera. Hand-held steadycam, fixed, or bodycam cameras are best used for reportage, live, and unrehearsed action or where "cinéma-vérité" qualities are required.

△ **Use a drone** for aerial shots, giving a high viewpoint with sweeping shots that are difficult from the ground.

◁ **Digital SLR** cameras are light, portable, and provide excellent opportunities on a relatively low budget.

▷ **A steadycam or gimbal** is useful in moving or tracking shots but also where keeping up with any action is required.

SOUND AND LIGHTING EQUIPMENT

Digital and video cameras have built-in microphones. For better sound quality and more control, it is possible to connect external microphones. You can choose to capture sound from all directions or switch to a shotgun or directional microphone that can be aimed in a specific direction. Some microphones attach to the camera, and some can be held on boom poles. Small, clip-on microphones can also be used and help eliminate background noise.

Lights, camera, action

Controlling the lighting is essential, from helping to see the action, to spotlighting, creating an atmosphere, and evening out shadows. Reflectors help direct light, especially outdoors. Camera-mounted lights are good for instant results.

STORING IMAGES

Your footage needs to be safely stored, initially on memory cards in your camera and then downloaded to a hard drive. When making analog films, with Super 8 film, for example, you may wish to convert the film to a digital format for safe storage.

△ **On-camera lights** shine directional light onto whatever you're filming.

△ **Softbox lights** are fixed to a stable base and can be used in the studio to create uniform and diffused light that reduces hard shadows.

Shotgun microphone Lavalier microphone

△ **Directional shotgun microphones** attach to a camera, or you can capture sound with hidden lavalier microphones that transmit wirelessly. Monitor sound quality with headphones.

External hard drive

USB stick

Memory card

Memory card

◁ **Memory cards and storage** are essential on any shoot so that you can continue to record and safely store all your footage. Remember extra camera batteries, too.

WAYS OF
MAKING ART

DRAWING

No matter what medium you choose to work in, a mastery of rudimentary drawing techniques is vital to your art—from creating a quick pencil sketch that captures the moment, to completing a colored pencil portrait or watercolor painting.

THE ACT OF DRAWING

For most artists, drawing is at the heart of their practice—as a way to record, visualize, and work through ideas. Each artist has their own style that enables them to communicate their thinking in two dimensions.

HAND–EYE CONNECTION

One of the biggest frustrations for aspiring artists is finding that their hand doesn't always do what their eyes and brain tell it to do. To improve this skill, try an exercise of drawing without looking at the paper.

This teaches your hand to capture what you see rather than what you think you see. Doing a drawing with your nondominant hand can also be helpful. Because drawing is about choosing what information to record, making the act more challenging can increase focus.

△ **To practice drawing** without looking at the paper, focus on the edges of an object. Slowly trace it with your eyes, moving your pencil on the paper at the same speed.

◁ **Drawing with your** opposite hand can help you sharpen your focus, and in turn see an object with greater clarity. You are likely to be more economical with your marks, but this can lead to some exciting and unexpected results.

PARING BACK

A successful drawing usually gives just the right amount of information—it can be easy to overload a sketch and lose clarity. To train yourself to focus on what is most important to record, try repeating a drawing several times, each time restricting the number of lines you use, as shown here. As well as helping you think about what is most essential, this exercise also helps you practice drawing with increasingly confident lines.

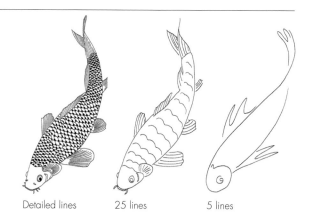

Detailed lines 25 lines 5 lines

PRACTICING YOUR CRAFT

Drawing can be viewed in the same way as learning a musical instrument, in that daily practice is an important part of learning, helping you improve your craft. Practice drawing as often as you can. Choose to explore certain aspects, such as color (if using colored pencils) or composition, and practice these again and again. Take a subject and repeatedly draw it, focusing on a different skill each time. Your enjoyment will increase as your skill grows.

△ **Explore different types of shading.** Experiment with methods such as crosshatching (see page 126) and soft lines, seeing how you can create contrasts.

△ **Focus on the composition,** sketching simple outlines and providing minimal detail to help you think about balance and structure.

△ **Introduce color.** You could select just a part of your composition to try out your chosen color media, thinking, too, about how light and shade will work.

△ **Look at positive and negative** areas in your artwork and observe how these can be used in combination to emphasize shape and form.

DOCUMENTING THE EVERYDAY

Drawing has the ability to capture moments and memories. You can use drawing to document your life, marking points in your day with quick sketches, possibly working them up later. This daily routine can improve your art and also help you record ordinary things that you might have overlooked, revealing their significance.

▷ **Recording a seemingly unimportant moment** can capture events and expressions that reveal relationships and may have a deeper resonance.

MARK MAKING AND SHADING

Mark making in a traditional drawing context is the visible expression of a medium on a support. The media chosen for mark making helps convey meaning and expression. Shading is a type of mark making.

Mark making is drawing in its most basic form, yet it can be very sophisticated. Each medium has qualities that allow mark making to convey emotion and depth, as well as to depict an item. For example, with representational work, your choice of mark making not only identifies your work as an artist, but also conveys your perception of the subject being drawn.

Experiment with various media. Vary your blending tools and application methods. The size of and level of control over a mark is key, too. Some media, such as graphite and colored pencils, have a smaller surface area and make smaller, more considered marks. Media such as chalk, soft pastels, or ink have a larger reach and are less predictable.

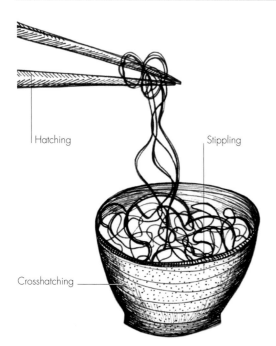

SHADING

Shading is a form of mark making that applies tone (in black, white, or color) to convey form and depth, elevating a flat 2D shape into a 3D form. Marks such as hatching (parallel lines), crosshatching (crossed lines), stippling (dots), and contour (curved) lines are all relatively quick ways to create tone in a drawing.

Hatching

Stippling

Crosshatching

△ **Hatching** uses lines in one direction for shade; crosshatching darkens the tone with lines across on top; stippling with dots adds tone and texture.

△ **Contour shading** uses lines to follow the shape of an object to create tone and form. Here, colored pencils depict the contours of the shell.

CONVEYING A MESSAGE

There's a huge variety of marks that can be made in each medium, depending on the way the medium is applied to the support and the support itself. Each person's mark-making language is different, and experimentation is key to finding your own way of making marks. Try flicking or dripping with different tools, for instance, and familiarize yourself with different media and the way they feel.

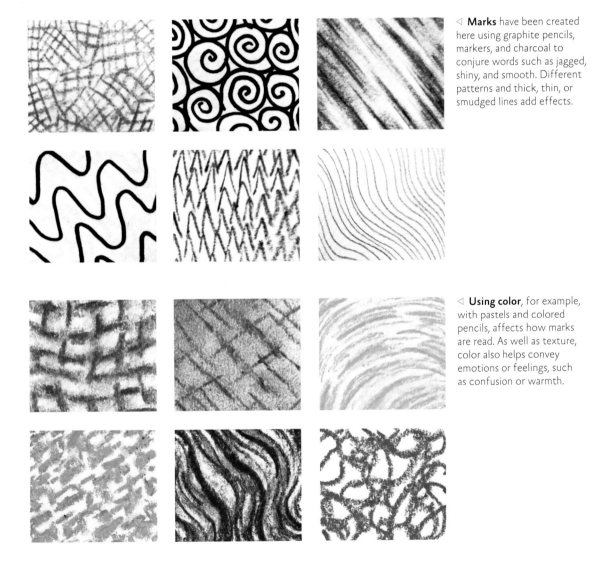

◁ **Marks** have been created here using graphite pencils, markers, and charcoal to conjure words such as jagged, shiny, and smooth. Different patterns and thick, thin, or smudged lines add effects.

◁ **Using color**, for example, with pastels and colored pencils, affects how marks are read. As well as texture, color also helps convey emotions or feelings, such as confusion or warmth.

TONAL DRAWINGS

"Tone," or "value," describes the lightness or darkness of a subject (see page 34). The drawing media you use—graphite pencils, charcoal, or chalk—can work with light or dark supports to help you control tone.

Tone is created through shading (see page 126), the various forms of which can add depth. You can also blend tones using tools to achieve a smooth gradient. A combination of techniques can be used to create shape and form.

Tonal scales

A tonal, or value, scale (see page 34, right, and opposite) is a good way to practice shading techniques before applying them to an artwork. A tonal scale is helpful for understanding tonal relationships in the set-up that you're drawing. It also allows you to gauge the tonal range of your chosen medium and how it will work on your support. You might decide to use various media for a range of tonal effects. For example, if you're working on a midtone ground, you could create light tones by using a light-toned medium such as chalk and produce contrasting dark tones with a darker-toned medium such as charcoal. Alternatively, if you're working on a dark-toned support, try working up from the dark by adding chalk to create lighter tones.

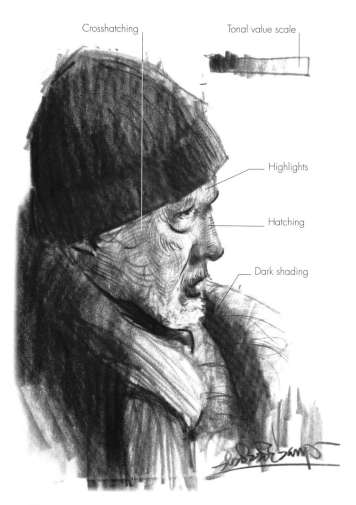

Crosshatching

Tonal value scale

Highlights

Hatching

Dark shading

△ **Here, a tonal scale** has been sketched in by the artist to establish the tonal range that will be used in the portrait.
Sketch of a Commuter (2020) Adebanji Alade

Light and shadow

When drawing (or painting) realistically, the tone of your drawing depends on the position of the light source. Creating a separate value study on a preliminary sketch is a good way to map out values.

After completing a value scale on your support, add the darkest and the lightest tones into your sketch, then add midtones. Once you've appraised each part, you can be confident of the tone of each area when you start on your main piece.

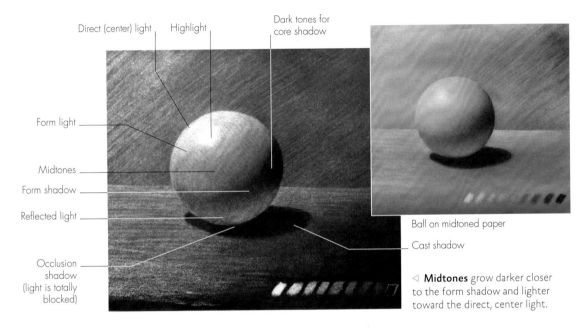

Direct (center) light

Highlight

Dark tones for core shadow

Form light

Midtones

Form shadow

Reflected light

Occlusion shadow (light is totally blocked)

Ball on midtoned paper

Cast shadow

◁ **Midtones** grow darker closer to the form shadow and lighter toward the direct, center light.

TONAL STUDY

This pencil study of a coastal landscape demonstrates how focusing on tonal values—here, using hatching for midtones and crosshatching for darker tones—can create structure and form to define a composition.

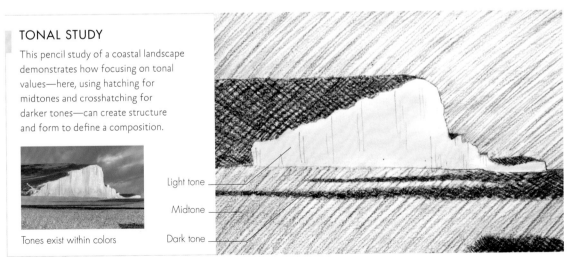

Tones exist within colors

Light tone

Midtone

Dark tone

USING COLOR

All the basic principles of mark making, shading, and tone (see pages 126–129) apply to color. There are also some fundamental techniques for colored pencils and pastels that create different textural effects.

The application of color can vary greatly according to the consistency and properties of a medium. Understanding how to create different effects with colored pencils and pastels takes time, so practice various techniques before starting your piece.

COLORED PENCILS

Layering, blending, and burnishing can be used with all colored pencils. Wax- and oil-based pencils can react differently, so test them first.

Layering with one color deepens tone, or you can create different colors by mixing. Underlying layers will be partly visible, as will areas of the support, especially if the paper has a "tooth."

Blending or burnishing involves merging layers of color for a smooth, solid finish, whether in one color or overlapping colors to create gradients. To blend, use a paper stump, colorless blender, or white pencil to merge the pigment. You can also apply a solvent to break down the binder and disperse color. Burnishing requires heavy pressure, so use a burnishing pencil or apply a final top layer of your chosen colored pencil.

▷ **Creating swatches** will help you understand how media react together, how they take to the support, and how colors blend.

The support is seen through two layers in the same colored pencil

Four layers darken the tone, though the support is still visible

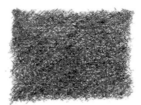
Color mixing with blue and red layers here creates violet

Roughly applied circular shading adds texture

Layering in one direction

Blending with a paper stump merges layers for a solid look

Burnish for a smooth finish

A solvent creates a wet blend

PASTELS

When using different pastel techniques, be aware of muddying or dulling the colors. Techniques for applying pastels include layering, blending, scumbling, feathering, and scratching off a top layer, known as sgraffito. Layering pastels is often done using the side of the pastel. Blending can be done directly, with a tool or a solvent (oil pastels only). Scumbling describes using light, circular marks to layer pastels without blending them so that the colors mix optically (see page 150). Thin lines in the same direction, called feathering, create texture.

▷ **Layers** of one color pastel can be applied, or layer different colors to create a new color. With scumbling, experiment with light on dark, dark on light, and with different colors.

Layering with soft pastels

One layer of soft pastel blended with a paper stump

Scumbling

▷ **Feathering and stippling** can be done with soft, hard, and oil pastels. Like scumbling, they mix colors optically. Sgraffito can be used to add detail.

Feathering

Stippling

Sgraffito with black oil pastel over red

▷ **Blending pastels** creates a soft finish. Light layers blend best with soft pastels. With oil pastels, heavy pressure creates a solid layer, and light pressure gives a delicate look. Smudging layers can dull colors.

Blending two soft pastel colors using a finger

Light pressure blending of two colors with oil pastels

Heavy pressure blending of two colors using oil pastels

Blending a layer of yellow oil pastel over blue creates green

A solvent is used here over one color in an oil pastel

A solvent used on a four-color gradient in oil pastels

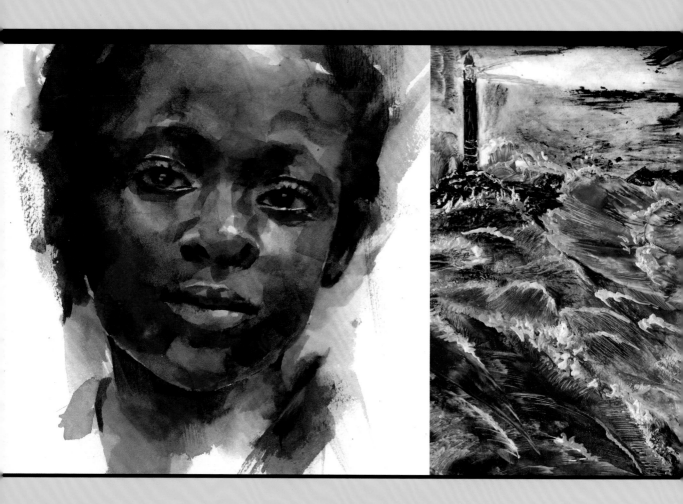

PAINTING

From prehistoric times to the present day, our desire to paint has been limited only by our imaginations. Advocates of each painting medium would defy you to find a better one, but the only way to decide is by trying them yourself.

MARK MAKING

Different marks can be made by varying the tools and brushes you use. The more you experiment and get to know the utensils at your disposal, the better you can add to the overall impact of your finished paintings.

BRUSHES, TOOLS, AND SUPPORTS

Selecting the right brush size and shape for your subjects will help you paint with confidence (see page 78). Get to know the full range of marks you can make with your brushes. For example, use the tip of your brush to produce thin, linear strokes, perfect for detail such as tree branches or blades of grass. Adding pressure to the side of your brush will create broad, thick strokes. Such marks could suggest leaves or flower buds.

There are also many tools you can use to create unique effects (see opposite), including straws, sticks, feathers, sponges, and fingers.

Your choice of painting surface, whether smooth or more textured, will affect the final image (see page 48). For watercolor, working on wet or dry paper also varies results. Dry paper is best for sharp edges and textural effects. Marking damp paper gives a diffuse, feathery edge, depending on how wet the paper is. This can be less predictable, as marks can disappear.

◁ **Experiment with angles** and practice control by using all sides of your brushes and varying the pressure you apply.

△ **Create a variety of lines** by simply twisting and flicking the brush tip or dragging the brush lightly across the paper.

SPATTERING AND SPLATTERING

These are two ways to add dappled color and a sense of spontaneity to your paintings, useful for land and seascapes, for breaking up flat foregrounds, and for abstract work. The result can suggest a field of wildflowers, trees, sea spray, or a dynamic composition of color. Different brushes will vary the effects, as will using colors on wet paper or splattering water on a still-wet watercolor wash.

△ **Splattering** creates a fine spray. Load a stiff brush with paint. Angle the brush close to the paper; flick the bristles back with your finger.

Splatter on dry and wet

△ **Spattering** results in dots of paint. Dip a coarse-bristled brush in paint. Tap it against your finger to make paint drops fly off in random spatters.

Spatter on dry and wet

EXPERIMENT

Try painting with items other than brushes that strike you as interesting to explore the challenge of incorporating new tools into your art.

◁ **Create varied** lines and effects by using natural materials, such as a feather for painting or a stick for drawing.

Feather Stick

◁ **Try blotting** by using an absorbent paper towel or small sponge to lift excess paint gently from a wash before it dries.

◁ **Lightly drag** or dab natural sponge over paper to create layers of varied texture for dappled light, sea spray, or foliage.

◁ **Use a straw** for a dramatic effect. Blow trails of color onto a puddle of paint— tip the paper to encourage drips.

WASHES AND GLAZES

A watercolor wash is a thin application of pigment mixed with water; there are many types, each with unique effects. A glaze is when a wash is placed over existing dried washes to strengthen color and tone.

The transparency created by layering and mixing colors is unique to watercolor painting and, with a bit of practice, can produce beautiful results. Both washes and glazes require the same three ingredients: water, pigment, and paper.

Strong and weak washes

The strength of a wash will vary depending on the proportion of water to pigment. For example, for rich color, you would add more pigment, or to achieve delicate color, more water is added to produce a weaker mix. Glazes, on the other hand, are always weak and transparent, as their purpose is to alter subtly the color or tone of layers that they are applied to. The thinness of a glaze will affect the way it dries and the effect this produces.

Paper types

Washes can be applied to dry, damp, or wet paper—this will affect the outcome (see opposite), as will the paper's texture, weight, and sizing. The smoother the surface, the better it will show detail, while a rougher surface allows for more interesting washes and looser detail. The paper's absorbency also affects the result. Heavier, more absorbent paper produces softer effects than lighter paper, which dries more quickly.

You can also control the effect of your wash by tilting the paper after applying a layer of color.

Rough paper often causes the pigment in the wash to granulate (form into particles); smoother surfaces tend to allow the paint to run freely in all directions when tilted, so control is needed.

MULTILAYERING WASHES

In this painting, the artist has overlapped washes in a variety of colors to bring out the subject's tonal values. The colors bleed into each other, adding dimension and depth to the face. Around the neckline, layers of flat washes with more controlled edges complete the composition.

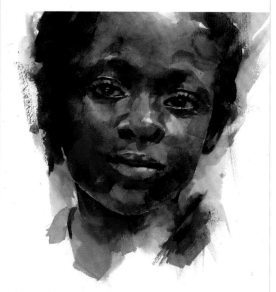

Memories Longing (2014) Stan Miller

TYPES OF WASH

You can create a huge variety of effects by changing the amount of water and pigment, altering the dampness of the paper, using a rougher or smoother surface, and applying paint with a wet or dry brush.

Dry brush washes create a textured effect by using very little paint on the brush. Brush strokes look "broken," which rough paper will exaggerate. This effect is especially good for impressionistic depictions of nature and for creating a feeling of spontaneity in a portrait or a still life detail.

A flat wash is a smooth application of even color, which is laid on dry paper with lots of paint loaded onto the brush. It is ideal for large areas of background, such as a blue sky, but can also be used for a simple foreground, as shown here, or for laying blocks of rich color for strength and depth.

Graduated washes fade from strong to weak color. This is achieved by adding more water to dilute the color as the wash is applied and by tilting the paper to encourage the pigment to disperse. They are ideal for creating a sense of distance in landscapes (see page 171).

Wet-in-wet washes are applied to paper that's wet (either with clean water or another wash of color) to create soft edges. This is a versatile technique for both landscapes and portraits. The wetter the surface, the more the paint will spread and the less control you have over the outcome.

Granulated wash

This technique works best on medium or rough textured paper. It uses the natural granulation of pigment particles in the paint to give interesting textures to washes that may otherwise appear flat.

Pigment gives a grainy appearance, adding texture

Glazed wash

A glaze enhances washes and helps a composition work by adding or changing color variations. Its success relies on the transparency of the washes. Keep to a maximum of three glazes to prevent the pigment from appearing dulled.

Glazes are useful for achieving tone and balance

Variegated wash

This is where colors bleed into one another. Use a variegated wash for a first layer—or underpainting—of a landscape and for portraits, where light and color effects can enhance character. It is particularly effective on a smooth paper surface.

Colors blend into each other to set the tone

Separated washes

Mixed pigments in some paints can separate into different colors when combined in a wet-in-wet wash. When used with bright colors, the effect is excellent for florals, still lifes, and even for the impression of foreground detail in landscapes.

Separated washes can add layers of depth to your work

APPLYING THE TECHNIQUES

A combination of washes in this landscape produce detail and depth. Dry brush washes add small details on the land; flat washes depict large features such as the hillside; a separated wash suggests shrubbery; a granulated wash brings detail to clouds; and glazes add tone.

▷ **Here, a graduated** wash moves from darker to lighter, producing reflections in the water that give a sense of depth.

Wet-in-wet

GRANULATING PIGMENTS

Different colors, brands, and grades of paint vary widely in their granulating properties. Cheaper watercolors, such as student grade paints, often contain less pigment, so they don't granulate as well as professional grade paints.

Light red

French ultramarine

Mix of the two

△ **Mixing certain pigments** together can encourage granulation and enhance the effect.

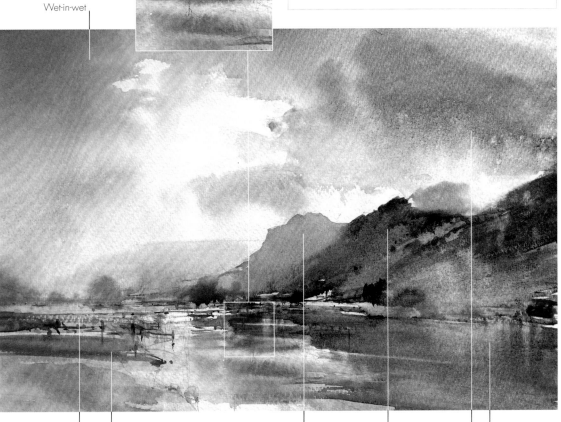

Dry brush | Glazed wash | Flat wash | Variegated wash | Granulated wash | Separated wash

WET-ON-DRY

Layering color washes over dried ones is a classic method for building up a watercolor painting. Overlaying washes in successive layers in this way creates intense areas of color and detail.

Painting wet-on-dry allows good control over brush strokes, because the paint will not flow beyond the edges of the shape you've painted, making it ideal for creating detailed and defined shapes. With this technique, you can paint flat, uniform shapes by applying wet paint onto dry paper; you can apply wet paint over areas of dry paint; or you can paint shapes of variegated color that vary in hue, tone, and intensity.

Working wet-on-dry requires patience, because previously laid paint can be easily disturbed. Always allow each wash to dry and don't be too vigorous when adding new layers of paint.

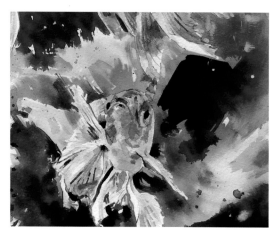

△ **Wet-on-dry** is used here to achieve layers of intense color and defined shapes, giving a sense of movement.

CONTROLLING EDGES

Hard, crisp edges are created when you paint on dry paper or paint, giving the illusion of both nearness and depth. Areas of light and dark are clearly defined, as are the sharp edges, which brings parts of your work into focus.

1 To control the edges of your painted shape, wait for the previous layer of paint to dry completely before applying more paint on top.

2 Stop colors from bleeding into surrounding areas by using only the amount of water on your brush needed for it to glide easily over the surface.

BLENDING

Working wet-on-dry gives you more control when blending colors than with a wet-in-wet approach (see page 142). With wet-in-wet, new color laid into an area of paint that hasn't dried connects the two colors as the fresh color flows into the first wash. By mixing wet-on-dry, you still have the control of flat washes but with added visual interest.

△ **Start with light values** and work toward darker layers. Keep overpainting to a minimum so as not to overwork or muddy the painting.

CREATING INTENSITY

When you paint small passages of paint on top of another layer of dry paint, you are in essence using glazing techniques to create new colors (see page 136). Layering paint in this way is useful for altering the color and intensity of your painting, and it is ideal for building up flesh tones or layers of foliage.

△ **Where each new layer** of paint overlaps, the optical mix creates a new color and adds to the overall tone.

HIGHLIGHTING THE LAYERS BENEATH

Removing layers of paint is a useful technique to create subtle highlights in watercolor paintings.

Lifting out

Using a damp brush, tissue, or sponge to lift out areas of paint will form a textured highlight that adds dimension and visual interest.

Paints with staining qualities will leave some color behind

△ **Lifting out** when the wash is dry will give you harder edges than the diffused effect created when lifting off wet paint.

Scraping out

You can achieve a sharper highlight by scraping off layers of paint as it dries—scraping out when the wash is still too wet will result in colors running back into the area.

Reveal the lighter areas beneath scraped layers

△ **Experiment with different tools** for scraping out. Try a credit card, plastic spoon, palette knife, and more.

WET-IN-WET

Commonly used with watercolors, this technique describes adding pigment or water to an existing wash on paper that has not completely dried. It is a must-have skill for watercolor painting.

CREATING EFFECTS WITH WET-IN-WET

The wet-in-wet technique creates a soft and sensitive effect in watercolors and beautifully complements harder edges or areas of detail. Depending on how wet the first wash is and the consistency of pigment in the second wash, the timing of adding the second wash is crucial to its success.

Detail from *Scottish Coastline*

Balancing tones

Successful paintings have a good balance between light and dark tones. To change a tone in watercolor, there are two techniques: glazing (see page 136) and wet-in-wet. Wet-in-wet allows you to control tone before the wash dries and lightens, making it an effective method when time is short.

Adding pigment to a damp area adds dark tones and gives depth to landscapes

Detail from *Breakers at Whitstable*

Creating hard and soft edges

Wet-in-wet can create diffused, soft edges, which tend to recede, helping harder edges stand out. Aim for a balance of both in your work; too many soft edges can lead to a lack of any obvious focal point, while too many hard edges can make a painting look overworked.

Add a stiffer mix of pigment to a wet wash to darken yet soften reflections and create moodiness

Detail from *Mountains, Heaths and Scrubland*

Detail from *Sunset Evening*

Detail from *Lake District Scene* Wet on damp
defines near hills

Detail from *Lily Pond Reflections*

Suggesting detail

Watercolor can have an impressionistic quality while retaining realistic detail. Wet-in-wet is a good technique for suggesting detail—such as cornfields, thistles, sea spray, and beaches—without being too time-consuming.

Flick water and wet paint into a damp wash to convey heaths and scrubland

Merging colors

Use wet-in-wet to merge two or more colors and achieve a variegated effect (see page 138). Some pigments maintain their hue, while others dominate or combine to make new colors. Tilt the board to 45 degrees to achieve this effect.

The blue evening sky merges with the warm setting sun for an overall soft and atmospheric effect

Building depth

Paint dries much lighter when the wash is applied to a soaking-wet area. To create depth, add the first wash to soaking-wet paper. As the paper dries, add the same mix to bring parts of the foreground into focus.

Using a wet wash on soaking-wet paper suggests distant hills

Adding natural reflections

A spray bottle can be used to add water to a strong, damp wash to create a very fluid, dynamic painting. To create a wet and misty effect, try tilting the paper before spraying so that the wash runs down the painting.

Spraying water on a damp wash is particularly effective for suggesting reflections

ENCAUSTIC AND WAX RESIST

Encaustic and wax resist both use wax as a creative way to add unique textures to works of art. They are versatile techniques that appeal to all levels of knowledge and can be used on their own or with other media.

ENCAUSTIC

Encaustic wax painting is a fascinating technique where clear or colored hot wax is brushed onto a surface after being melted in a pan or bain-marie.

You can buy ready-made encaustic wax blocks or make your own with beeswax pellets and damar resin (as a hardener). Damar resin melts at a higher temperature than wax, so melt it first before adding the wax. Once melted, add dry pigments to create color or use it as it is to create wax "veils" over an artwork or to enclose collage elements within the wax. Keep the wax warm over low heat while you work and use natural bristle brushes, as synthetic ones will melt. Rigid supports are best for encaustic—using flexible ones, such as canvas, may mean the wax cracks later due to changes in humidity. Wooden panels are ideal, because they absorb some of the wax and create a stable foundation.

You can work in layers over an existing painting or collage or paint in different colored waxes. Use a heat gun (on low heat) to fuse each layer of wax before adding the next. Other media can be used on top of encaustic, such as pen, paint, or pastels.

◁ **Stunning effects** can be achieved by scraping, carving, collaging, texturing, and polishing the layers of encaustic wax.
Storm with Silver Waves (2017) Nadia Davidson

△ **Melt** the damar resin and wax in a glass bowl over simmering water.

WAX RESIST

Applying wax candles or wax crayons to paper will repel paint from certain areas and produce marks that can imitate natural textures such as sparkling water, rocks, and tree trunks. Unlike masking fluid, you don't have to wait for the wax to dry.

Marks on smooth papers will be more defined, whereas marks on rougher papers are more textural. Other effects can be achieved by scraping wax off with a knife to reveal color beneath or melting it onto a surface with wax paper and an iron.

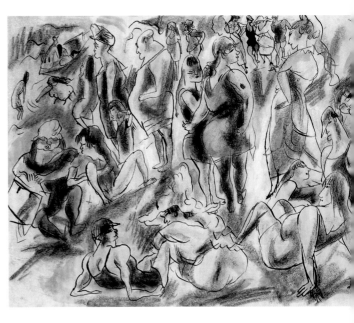

▷ **Create layers** of texture and vibrant color by using wax crayon both under and over other media, such as watercolor, pencil, and ink.
American Beach (c. 1917) Jules Pascin

APPLYING A WAX RESIST

Wax is an ideal tool for creating striking visual effects within watercolor paintings. Use different parts of the wax sticks to make detailed or expressive marks. Sharpen the crayon or candle to a point with a craft knife for fine lines or use the side for dramatic results.

EQUIPMENT
- Watercolor paper
- Wax candle or crayon
- Watercolor paint
- Paintbrush

1 Apply clear or white wax to watercolor paper. Vary the pressure you use to achieve different marks. Apply a wash of watercolor.

2 Apply more wax marks to the dry paint, then follow with another watercolor wash in another color. Repeat with successive layers.

145

EGG TEMPERA

To "temper" can mean to mix ingredients. Classic egg tempera paint mixes powdered pigments with egg yolk and water. Popular in medieval and Renaissance times for its luminous, long-lasting color, it is still used today.

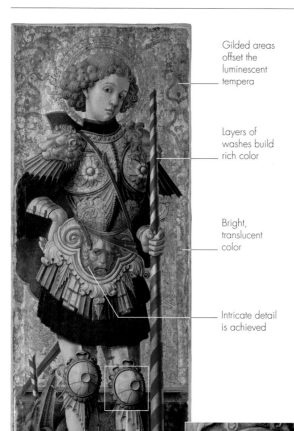

Gilded areas offset the luminescent tempera

Layers of washes build rich color

Bright, translucent color

Intricate detail is achieved

Saint George (1472) Carlo Crivelli

Tempera refers to artists' emulsions, or mixes, that carry paint pigment. Egg yolk is the best known tempera emulsion, but temperas are also made with glue, gum arabic, oil, whole egg, resin, or wax instead of—or in addition to—egg yolk. Tempera is ideal for fine detail and, being fast-drying, for layering color.

In medieval and early Renaissance times, egg tempera was celebrated for its luminescent color; it was especially effective used with gilding (see page 264) in religious paintings. By the 16th century, it was being eclipsed by oil. It was revived in the 1800s and 1900s by Arts and Crafts artists and in the 20th century by realist painters such as Andrew Wyeth.

Painting surfaces

Dried traditional egg tempera isn't very flexible, so works best on inflexible supports such as wood panel primed with gesso (see page 54). Mixing it with oil improves flexibility for working with other supports.

Fine lines are visible

◁ **This detail** of St. George's armor reveals the meticulous detail that Renaissance artists achieved using the disciplined technique of egg tempera.

Working the paint

Classic egg tempera often dries to the touch within seconds of application, so it can't be blended on the support. Mix colors on your palette first and build up color layers on the support with thin washes. Individual strokes can be visible, which is ideal for fine detail. Tempera artworks often use subtle areas or layers of hatching and crosshatching for tones. Color blending works well if done optically (see page 150), either with adjacent strokes of color or by building layers of thin, translucent washes.

Tempera can be worked with various tools, such as brushes, sponges, and stamps. Most effects, other than true impasto, are possible depending on what is added to a mix (see opposite and below). Home-made tempera is usually fairly natural and nontoxic.

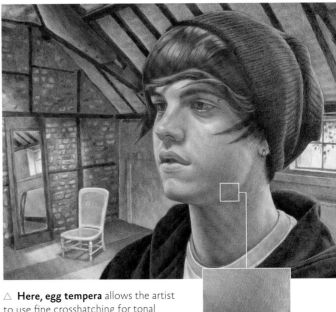

△ **Here, egg tempera** allows the artist to use fine crosshatching for tonal changes and gives skin a matte sheen.
The Art Student (2013) Robin-Lee Hall

Optical color mixing creates skin tones

MAKING EGG TEMPERA

Egg binds paint and makes it adhere to a surface. For a basic recipe, mix pigment, water, and egg yolk (see below). Add more or less water for transparency or opacity. The addition of oil will increase drying times and give greater workability, while adding gum arabic will mimic watercolor or acrylic painting.

EQUIPMENT

- Egg
- Glass or jar
- Particulate mask
- Powdered pigments
- Distilled water
- Teaspoon or palette knife
- Nonporous surface
- Brush

1 Separate out the egg yolk, prick it to release its contents, and discard its sac to produce your egg emulsion.

2 Add a few drops of water to a small pile of pigment. Make a paste. Mix in a little yolk. Adjust for consistency.

3 Test the consistency and add more pigment or water as needed and apply paint. Wash brush right after use.

COLOR MIXING

There are three key ways to mix oil or acrylic paint: mix the paint on the palette; mix it on the support by layering one color over another; or dot colors alongside each other on the support for an optical mixing effect.

BASIC PALETTE OF COLORS

It's best to start with a basic palette of hues that includes the primary colors, plus burnt umber and titanium white. With these, you can make almost any color, combining primary colors to make secondary ones. Ideally, have warm and cool versions of each primary color to create vibrant secondary colors. Burnt umber is included, because it's hard to make a dark brown with primary colors; mixing it with ultramarine blue will also make black.

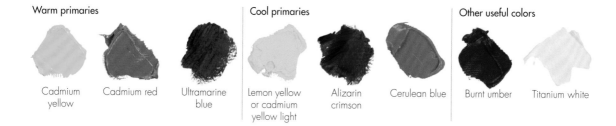

Warm primaries

Cadmium yellow

Cadmium red

Ultramarine blue

Cool primaries

Lemon yellow or cadmium yellow light

Alizarin crimson

Cerulean blue

Other useful colors

Burnt umber

Titanium white

MIXING PAINT ON THE PALETTE

Experiment to discover what effects you can achieve with mixing. Bear in mind that secondary color mixes will be affected by whether you use warm or cool primaries. Ideally, mix no more than two to three colors at a time—mixing too many at once can make paint look dirty. Once the paint is mixed on the palette, use a small brush stroke to test it on the support. It may look altered next to other colors, especially if your palette and support are different colors.

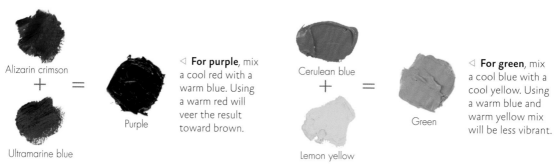

Alizarin crimson
+
Ultramarine blue
=
Purple

◁ **For purple**, mix a cool red with a warm blue. Using a warm red will veer the result toward brown.

Cerulean blue
+
Lemon yellow
=
Green

◁ **For green**, mix a cool blue with a cool yellow. Using a warm blue and warm yellow mix will be less vibrant.

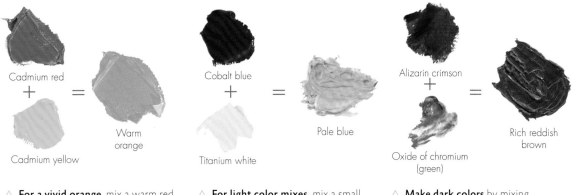

Cadmium red
+
Cadmium yellow
=
Warm orange

Cobalt blue
+
Titanium white
=
Pale blue

Alizarin crimson
+
Oxide of chromium (green)
=
Rich reddish brown

△ **For a vivid orange**, mix a warm red with a warm yellow. Mixing cool reds and yellows creates a less vivid orange.

△ **For light color mixes**, mix a small amount of a darker color into a larger amount of a lighter one (or white).

△ **Make dark colors** by mixing complementary colors instead of by adding black or brown.

GLAZING

This involves laying transparent colors over other colors already down so that you can mix colors on a support. Glazes intensify a color to create a vibrant effect. You can make oil paint transparent using stand oil, sun-thickened linseed oil, or glazing medium (see page 94). Dilute acrylic paint with water or with a medium, such as gel, for thin, transparent layers. Apply a glaze with a clean brush, as any opaque paint on the brush will muddy a glaze.

Oil vs. acrylic

For oil paint, a medium makes the paint easier to manipulate. Mix plenty of color with the medium. Control color intensity by reworking it with dry brushes or a rag; you can reduce it with a clean, dry brush or remove it with the corner of a clean rag.

Acrylic paint dries fast, so it is harder to rework, but you can make vibrant colors with a series of transparent layers. You can also cover a large area with one transparent color, then work up detail.

◁ **A glaze can help** unify an image. For example, by glazing an image of fabric, it will soften and blend the tones used for the folds, creating a realistic effect.

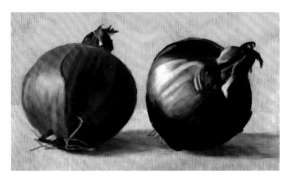

△ **In this study** of two red onions, using a glaze to mix colors gives a luminosity. The underlying burnt umber glows through the alizarin crimson glaze.

SCUMBLING

A similar technique to glazing, scumbling involves using a dry brush to apply a thin film of opaque or semiopaque paint loosely over a dry color; this film breaks up to reveal areas of the underlying color.

◁ **Add texture** to your work with scumbling, or use it to help break up a background.

◁ **Scumbling** is also a helpful technique for adding highlights to darker colors.

OPTICAL COLOR MIXING

When two distinct colors are close together, our eyes perceive a mix of those colors, even though they are not physically mixed. For example, if yellow and blue are adjacent, the perceived color is green. Known as optical color mixing, this can create more vibrant colors than other methods of mixing paint.

Pointillism was favored by post-Impressionists. This optical color mixing method lays small, different colored dots next to each other, creating a perception of a third color. Georges-Pierre Seurat (1859–1891) and Paul Signac (1863–1935) pioneered the technique.

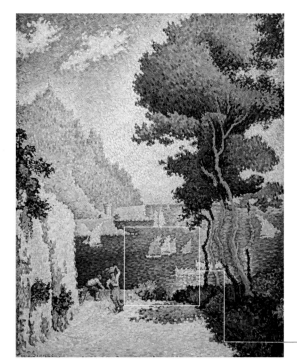

△ **By placing dots** of pure colors side by side with great care, Signac created color perceptions and an intensely vibrant image.
Capo di Noli (1898) Paul Signac

Structures are meticulously worked up with dots

Juxtaposing complementary colors such as blue and orange intensifies each one

ALLA PRIMA

Meaning "at first attempt," *alla prima* is a painting method that involves applying all of the paint in one session while it is still wet instead of allowing layers to dry. It is also known as direct painting.

This method involves working wet-into-wet in one layer, making it suitable for oil paint rather than acrylic, which dries too quickly. Working *alla prima* allows you to record a scene quickly—the Impressionists used it as a means to capture fleeting light and color.

Painting in one session instead of over several sessions gives works a fresh immediacy, although *alla prima* has its challenges. Painting in one sitting means that the artist must be skilled at drawing with a brush, mixing colors and tones accurately, placing colors effectively, and selecting the right brushes and strokes—although it is possible to make corrections by scraping off paint and reapplying it.

You can also paint *alla prima* over a colored ground or an underpainting (see page 154) and allow the color of the ground to show between brush strokes for a unifying effect.

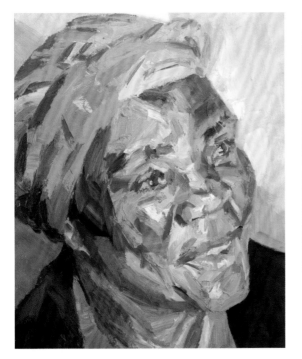

◁ **Large, bold brush strokes** and impasto layering create a lively, warm portrait that radiates the sitter's personality.
Ene, Traditional Healer (2017) Tim Benson

WORKING WITH WET PAINT

Plan carefully when painting *alla prima*. Decide which areas and colors you will apply first, where you can cut around shapes, and where you will work wet-into-wet.

- **Mix colors** on the palette before applying to canvas.

- **Use several brushes** to avoid muddying your colors.

- **Load your brush** or painting knife well and drag one color over the color below to keep the top color clean.

- **Vary your brushwork.** For example, contrast smooth strokes with thick impasto techniques (see page 153).

- **Embrace paint's unpredictable nature.** For instance, if unexpected colors emerge on the canvas or edges appear or are lost, go with it instead of always trying to correct it.

BLENDING, MASKING, AND IMPASTO

Some of the most useful techniques for oil and acrylic painting are blending to create soft edges, masking to make hard edges, and laying paint thickly for "impasto" texture. A paint's properties can create different effects.

Oil paint flows easily and dries slowly, making it easy to move around, build up thickly, and blend one color into another. Acrylic paint is less easily manipulated but dries quickly. These properties make acrylic easy to apply in layers and allow you to create clean, hard edges between colors. You can add acrylic mediums to create various effects or make the paint easier to manipulate (see page 95).

▷ **Hard edge painting** has been used here with acrylics to produce clean lines and blocks of color.
Rock 'n' Roll Singer [after Malevich 1932] (2018) Juan Bolivar

BLENDING ADJOINING COLORS OR TONES

Blending creates smooth transitions between colors or tones so you can imitate the way that light changes as it falls across an object or scene and create a three-dimensional effect. It also makes brush strokes seamless. Oil paint is blended easily because it stays wet; blending acrylics can be done if you work quickly, using one brush to lay paint and a second, damp brush to soften edges.

EQUIPMENT
- Canvas or other support
- Oil or acrylic paint
- Bristle or synthetic brushes
- Clean, soft synthetic brush for blending

1 Lay the tones side by side from light to dark or vice versa. Where tones are adjacent, a sharp line will appear.

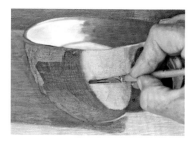

2 Using a clean, soft, dry brush (or damp brush for acrylic), stroke the join, wiping paint off the brush as you go.

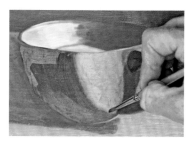

3 The joins are no longer sharp lines, and the different tones are blended into one another.

MASKING

To create hard, straight edges between one color or tone and another, you can use masking tape, which makes a crisp line and stops colors from bleeding into each other. Masking works well with acrylic, because it dries fast; for oil, allow at least one day to dry between each application of color. Ensure the surface is flat and choose a tape that is not too sticky, which can pull paint from the base layer, but is sticky enough to stop paint from bleeding.

EQUIPMENT

- Canvas or other support
- Oil or acrylic paint
- Masking tape
- Clear medium (for oil paint) or matte medium (for acrylic paint)
- Bristle or synthetic brushes

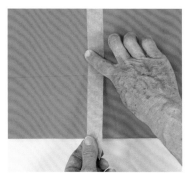

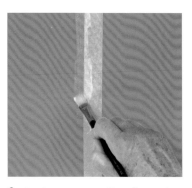

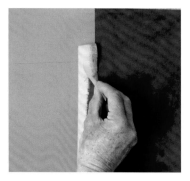

1 Apply the first color. Once dry, use even pressure to apply masking tape along your chosen line.

2 Apply a matte medium for acrylic paint and a clear medium for oil paint to stop the edge bleeding. Leave to dry.

3 Apply the second color. Allow it to dry, then peel off the masking tape, peeling toward the painted edge.

IMPASTO

Impasto painting involves applying oil or acrylic paint thickly using either a brush or a painting knife so that the strokes are visible, textured, and sit proud of the support when dry. You can use more than one color on the brush. If applied wet-into-wet, the colors can mix partially to create striated color effects. You can also make a stipple-textured effect by pushing the tip of a bristle brush into wet paint on the canvas.

Oil paint impasto applied with a brush

Oil paint impasto applied with a knife

Acrylic paint impasto applied with a brush

Acrylic paint impasto applied with a knife

GROUNDS AND UNDERPAINTING

Applying a ground is a good way to start a painting in oil or acrylic, giving you a base color for your painting. You can also create an underpainting, helping you establish the tonal values of your painting.

GROUNDS

A "ground" is a thin layer of paint applied uniformly to a prepared (primed) support. Applying a ground helps you see more clearly the tones of your painting—the primed, white surface of a bare canvas is very bright, so it can give a false sense of the other tones or colors you paint onto it. The ground provides a light-to-midtone base over which you can build up lighter tones, highlights, and mid-to-dark tones. This can form the basis of an underpainting (see right). Neutral colors are best for helping you judge tonal range, while brighter colored grounds can achieve dramatic effects.

Types of ground

For oil painting, you can apply either oil paint or acrylic paint as a ground, although oil paint is preferable. Mix the oil paint with an oil painting medium to help it dry more quickly (see page 94). For acrylic painting, you will need to apply an acrylic ground of paint diluted with water.

The ground can be opaque, for example, by mixing another color with titanium white, or transparent to allow the white primed surface beneath to glow through. This latter method is the traditional way, known as an *imprimatura*, which translates from the Italian as "first layer of paint."

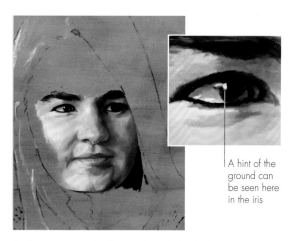

A hint of the ground can be seen here in the iris

△ **A green ground** will complement the flesh tones when used in a portrait (see page 166), giving a harmonious base to build on.

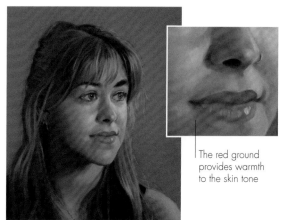

The red ground provides warmth to the skin tone

△ **An orange, yellow, or red ground** will warm up the painting, whereas a cool blue or green ground will have a cooling effect.

UNDERPAINTING

An underpainting helps you work out the tonal values—the degrees of light and dark—in your painting before you apply color. You can then either allow the underpainting to show through in the finished work by layering thin paint on top or use it as an understudy and cover it with opaque paint. If applying a ground first, ensure it's totally dry, which will take at least a day for oils and 20 minutes for acrylics.

1 Apply a light layer of burnt umber to the canvas. Use a small brush and a midtone of the same color paint to lightly sketch the image.

2 Paint the mid-to-dark tones using the same color. You can make the paint lighter by thinning it with a medium (for oil) or water (for acrylic).

3 Paint the mid-to-light tones by adding different amounts of white to the ground color as appropriate, modifying the background with a paler mix.

4 Finally, apply thicker paint to deepen the colors and accentuate the highlights to give form to your image. The ground unifies all the tones.

EQUIPMENT

- Canvas or support
- Small round brush
- Large round brush
- Flat brush
- Burnt umber oil paint
- Titanium white oil paint
- Solvent or thinning medium

FAT-OVER-LEAN

In oil painting, the amount of oil, or fat, in the paint affects how quickly it dries. "Fat" paint—neat, or made fatter with an oil-based medium—is flexible and dries slowly. Oil paint that has been thinned with a solvent is described as "lean" paint, because it dries more quickly and is more brittle. Applying lean paint over a fat layer of paint can cause an oil painting to crack when it dries. To avoid these problems, always apply "fat-over-lean."

Fat paint Fatter paint

Lean paint

TEXTURES

Creating texture in painting adds volume, surface interest, and experimental effects. As well as using painting techniques to add texture, you can use handmade or household tools and other materials to create intriguing effects.

Oil paint by its very nature can be used texturally when painting in the impasto style (see page 153). Techniques can also be used to add textural effects to oil after painting with it. Changes in the textural appearance of watercolor and acrylic paints can be achieved in a variety of ways—for example, by using tools such as a sponge, adding granular particles such as salt, or using acrylic gels and pastes.

 Another effective way to create texture and structure is with collage (see page 270). Adding materials such as paper cuttings, textiles, and found objects, known as assemblage, transforms a two-dimensional surface into a three-dimensional one.

△ **Here, texture is created** by painting oil on layers of mesh. Each layer represents part of the image.
Passing By (2020) Maša Travljanin

ADDING TEXTURE TO WATERCOLOR

Experiment by adding a substance or other media or making impressions in wet paint to enliven the surface of your watercolors.

Plastic wrap Bubble wrap

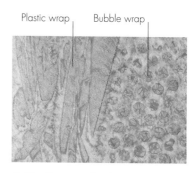

△ **Dabbing a sponge** over your wet paint creates a soft, stippling effect. The dappled paint suggests areas with varied textures.

△ **Salt absorbs pigment.** Add salt crystals to semiwet watercolor paint and leave to dry. Gently remove to reveal constellationlike shapes.

△ **Gently press plastic wrap** or bubble wrap onto wet paint, then carefully peel them away to imprint the impression of a surface texture.

ACRYLIC TEXTURES

There are numerous mediums that work with acrylic paints to create surface effects, volume, and transparency, all of which add to the texture of a piece. The type of acrylic you use can also help you achieve textural effects in your finished work (see page 81).

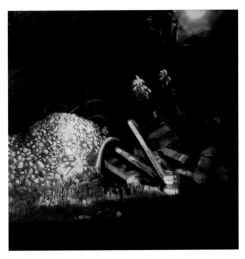

▷ **For an impasto effect**, mix an acrylic heavy gel or modeling paste with a base paint layer. Apply with a palette knife or brush, leave to dry until clear, then carry on painting. Sand when dry if needed.

△ **This painting was made using numerous** thin layers of acrylic mixed with gloss medium to create a subtle image that emerges from the background.
The Importance of Improving Real Landscape (2015)
Alison Hand

REMOVING PAINT TO ADD TEXTURE

Removing paint, shown here with oil, is possible with all painting media. Some techniques involve dissolving with a solvent, while others use manual scraping or wiping.

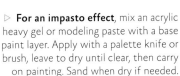

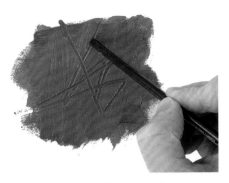

▷ **Drip or run** a solvent down an oil painting to cut beautiful rivulets through the paint. A similar method with watercolor and acrylic is to pour, drip, or spray water on a work to disrupt and erase areas.

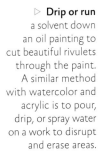

△ **Use any sharp tool** to remove layers of dry or semidry paint to reveal the paper or another color beneath and create texture.

MIXED MEDIA

Each medium has its own language and feel, and by combining them, you can create exciting textures and effects. Here are some of the most popular combinations, but there are many more to experiment with.

Combining oil and acrylic paints

Teaming oil and acrylic on a surface can work very well, as the paints have different properties. Oil paint has more body and will maintain its shape when dry, whereas acrylic will flatten as it dries unless a textural medium is added to it, so you could combine an impasto, textured area of oil paint with a hard-edged, flat area of acrylic paint.

Oil-based paints generally apply well over the top of water-based paints; the reverse can cause cracking. Art is really not about rules, though, so experiment!

Drawing on top of paint

There is an enormous variety of marks to explore when you add drawing media into or on top of oil, acrylic, and watercolor paints. For example, you can use pastel, chalk, and Conté crayons for soft, dry effects or achieve sharper, free-floating lines with fineliner pens. Graphite and charcoal can create dense, smudgy softness and atmospheric areas—the latter even works beautifully on raw canvas. Graphite powder is a lovely ephemeral material that can be scattered or brushed onto the surface with a dry brush.

Ink works well with mixed media such as charcoal and graphite. Quink™ ink reacts to household bleach and creates wonderful dispersion, or you can use wax resist techniques (see page 145) to repel the ink and create volume and drama.

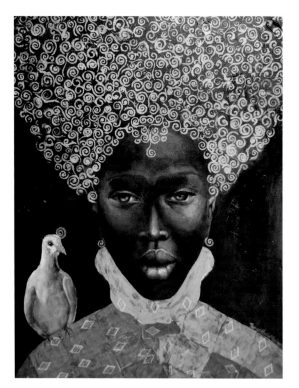

◁ **Combining acrylic and gold leaf**, here the artist has also used quilted fabric to contrast with the flat paint.
The Black Queen (2010) Tamara Natalie Madden

USING PHOTO TRANSFER

In this process, a medium is used to transfer the ink from a photocopied image onto another surface. It is a technique that creates a fragmented, nostalgic feel to the resulting image and can be used in combination with a painting or drawing.

Primed MDF board

Apply medium generously

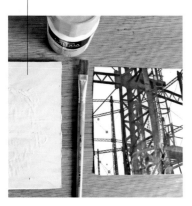

1 **If you prefer a white surface** to transfer the image to, you can prime your canvas or MDF with acrylic primer and leave to dry.

2 **Spread the acrylic medium** over the image with a brush, ensuring that you cover the whole image that you wish to transfer.

3 **Press the image face down** onto the prepared surface and smooth out any air bubbles. Leave for at least two hours and preferably overnight.

4 **Add warm water** over the whole paper surface, then gently rub with your fingers to dissolve the paper so that it can be removed.

5 **Continue to rub**, removing the paper until the image is revealed. If any white marks are left when dry, rub gently to remove them.

6 **The image will have transferred** onto the surface in reverse. Some areas may be fragmented, which is part of the aesthetic of this technique.

OBSERVING AND IMAGINING

Painting a still life in the studio or capturing the expression of a live model in a life-drawing class are quintessential artistic pastimes, but the breadth of observational art and the workings of the artistic mind include so much more.

STILL LIFE

Still life—derived from the Dutch word *stilleven*—describes an arrangement of inanimate objects. A still life is usually set up in a studio environment, making this an ideal genre to demonstrate technical ability.

The earliest still lifes can be traced back to antiquity, representing gifts of fruit, game, and produce. Romans then incorporated them into frescoes. In the 16th century, still life became a distinct genre. Dutch artists displayed their mastery of optical realism, creating highly detailed flower paintings and studies. Spanish artists embraced the genre, with often sparse compositions focusing on light, textures, and contrasts.

The objects chosen in a still life are important. They can have symbolic or allegorical meanings, as is the case with "vanitas" objects, which symbolize the transience of life and the fleeting nature of beauty.

◁ **Here, composition** and color are finely balanced. The vase of flowers is depicted with precision. The transient nature of the blooms and a lizard suggest life's brief nature, while the exotic shells signify Dutch prosperity at this time.
Still Life with Flowers (c.1625) Balthasar van der Ast

△ **Many modern still life** pictures comment on social issues or natural processes such as death and decay.
Carbon Magic (2019) Cindy Wright

HOW STILL LIFE HAS EVOLVED

A fascination with depicting objects from life has endured. Traditionally, still life included natural items such as flowers and fruit, or man-made objects such as books and vases. Over time, the still life genre has evolved. For example, objects have been incorporated into other genres, such as portraits. In modern and contemporary art, still life has also been used to show a new perspective on the world. In the 20th century, artists such as Picasso depicted abstract still lifes to challenge the viewer. Still life can also be charged with social commentary or political issues, and contemporary still lifes often cross disciplines by using 3D media or sculpture.

SETTING UP

A still life begins with your choice of objects, so choose carefully based on your reason for creating. Do you want to learn from your piece, for example, to understand tone or different textures? Do you wish to show a particular aspect of your personality, similar to a self-portrait, or do you intend to draw attention to a certain concept or issue?

Arranging the objects into a composition is the next step, ensuring you are happy with this before you start to work. Deciding where you will work in relation to your set-up is also key, so move around to find the best position or height. Whether the set-up is at eye level, or you are looking from above or below, can change the reading of the objects and create dramatic perspectives (see page 40).

Consider how light changes in the day; and how natural light is soft, while artificial light casts dramatic shadows

Add visual interest with textures

▷ **Take time** to work on your composition—think about how objects provide balance or add contrast.
Festive (2017)
Paul S. Brown

Think about height; different heights can add rhythm to your composition

Factor in the background: is it near or far, plain or patterned? How much will you see?

Look for color and tonal contrasts; you can exaggerate or pare down tone to emphasize a specific focal point

INITIAL SKETCHES

A good way to work out your composition is to create a viewfinder and sketch out compositional boxes, or thumbnails. Keep these small and simplify content. These also form the basis for a valuable tonal study (see page 129).

Work out tonal values

Notice how shadows are cast

FIGURES

The human figure is a constant source of artistic study, exploration, and fascination. Working out how to represent the human form is possibly the hardest task an artist will face, and arguably the most rewarding.

Working from life helps an artist understand a body's general construction, how a person moves, and how to measure proportions. With practice, you will be able to identify the key aspects of a pose and understand where best to start your drawing, which is not always the head.

A quick sketch, without detail, can help you note the overall look, feel, and gesture. Sketching quickly can be frustrating initially, but distilling a pose quickly to its shapes and lines sharpens the eye.

For most artists, depicting the human figure is about creating an emotional and an aesthetic connection. Where a figure is situated; whether they are clothed or nude; whether there are other figures; whether to use marks to convey movement or stillness; and the scale, viewpoint, and use of color all need to be considered.

Drawing from a photo or sculpture is an accessible way to practice. However, this differs from life drawing, as the muse is static and you can work in your own time, as opposed to time-limited life drawing.

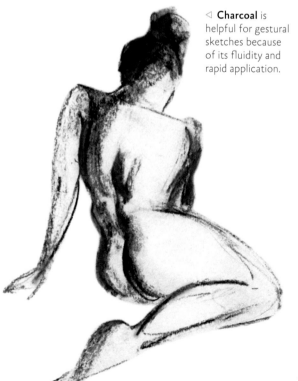

◁ **Charcoal** is helpful for gestural sketches because of its fluidity and rapid application.

DISTORTING REALITY

Artists sometimes alter body proportions and use distortion to convey meaning. Mannerists used distortion to exaggerate movement and add drama. The Ancient Egyptians changed a figure's size to correspond to their societal significance, known as the "hierarchy of scale."

◁ **The elongated** neck and limbs and refined poses lend this painting both sensuality and drama. *Madonna with Long Neck* (1534–1540) Francesco Mazzola, known as Parmigianino

COMPARATIVE MEASUREMENT

This involves assessing the size of one area by comparing it to another. In figure drawing, head length is often used to measure height. Staying still, hold a thin stick or pencil and extend your arm in front of you. Try to use your nondominant hand so your drawing hand can mark your findings. Close an eye (always the same one), align the stick's tip with the top of the cranium and move your thumb to the end of the chin. See how many times this measure goes into the height of the whole figure. Then turn the stick horizontally to work out the model's width.

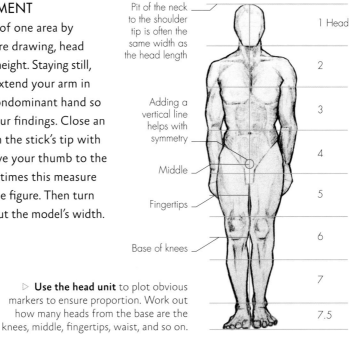

Pit of the neck to the shoulder tip is often the same width as the head length

1 Head

2

Adding a vertical line helps with symmetry

3

4

Middle

5

Fingertips

6

Base of knees

7

7.5

▷ **Use the head unit** to plot obvious markers to ensure proportion. Work out how many heads from the base are the knees, middle, fingertips, waist, and so on.

FORESHORTENED FIGURES

Changes in perspective can make areas seem larger or smaller. This affects proportional understanding, so establishing measures avoids making, say, a foot too large. If the head isn't visible, use a foot or hand to establish proportions. You can also use a measuring stick to understand angles. Turn it counterclockwise and clockwise (never forward); hold an angle and move it to paper. Use vertical and horizontal guides for placement (see right).

— Plot the head measurements vertically and horizontally

— Angles can position hips, shoulders, and limbs

— Use external guides to plot intersections and placement

— Areas other than the head can be used to measure

1 head

2 heads

3 heads

1 head 2 heads 3 heads 4 heads

▷ **Several techniques** can be used to help you accurately depict angles and represent foreshortened aspects proportionately.

PORTRAITS

Portraiture usually focuses on a person's head and is about capturing a likeness or essence, but the chosen discipline, style, colors, and scale all say something about the sitter and about the person creating the portrait.

Portraiture has seen many changes in style and discipline over the centuries; however, the artist's fascination with the face and what's behind it endures. Historically, portraits were commissioned by wealthy patrons to assert their beauty, standing, wealth, or other factors deemed important, such as a significant event. Certain clothes or objects added to the viewer's understanding of the situation and sitter. Portraits tended to be flattering, with

fashionable clothing, desirable locations, and flaws erased, though there were notable exceptions: Oliver Cromwell told Sir Peter Lely to paint him "warts and all," and Francisco Goya's portrait of Charles IV and the Spanish royal family is notoriously scathing.

When starting a portrait, consider what you want to convey about the sitter and how the pose, setting, props, clothes, and your medium and style can all help capture their personality.

△ **Portraits instigated by the artist** of a loved one or of a model the artist is inspired by can have a particular feeling and significance.
The Artist's Youngest Daughter (1920) Albin Egger-Lienz

△ **A portrait can be expressive** rather than realistic in style. More abstract handling of a subject can denote an intimacy with and in-depth knowledge of the sitter.
Head of J.Y.M. (1973) Frank Auerbach

DRAWING A PORTRAIT

Capturing a likeness takes practice and can be a daunting task. Whether working from a photo or drawing from life, understanding the correct proportions of the face and how features are generally positioned on it is helpful. Sketching individual features can be good practice and a useful reference, and making a simple map of the face and its features before embarking on the final piece helps you work from a strong base.

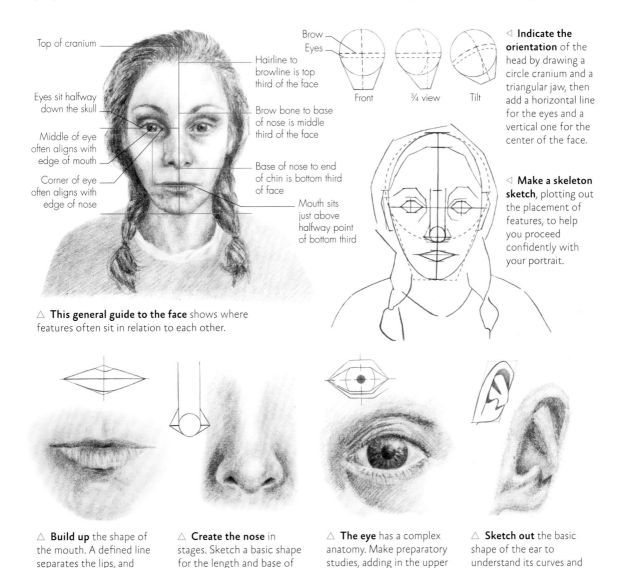

Top of cranium

Eyes sit halfway down the skull

Middle of eye often aligns with edge of mouth

Corner of eye often aligns with edge of nose

Hairline to browline is top third of the face

Brow bone to base of nose is middle third of the face

Base of nose to end of chin is bottom third of face

Mouth sits just above halfway point of bottom third

△ **This general guide to the face** shows where features often sit in relation to each other.

Brow
Eyes

Front ¾ view Tilt

◁ **Indicate the orientation** of the head by drawing a circle cranium and a triangular jaw, then add a horizontal line for the eyes and a vertical one for the center of the face.

◁ **Make a skeleton sketch**, plotting out the placement of features, to help you proceed confidently with your portrait.

△ **Build up** the shape of the mouth. A defined line separates the lips, and shading under each lip emphasizes structure.

△ **Create the nose** in stages. Sketch a basic shape for the length and base of the nose, then shade in the nostrils and curves.

△ **The eye** has a complex anatomy. Make preparatory studies, adding in the upper and lower lids, pupil, iris, tear duct, and lashes.

△ **Sketch out** the basic shape of the ear to understand its curves and folds, then define these areas with tonal shading.

CARTOON STRIPS AND COMICS

Often humorous, cartoons commonly appear in newspapers, either individually or serially in strips. Comics, Manga, and graphic novels are as visually direct as cartoons, but their aim is to tell a story.

Originally, a "cartoon" was the name given to a preparatory drawing for an artwork. However, nowadays, the term is widely used to describe a style of art used in satirical illustrations, comics, cult 'zines, and graphic novels. The popularity of comic art centers on creating memorable characters, from Snoopy to Wolverine. Caricatures of public figures, such as politicians, are used to lampoon them.

There are a few key factors to success in this genre, such as using confident lines to create strong, graphic shapes; close study of facial features; and understanding how, for example, a simple line to show an arched eyebrow can speak volumes.

Graphic pioneers
The 1700s brought the rise of political cartoons and what may be the first graphic novel, *Lenardo and Blandine* (see below left). In the 1800s, several more Western names appeared, such as *Punch* in the 1840s in the UK. These political cartoons paved the way for cartoons that provided a social commentary, such as Richard Outcault's *The Yellow Kid* in the US (below). Then, in the 20th century, this graphic genre saw the dawn of a proliferation of cartoons, from Popeye to Tintin; and from the turn of the century, Japanese Manga strips and graphic adventure novels, such as Marjane Satrapi's *Persepolis*, spread worldwide.

◁ **Often described** as the first graphic novel, *Lenardo and Blandine* (1783), created by the German illustrator Joseph Franz von Goez, tells a story through a pictorial narrative in a sequence of 160 etched drawings.

▷ **About a New York** street urchin, *The Yellow Kid* reflected the class tensions of the day. *Amateur Circus: The Smallest Show on Earth, New York World* (1896) R. F. Outcault

CREATING A CARTOON

Traditionally, all cartoons and comic book art were drawn and inked by hand, but many are now produced entirely using illustration software. Some artists use a mixture of both methods; for instance, they hand-draw the cartoon outlines and then transfer the drawing to a computer for coloring. For all styles of cartoon or comic strip, it is important to make every part of a line count to express the message effectively.

1 A preliminary sketch maps out the layout of the cartoon drawing and the loose details, plus the outline of any facial characteristics, if it is a person.

2 The linework is then applied on a separate layer (on a computer), directly over the rough, or traced in ink onto a clean sheet of paper over a lightbox.

3 Finally, color is added. Today, this is most often done on a computer, but some still prefer to use colored ink or paint, then scan the finished work.

CONVEYING EMOTION

In comic strips and graphic novels, various graphic elements must work together to convey a story. Precise artistic skills are used to convey things such as complex emotions, not only through facial expression, but also through the use of smooth or jagged lines and gentle or vibrant coloring. Accurately repeated elements enable the reader to move on to the next frame effectively.

▷ **Harking back to the work** of the 18th-century artist Hokusai, Manga cartoons continue a long tradition of storytelling in Japan.

LANDSCAPES

The wealth of subject matter in the natural world—distant mountains, sculptural trees, cloudy skies, river reflections—inspires landscape art in realistic representations or abstract interpretations.

As a genre, landscape wasn't respected until relatively recently in western art history, but it was highly regarded in China for over a thousand years. In the 17th century, artists such as Claude Lorrain let their stylized landscapes become the main focus. At the same time, Dutch artists were creating naturalistic landscape representations. John Constable and J. M. W. Turner later gained recognition for their landscapes, heading toward Modernism and experimentation. During the 20th century, artists continued to be inspired by the landscape in new disciplines such as photography (see page 228) and land art (see page 288).

△ **In China, traditional landscape painting** styles emerged during the Tang Dynasty, known as "blue-green landscape." In Japanese landscapes, painted marks entwine philosophy and art in a harmonious and spiritual connection with nature.
Otome Pass, Hakone (c.1932) Takahashi Hiroaki

CHANGING LIGHT

Different times of the day will dramatically affect the way a subject or view is seen. Rough sketches will help you capture the best light to show in your artwork and give you a reference to work from when that light changes. The same view at different times of the year can also dramatically change the reading of a landscape.

Morning light

Midday light

Afternoon light

Ways of working

You could create a landscape from imagination, from a photograph, or—if the view is easily accessible—work *en plein air* ("in the open air"). Each approach offers a different experience and noticeably different results.

Working outdoors means the elements will influence your artistic response, as will the effects of changing light (see box, left) and seasons. You'll also need to choose a practical kit that you can carry with you, such as dry media or relatively quick-drying watercolor.

When working from a photograph, you can take time in the studio to make the piece as accurate as you want or experiment with studio-based techniques. Whichever approach you take, this is your work, so you could also flatten perspective, create something abstract, or use unrealistic colors. Mark making (see page 126) is also a way to add texture and interest.

COMPOSING A LANDSCAPE

There are various devices and artistic principles to help you interpret your view. Using a viewfinder and creating compositional thumbnails is a good way to start. Make a tonal study, especially in changing light, for reference before embarking on your final piece.

The horizon's position and therefore how you divide your landscape will change the feel and balance of your image, so applying the rule of thirds might help (see page 38); you could choose to have a high horizon with a low, long foreground, or focus on the sky with a low horizon.

You may need to employ linear perspective (see page 40), but with landscapes, aerial perspective (also known as atmospheric perspective) is also used. This creates depth through detail and color; the farther away from our eye, the cooler the colors and the less detail is visible, whereas items in the foreground are warmer and more detailed.

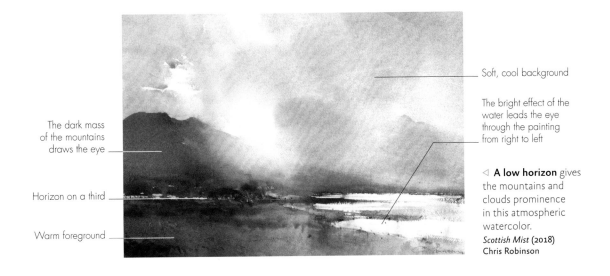

The dark mass of the mountains draws the eye

Horizon on a third

Warm foreground

Soft, cool background

The bright effect of the water leads the eye through the painting from right to left

◁ **A low horizon** gives the mountains and clouds prominence in this atmospheric watercolor.
Scottish Mist (2018)
Chris Robinson

CITYSCAPES

Cityscapes draw on the geometric patterns of the urban environment for their inspiration, highlighting the relationship between buildings, skylines, and streets and the people who inhabit these spaces.

Ever changing, city life has fascinated artists for centuries. Urban scenes appear in Japanese art from the Edo Period (1603–1868), and in Western European art, the first cityscape is accepted to be Ambrogio Lorenzetti's *City by the Sea,* in 14th-century Italy. In the 18th century, the British aristocracy returned from the Grand Tour with souvenirs of cityscapes in paintings, drawings, and prints. The city really became the star in depictions by the painters of the Delft School.

Exploring the relationship between a city and its inhabitants continued to intrigue artists in the 19th and 20th centuries, notably members of the "Ashcan School" and Edward Hopper, with their inclusion of lone figures in urban scenes.

△ **Canaletto's city scenes** place buildings and their ornamentation at the center of the composition, with a supporting cast of people.
Campo Santa Maria Zobenigo, Venice (1730–1739) Canaletto

CITY LIGHTS

An urban environment is full of different light sources, and when creating a cityscape, dramatic effects and feeling can be created by using light and corresponding shadows. Alongside natural shadows created by sunlight and moonlight, an artist can draw on sources of artificial light, too, from buildings and street lamps, vehicles, and neon signs. In this night view, Hiroshige uses light in many ways: lamp lights in the buildings and stalls draw your eye, while cast shadows add to the human interest.

Artificial light adds warm contrasts

Cast moonlit shadows

Night View of Saruwaka-machi (1856) Hiroshige

Choosing a view

As with a landscape painting, consider your eye level, or the horizon, focal points, and how aerial perspective (see page 171) applies to add depth and detail where the sky or distant buildings are part of the composition. Think about the street furniture, vehicles, pedestrians, signs, windows, and greenery. These will all become part of the composition and are integral to the urban setting.

Pattern and shape

If detail is the aspect you notice the most, or pattern might be more important than perspective, then explore different crops that eliminate the background. Close-up details can be rewarding in a city, with textures and patterns visible in stonework and the hard surfaces of walls and pavements.

Most visually associated with black and white photography but applicable to other disciplines, "urban geometry" focuses primarily on the arrangement of shapes, line, texture, and light found within an urban setting. People might be included but are often used for their formal aspect instead of their emotionally relatable qualities.

Urban sketching

Working on site means your sketches are affected by other sensory factors such as sounds and smells, resulting in responsive and exciting drawings. Despite the rigid lines of buildings, windows, pavements, and roads, try to free up your sketches and draw lines freehand. Reference photos could even be taken to develop ideas later. These could be gridded for more accurate recreation (see page 175).

Buildings fill the background

Figures add a sense of movement

Wet pavement lightens the foreground

▷ **This street scene** captures busy city life, with anonymous figures adding color to the urban backdrop.
The Day it Rained, Charing Cross (2017) Adebanji Alade

PAINTING FROM PHOTOGRAPHS

Many artists work very successfully creating paintings from photographs. Whether used as the basis of a photorealist work or the launchpad for an idea, you can incorporate your own images in a multitude of ways.

It is often best to take a photograph specifically for the purpose of painting from it. Ideally, it should be your own photo to avoid the risk of infringing copyright law. Look carefully and make choices before you take the photograph. Work out how to crop the scene. What do you want to focus on—what will you include and leave out? Ensure that it is high resolution if you want to enlarge or crop it.

Be aware that what you see when you look is different from what the camera lens will capture. The colors of your subject matter may be altered in the photograph or there may be the same degree of detail across the whole image, whereas you want to show less detail or bring some objects into focus.

Ideally, take the photograph in natural light. If the photograph is for a portrait, ask your sitter to sit or stand next to a window, with the light falling on one side of their face, but avoid bright sunlight. Lastly, don't use a wide-angle lens or alter the perspective by shooting your object from above or below, as this won't translate well onto canvas, unless that is your intention. Take many more photos than you think you'll need.

Transferring your image
If you are using your photograph as a loose source or inspiration for your painting, then you might just copy it freehand either in paint or a drawing medium. Alternatively, use a projector to shine the image onto the canvas or support and lightly paint or draw over the outlines. Take care that the projector is perpendicular to the canvas, or the image will distort.

◁ **Photorealism** is when a photograph is used to capture an exact likeness, as in this oil painting. *On Assi Ghat* (2009) Edward Sutcliffe

USING A GRID

Another way of transferring your image is to create a grid both on the photograph and on your canvas or support, which will guide you as you copy the image, working from one square to the next. This also enables you to scale up your image if your canvas or support is bigger than your photograph.

EQUIPMENT

- Photograph
- Canvas or support
- Ruler
- Pencil
- Paintbrushes

- **Oil paints:** titanium white; cadmium yellow; yellow ocher; cadmium red; alizarin crimson; burnt sienna; French ultramarine; burnt umber; ivory black

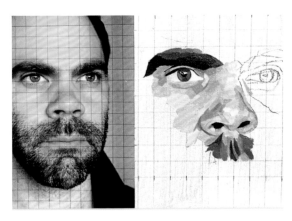

1 Draw a grid on your photograph. You can use small squares (¾x¾in/2x2cm) or larger squares. If scaling up, make sure you do it proportionately.

2 Draw a grid on your paper or canvas and begin to sketch in the tonal outlines within each square—there's no need to go into minute detail yet.

3 Referring constantly to your source image, begin to block in the largest shapes of light and dark tone or color.

4 Gradually build up the smaller shapes and patches of tone or color, working across the whole image square by square.

ILLUSTRATION

The graphic art of illustration is used to explain, decorate, and prompt—whether this is in a children's story, an instructional diagram, or in signage or packaging.

The art of illustration has evolved in line with technical processes. In medieval times, stunning hand-created images on illuminated manuscripts brought religious writings to life. From the advent of the printing press in the 15th century onward, woodblock, etched, and engraved illustrations were widely distributed; and in the 19th century, developments in lithographic printing processes saw the heyday of the illustration in newspapers, magazines, and novels.

Today, digitally or part-digitally generated images are used in book illustrations and packaging, as well as in film, animation, and gaming, where specific software has greatly influenced styles outside of the digital sphere.

Commissioned illustrations

Commercial artists work to a brief, for example, from a publisher or an advertising agency. On receiving a commission, typically, the first step is to identify the concept, story, or message.

Next, research the topic, look for visual inspiration, and choose a style. Work up ideas as storyboards or sketches to create a moodboard. You might use online programs or apps to gather images. Experiment with color palettes, blocking out your basic design as you progress. Before adding detail, ask for constructive feedback.

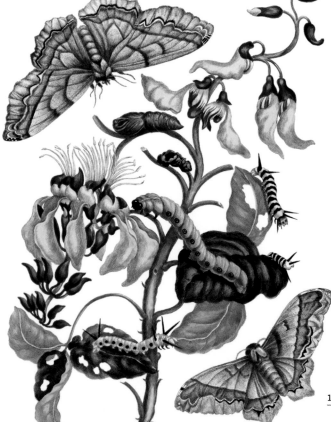

◁ **This hand-colored engraving** shows the artist's meticulous observation of insect life cycles. Such work enhanced scientific understanding at the time.
Illustration from *Metamorphosis* (1726)
Maria Sibylla Merian

Hone your style

When working commercially, think about how you will meet the brief. Once you've worked out the concept or message (see opposite), consider whether your illustrations will be enjoyed at leisure—for example, in a storybook—or if they will have to communicate instantly, effectively, and internationally, acting as signage. How will this affect the medium or style you choose? If you are creating a character, you might borrow from the disciplines of cartoons and comics (see page 168).

◁ **The illustration style** on this tea packaging, carried across all the products, creates an instantly recognizable brand identity.
Teastreet Packaging (2018) alt8.nl

ILLUSTRATING A STORYBOOK

Storybook illustrations tend to endure and have great artistic value, becoming synonymous with the tale. If you are commissioned to illustrate a children's book, your illustrations will tell as much of the story as the words (sometimes more) and can be instrumental in creating characters. Illustrations are usually worked up in stages, as shown below, following the design brief to the letter to allow room for story and jacket text.

1 A preliminary black and white sketch provides outline, structure, detail, and tonal values. Once approved, a color outline can be worked up.

2 Areas of color are blocked in, defining the color palette. Here, soft watercolor washes over water-soluble pencil lines add warmth and character.

3 The final illustration combines sketch and color. Color definition gives detail and facial features are filled in to reveal character and expression.

SCULPTURE

The art of creating 3D sculptural forms
traditionally included molding, casting, carving,
and fabrication, but modern sculpture now also
embraces exciting techniques such as assembling
"found objects," incorporating moving parts,
working with synthetic materials, and using
3D software and printing.

ARMATURES

Most modeling materials are not strong enough to bear their own weight. Just as our bodies require a skeleton for support, your sculptures may need an internal structure during modeling, known as an armature.

Use armatures for any sculpture not fired in a kiln; each new artwork will require its own customized frame. When making an armature, you are constantly balancing strength with flexibility; you want to be able to move elements around during modeling but don't want the sculpture collapsing.

When choosing armature wire, consider size, availability, strength, and flexibility. Square aluminum is very good for large armatures, while galvanized, and particularly copper, wire is used for small armatures. Softer modeling materials require more support.

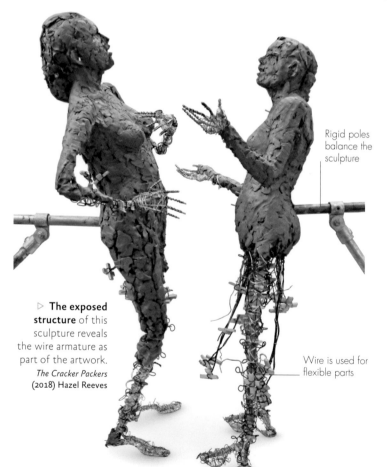

Rigid poles balance the sculpture

▷ **The exposed structure** of this sculpture reveals the wire armature as part of the artwork.
The Cracker Packers (2018) Hazel Reeves

Wire is used for flexible parts

BACK IRONS

Medium or large sculptures that need extra support or flexibility in all their parts will require an external rigid support, or "back iron," made with welded mild steel. Alternatively, you can use a strong but bulkier material, such as wood. Fix the binding wire in place with adjustable hose clamps, or use cable ties first before committing.

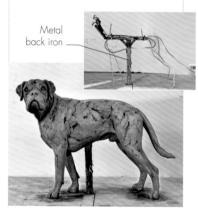

Metal back iron

MAKING AN ARMATURE

To make a medium-size sculpture, you will need to build the armature on a wooden board, following a rough sketch of the piece that shows dimensions and the position of the armature inside.

EQUIPMENT

- Wooden board
- 9–4 gauge (3.5mm) copper wire
- Wire cutters
- Staple gun
- 10 gauge (3.17mm) square aluminum wire
- Cable ties
- 13, 15, 20, and 24 gauge (1.8mm, 1.5mm, 0.8mm, and 0.5mm) copper wire
- Pliers
- 19 gauge (0.9mm) galvanized wire

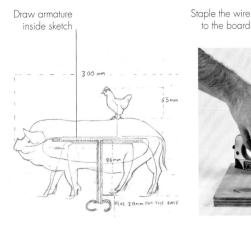

Draw armature inside sketch

Staple the wire to the board

1 **Make a rough sketch** of your intended sculpture, showing the main sizes and proportions. Use your drawing to consider the thickness of the wire needed for each part.

2 **For a medium-size sculpture**, make a back iron from two pieces of wire; curl the ends in a loop and attach to a wooden board as the base. For larger works, screw a back iron in place.

3 **Start cutting and attaching** lengths of wire of the appropriate length and thickness to the back iron using cable ties. For the main bulk of the pig, use a square aluminum wire.

4 **Use different widths** of wire for the different elements. Here, 13 gauge wire is used to support the chicken; 15 gauge for the pig legs and tail; and 20 gauge for pig ears and chicken limbs.

5 **Next, bind the pieces** of the armature together like a splint by winding galvanized wire along the length, similar to a bandage, using pliers to manipulate the wire.

6 **Bind any final pieces** together, like the chicken, using very thin wire, such as 24 gauge width. Wrap each of the limbs in the thin wire to help the clay grip. Remove the cable ties.

MODELING

Modeling is a method of creating sculpture using malleable materials such as clay or wax. It is a good choice if you enjoy manipulating material with your hands and creating artwork with subtleties of form.

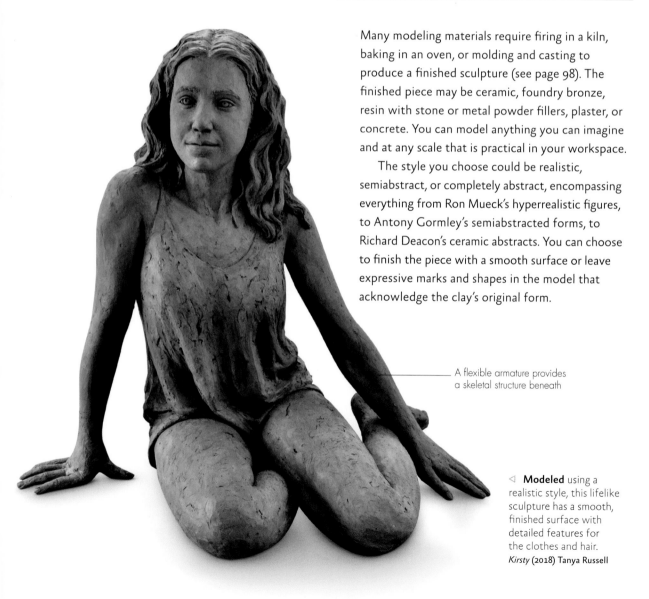

Many modeling materials require firing in a kiln, baking in an oven, or molding and casting to produce a finished sculpture (see page 98). The finished piece may be ceramic, foundry bronze, resin with stone or metal powder fillers, plaster, or concrete. You can model anything you can imagine and at any scale that is practical in your workspace.

The style you choose could be realistic, semiabstract, or completely abstract, encompassing everything from Ron Mueck's hyperrealistic figures, to Antony Gormley's semiabstracted forms, to Richard Deacon's ceramic abstracts. You can choose to finish the piece with a smooth surface or leave expressive marks and shapes in the model that acknowledge the clay's original form.

A flexible armature provides a skeletal structure beneath

◁ **Modeled** using a realistic style, this lifelike sculpture has a smooth, finished surface with detailed features for the clothes and hair.
Kirsty (2018) Tanya Russell

REALISTIC OR ABSTRACT?

Modeling "realistically" is very subjective, as we all perceive things differently. When a cheetah runs, you do not see individual hairs on its body with the human eye. Modeling the cheetah frozen in midstride, as it looks when captured by slow-shutter photography, is realistic.

Modeling the cheetah blurred in motion as seen by the human eye is also realistic but referred to as "semiabstraction." Semiabstract sculptures are still recognizable, but their modeling is less literal. An artist may express their ideas through familiar forms, which may be highly stylized, exaggerated, reduced, suggested, or otherwise altered.

Anatomical knowledge broadens your modeling choices, informing your sculpting language even when you choose to abstract the form.

The concept of abstraction is not new, having a long tradition in ancient art, where it is often linked with symbolism. Pure abstraction displays nothing literal for the viewer to respond to. Its formal elements aim to evoke an emotional response without familiar visual references from the world. Common themes of abstract sculpture include geometric shapes, fragmentation, repetition, and strong lines or planes. Your modeling material may also be a source of inspiration, where a visceral connection between maker and piece is visible.

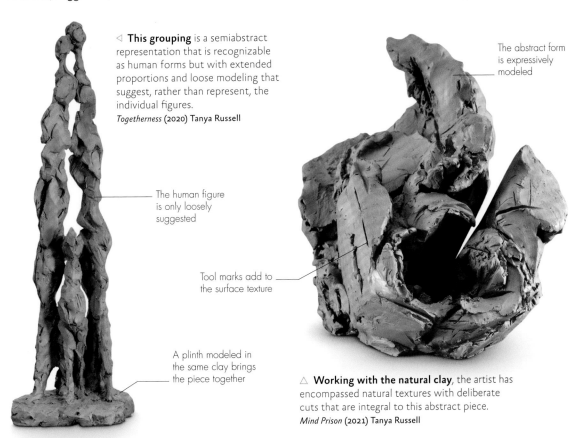

◁ **This grouping** is a semiabstract representation that is recognizable as human forms but with extended proportions and loose modeling that suggest, rather than represent, the individual figures.
Togetherness (2020) Tanya Russell

The human figure is only loosely suggested

The abstract form is expressively modeled

Tool marks add to the surface texture

A plinth modeled in the same clay brings the piece together

△ **Working with the natural clay**, the artist has encompassed natural textures with deliberate cuts that are integral to this abstract piece.
Mind Prison (2021) Tanya Russell

MODELING THE SCULPTURE

Once your armature (see page 181) is complete, you can begin modeling. Build all parts of the sculpture together instead of focusing on one area at a time, regularly standing back to assess from different angles how it is progressing in its entirety.

EQUIPMENT

- Sculpting platform
- Reference material
- Armature
- Modeling clay
- Large and small modeling tools
- Measuring tool

1 Place your armature on a bench or sculpting platform and begin to add your modeling material, working from the bottom up and referring to your original sketch. Work relatively quickly.

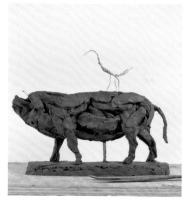

2 Roughly create the overall form of the sculpture using slabs of modeling clay. Build up all parts at the same time fairly quickly so that you can see how the whole model works as one.

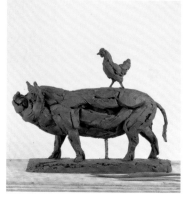

3 Use large modeling tools or your hands to create the big shapes, keeping the modeling material loose, so the surface does not become flat and lifeless. View the model from all sides.

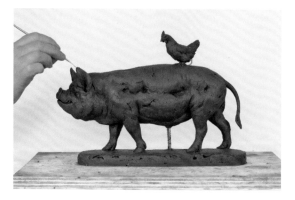

4 Move to smaller modeling tools when you are happy with the overall shape and proportion to refine the detail or adjust the texture and create interesting marks.

MEASURING WHILE YOU WORK

When modeling realistically, taking careful measurements from the subject or reference material is vital. If the subject is smaller or larger than your sculpture, use a conversion scale or proportional measurements. Use a plumb line to check vertical elements.

Use calipers to check your measurements

KEY DESIGN ELEMENTS

Used creatively, your modeling can produce art that triggers meaning and moments of powerful personal experience for the viewer. Concepts take form with energy, rhythm, dissonance, or any quality you choose. In order to do this, you need to consider the different elements that you use.

Space, both positive and negative, is important in a sculptural form. Consider both horizontal and vertical planes in your composition, using focal points or directional lines to guide the viewer.

△ **Made of fired ceramic clay**, this piece uses repetition of planes; geometry; lines; focal points; and rough, simple modeling to allude to a sense of nihilism in the urban and industrial jungle.
Cost of Progress (2016) Tanya Russell

△ **This piece utilizes a powerful**, strong central focal point, created through lines, mass, and void, and nonliteral textures that do not detract from the concept.
Tenderness (2019) Tanya Russell

▷ **The vertical silhouette** with a textured surface, cavity, strong lines, and negative spaces makes for a powerful work.
Angel (2020) John O'Connor

MOLDING AND CASTING

Clay sculptures can be transformed into many materials using the molding and casting process, whereby a negative or "mold" is made from the clay model and then a cast is produced from the mold.

MAKING A SILICONE "SKIN" MOLD

Before you create your mold, decide where your split line will be. Your mold can be made in two or more parts to avoid "undercuts" (areas that will catch and prevent the mold from opening). The rubber "skin" will then need reinforcing with a plaster "jacket."

EQUIPMENT

- Clay model or "master"
- Brass shims in 2×4 in (5×10cm) pieces
- Electronic kitchen scales
- Mixing bowls
- Silicone rubber
- Silicone rubber "fast" catalyst
- Old paintbrush
- Thixotropic additive
- Wooden spatulas
- Ready-made rubber keys
- Plaster of Paris
- Jute
- Silicone rubber release agent

Tape the ends of the shims

1 Decide where the undercuts are in the sculpture. Mark your split line and push the shims in along the line.

Be careful not to mark the clay

2 Mix the rubber and catalyst and paint the rubber onto one half of the sculpture. Leave to dry until tacky.

Stick rubber keys onto last layer while tacky

3 Mix more rubber with a few drops of thixotropic additive to make it the texture of custard. Paint twice more.

The keys "lock" the rubber skin into the jacket

4 Mix plaster and spread it over the rubber skin to create a jacket. Add jute to the plaster for reinforcement.

Add a pouring spout before making the other side of mold

5 Turn it over and rub release agent onto the rubber and plaster wall. Add the rubber skin and plaster on this side.

CASTING THE SCULPTURE

Once you have your silicone rubber mold, it can be used many times to cast sculptures in numerous different materials, such as resin, cement, and plaster. It can also be used to create a wax model for casting in metal.

EQUIPMENT

- Silicone rubber mold
- Plaster of Paris
- Mixing bowl or bucket
- Water
- Latex/vinyl gloves
- Dust mask

1 Half-fill the bowl with water and sprinkle the plaster into the water until a small, peaked island of plaster remains in the center of the bowl.

2 Allow the water to soak into the plaster powder, then mix it well with your hand until you have an even, creamy consistency to the plaster.

3 Pour the plaster into the mold, then tap the mold to remove air bubbles. Allow the plaster to set or "go off" before opening the mold.

THE "LOST WAX" METHOD

To cast an item in bronze or steel (see below left and right), make a wax model using your mold and send it to a foundry to be cast using the "lost wax" method. They will make a one-piece ceramic mold around the wax model; the mold and model are then placed into a kiln where the wax melts out in the heat, and molten metal is poured in its place.

▷ **Molten bronze** being poured into a mold at a foundry. Lower-melt metals and alloys, such as zinc, tin, and pewter, can be cast at home.
Bronze Age/Julian Wild

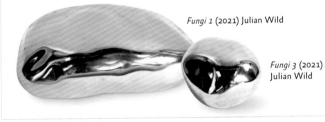

Fungi 1 (2021) Julian Wild

Fungi 3 (2021) Julian Wild

CARVING

Carving involves the cutting and shaping of a solid material, like wood, stone, or ice, to create a finished artwork. It is a subtractive art form, in that the artist only removes rather than adds during the process.

The art of carving has been with us since prehistory. There are many materials (see page 102) and techniques to choose from, such as using a whittling knife to shape a spoon, a mallet and chisel to produce a marble figurine or slate inscription, or even a chainsaw to transform a tree trunk into a totem or a block of ice into a lion. Whether carving directly in response to the material or indirectly using a model, the process follows similar stages.

Carving stages

Assess your material before you start, planning whether to cut a rough outline or to transpose a design onto all sides of the piece. Check for natural defects and consider the grain of the material, which can both weaken or strengthen the final piece and make it easier or more difficult to carve. If you have the time and spare stone or wood, practice "wasting" (removing unwanted areas) and mark making to get a feel for the material. Any carving will involve specific stages of removal or detailing with various tools and cutting techniques.

When working in the round, draw out an approximation of the design on all sides. "Rough" out the shape by wasting larger areas and removing corners. Refer to your model if you have one and use a 9H pencil to indicate areas to keep or remove. The bulk of the material can be chipped away, with the final surfaces being refined at the end.

▷ **Interest in direct carving** developed in the early 20th century and was quickly adopted by artists who created organic forms inspired by their materials.
Portrait of Ezra Pound (1914)
Henri Gaudier-Brzeska

Chisel marks are visible on the surface

Carved shapes follow the wood grain

Direct carving

In this approach, the form of the work develops as the artist intuitively responds to the material being removed instead of following guides of a preliminary model. The style suits organic, simple forms and lends itself to surfaces with markings and color that can be accentuated and become part of the finished piece.

WORKING A RELIEF CARVING

Practice your carving skills by working a three-dimensional piece comprised of simple geometric shapes, responding to the natural variation of the material and using undercutting and different surface texturing to play with light and shadow.

Draw directly on the block with a 9H pencil

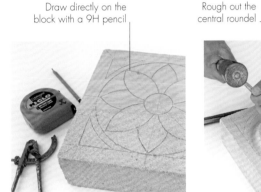

Rough out the central roundel

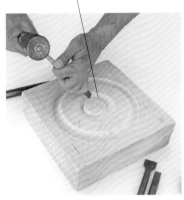

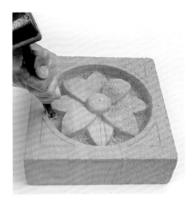

1 Prepare a flat block with abrasive pads. Use a metal or straight-edge ruler and dividers to measure and set out your design on the stone surface.

2 Use a nylon mallet and flat chisels to rough out the main shape and refine by chipping with a dummy mallet and letter-cutting chisels.

3 Reapply the design lines, then chisel the main elements: start with the upper petals, then undercut the recessed area to add shadow contrasts.

Spandrel

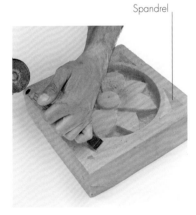

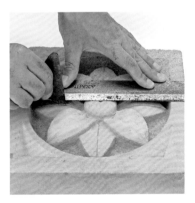

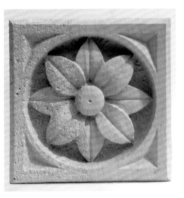

4 Cut a chamfered (angled) border around the edge and add spandrels with a dummy mallet and flat letter-cutting chisel held at a 45-degree angle.

5 Use a small drag (a piece of saw blade) to cut details into each petal and refine the design further with letter-cutting chisels.

6 The natural variation in the color and texture of the stone between the left and right sides has been left to create an interesting contrast.

SCULPTURAL CERAMICS

Sculptural ceramics involves sculpting clay by hand and firing it in a kiln.
It is an "additive" art form, in the sense that clay is added during the
process instead of being taken away, as when carving a sculpture.

Natural clay is available in a variety of textures. At one end of the
spectrum, you have porcelain, which is very fine and fired thinly, and
at the other end there is crank, which contains a large amount of grog
(small particles of dried clay in the wet clay) and can be fired thick.

Ceramic sculptures are fired at different temperatures, according
to whether they are glazed. A bisque-fired sculpture has no glaze and
is fired at 1,823–1,940°F (995–1,060°C). Glaze firing requires temperatures
of 1,940–2,372°F (1,060–1,300°C), depending on the glaze and clay used.

▷ **This ceramic piece**
is created from rings
of hollowed clay,
joined with slip.
Glazed sections were
assembled after firing.
Gestalt (2008) Julian Wild

HOLLOWING

Handbuilding and hollowing is the simplest way
to work sculpturally with clay: make a solid piece,
allow the clay to harden slightly, then hollow it out.
The process works best on more volumetric forms,
such as a head, and with heavily grogged clay.

EQUIPMENT

- Sculpture for hollowing
- Clay cutting wire
- Hollowing tool
- Skewer
- Slip paste

Air bubbles will make your
sculpture explode in the kiln

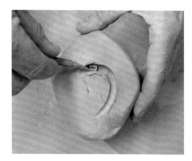

1 Place the sculpture on a cushion
to hollow from underneath. Mark the
area to be removed on the base.

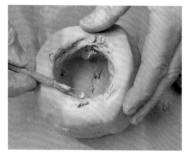

2 Use a clay hollowing tool to scoop
out the center of the sculpture, leaving
a consistent 2in (5cm) thick wall.

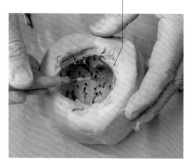

3 Prick the inside of the sculpture
with a skewer to get rid of air bubbles.
Join any cut sections with slip paste.

COILING A BOWL

Coil building involves making thin sausages that you coil up to create hollow forms. If you want to make a large sculpture, allow the clay to dry to soft leather-hard so that you can add more on top using cross-hatching and slip.

EQUIPMENT

- Clay with grog
- Slip paste

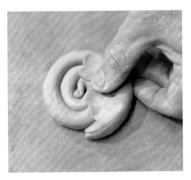

1 Use the length of your hands and even pressure to roll ½in (1cm) thick sausages roughly 12in (30cm) long.

2 Shape one sausage into a spiral for the base, coiling it around and smoothing the edges together.

3 Join another sausage to the base with slip and smooth together using your thumb to make a bowl form.

MAKING A SLAB BOX

In slab building, you roll out thick slabs of clay, allow them to harden, and then join them using slip paste made from a mixture of the same clay and water. This method is ideal for making box forms.

EQUIPMENT

- Clay with grog
- Wooden board
- Two batons
- Rolling pin
- Level
- Metal ruler
- Ceramic knife
- Slip paste
- Scoring tool

1 Roll the clay into a ½in (1cm) thick slab. Rotate to achieve an even thickness. Allow to dry a little.

2 When the slab is leather-hard but still soft, cut squares and rectangles using a metal ruler and a ceramic knife.

3 To make a box from the slabs, cross-hatch the areas that you are joining and use a slip as your glue.

FABRICATION

In sculpture, fabrication is the term used to describe the cutting, drilling, and assembling or joining of different materials either to create an entire artwork or to add an element, such as a base or plinth, to an existing sculpture.

When creating a fabricated work, your choice of material will be influenced by the size and shape of your design and the effect you're looking to achieve. For larger structures, strength and stability are key. If it is to be placed outdoors, think about the durability of the material when exposed to the elements. Aesthetic qualities such as texture, shine, color, and transparency will also be major factors in your choice.

It's important to have the right tools and protective equipment to work effectively and safely. Consider your workspace, too—many techniques are noisy and could disturb family or neighbors. Also, remember the completed work needs to be able to fit through the door! For a larger work, you may need to transport it in separate pieces and assemble it on site.

METAL

Each metal has its own properties, such as tensile strength (see page 104), which will determine how easy it is to work with. Mild steel is good for fabrication, as it can be cut, manipulated with heat (forged), and welded.

A metal's surface can add an interesting dimension to a sculpture—it can be polished or brushed to achieve different effects, such as a glossy "mirror" effect or a matte luster.

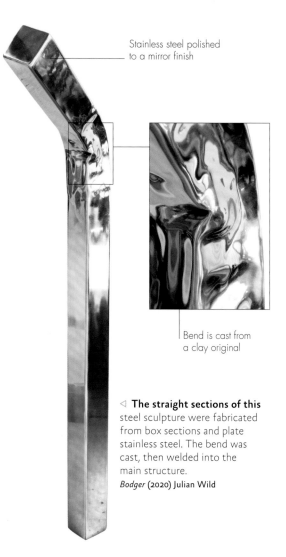

Stainless steel polished to a mirror finish

Bend is cast from a clay original

◁ **The straight sections of this** steel sculpture were fabricated from box sections and plate stainless steel. The bend was cast, then welded into the main structure.
Bodger (2020) Julian Wild

WOOD AND COMPOSITE

Natural wood is often chosen for the pleasing appearance of its grain, but it can be expensive. Composite boards, such as plywood, oriented strandboard (OSB), MDF, and chipboard, are usually cheaper and easier to work with. To cut curves, you'll need a jigsaw with a wood blade; for straight lines, use a circular or hand saw. Cutting compressed wood products produces harmful dust: always wear a dust mask and work in a well-ventilated space, or invest in a dust extracting system.

▷ **In this sculpture,** plywood layers were cut, stacked, glued, sanded, and finally bolted to a plywood plinth.
Helix Head (2007) Tony Cragg

ACRYLIC

Lightweight and reflective, acrylic is a popular material among artists working with color and light. Although more expensive than glass, it's lighter and stronger and can be more easily combined with metal. Acrylic can be cut or drilled (use tape when drilling to prevent cracking); it can also be bent into shapes by gentle warming with a hot air gun or bar heater. Use solvent cement or epoxy glue to join pieces.

▽ **This arched tunnel** is made from triangles of colored, mirrored, acrylic panels. As viewers move through, colors change depending on how light hits the surfaces.
One-way Colour Tunnel (2007) Olafur Eliasson

WELDING METAL

This fabrication process uses heat to fuse two parts of metal together, forming a bond as the metal cools. The weld gets very hot; you need to wear full protective clothing, including goggles or a welding helmet, heat-resistant gloves, and a respirator.

EQUIPMENT

- PPE equipment
- Mild steel plate
- Angle grinder
- Grinder and cutter disks
- MIG welder
- Welding wire and gas

Keep the disk straight

1 Cut the metal with an angle grinder and cutting disk. A jigsaw with a metal blade can be used to cut gentle curves in steel up to $5/64$in (2mm) thick.

Beveled edge

2 Use the grinding disk to prepare the metal and clean off any debris. Bevel thicker metal with the grinder to allow for the weld to penetrate.

3 Set the welder to the correct settings for the thickness of metal. Position the tip $13/64$in (5mm) away from the weld; check that you can see the tip.

4 Squeeze the trigger. As the wire melts at the end, move the torch slowly along, filling the gap between the two pieces of metal with weld.

MAKING A PLINTH

Constructing a plinth for an existing artwork is a useful first exercise in mastering some of the key fabrication techniques in wood or composite board—the cutting, joining, and fitting together of different pieces. Either buy the MDF precut or cut it to the required size.

EQUIPMENT

- PPE equipment
- 11×16in MDF:
 1 x 12×12in (30×30cm)
 2 x 11×12in (28.2×30cm)
 2 x 11×10¼in (28.2×26.4cm)
- Wood glue
- Clamps (corner or G-style)
- Cordless drill/screwdriver
- ⅛–³⁄₁₆in nonmasonry drill bit
- Countersink bit
- 6 x 1½in crosshead screws
- Wood filler and sandpaper

1 **Cut the MDF** into five pieces with a handsaw, jigsaw, or circular saw, if not precut. Glue the two edges that you are joining. Wood glue is best.

2 **Clamp the joined edges** and drill pilot holes with a ⅛–³⁄₁₆in drill bit on the top board. Countersink so that the screw head sits below the surface.

3 **Screw the pieces** together and remove the clamps. Once the glue has dried, cover the screw heads with filler, and sand to a smooth finish.

ATTACHING THE SCULPTURE

A removable plinth helps when transporting a sculpture. Ensure the base is the correct proportion to the height and weight of the sculpture and deep enough for the bolt that joins them together.

EQUIPMENT

- PPE equipment
- M8 bolt, nut, and washer
- Cordless drill
- Nonmasonry drill bit
- Socket or open-end wrench
- Sandpaper and paint

Sculpture with bolt

1 **Attach the bolt** (or as many as needed) to the base of your piece. Then drill a hole through the top of your plinth using a drill and drill bit.

2 **Pass the bolt through** the hole in your plinth, add the washer, and screw the nut in place. Tighten the nut with a socket wrench or an open-end wrench.

3 **For display purposes**, sand and paint the plinth. You can make an acrylic panel cover for your exhibit or order one from a specialist company.

KINETIC ART

These art forms use kinetic energy or motion as part of the final work. The movement is achieved using mechanical elements that are powered by anything from touch to wind, water, gravity, or an electric motor.

The introduction of movement into art began in the early 20th century, partly as a reflection of the importance of machines and industry in the modern world, but also due to changes in traditional artistic conventions and thinking.

The fathers of modern-day kinetic art are Marcel Duchamp, whose "readymade" sculpture, *Bicycle Wheel* (1913), is seen as one of the first kinetic works of art (see page 21). Naum Gabo, a Russian Constructivist artist with a background in engineering, is a key figure, as is Alexander Calder, who initially experimented with cranks and motors before creating mobile sculptures. László Moholy-Nagy's *Light-Space Modulator* was one of the first electrically powered light art pieces (see page 278).

△ **The mechanics of this wooden** piece are on view, displaying the crank and shaft that move the two figures together.
Kiss (2005) Kazuaki Harada

◁ **With moving metal** parts, this sculpture is set in motion by an electric motor. Made from aluminum plates and blades set in a steel frame, the piece is connected with metal axles.
The Theory of Twilight (1982–1983) Alice Aycock

Crank automata

Making a crank is an excellent way to start exploring kinetic art using a simple machine. You can adapt and use a basic crank to create many different designs. A crank can be made from wood, metal, or wire and consists of a central shaft held within a box that is operated by turning a handle.

Holes are drilled through the top of the box that enable vertical rods to rise up and down. Shapes are positioned along the shaft of the crank that push the rods up and also allow them to drop down. Creative elements can be positioned onto the ends of these rods that accentuate the motion.

Mobiles

The word "mobile" was coined by Marcel Duchamp as a way to describe the kinetic work of his friend, Alexander Calder. Calder developed unique moving sculptures whose elements harmoniously dance around one another without clashing. This style of making mobiles is still used today.

A mobile relies on balance and equilibrium around a central point, or "fulcrum," to move gently in air currents. From the fulcrum, the mobile is connected together with wire, thin metal, or twine to create a basic moving skeleton structure. Shapes or weights can be cut in any material, such as cardstock, plastic, or metal. The relative weights of the items and their distance from the center create balance.

Renewable energy

Kinetic sculptures can be powered by renewable energy sources, such as wind, water, or the sun. Wind sculptures normally incorporate "sails" that catch the energy of wind. These sail elements sit on bearings that allow the sculpture to spin easily. Solar power can be used instead of conventional electricity supplies by connecting solar panels to batteries that store their energy to power the motor of a kinetic sculpture. Other kinetic sculptures harness the power of rainwater or water courses such as streams to create water sculptures using chutes and paddles.

▷ **As the wind catches** the "sails" of this sculpture, the head and arms of the figure move hypnotically around.
Zavion (2021) Anthony Howe

READYMADES AND ASSEMBLAGE

In art, the term "readymades" describes objects, sometimes mass-produced, that are found and used for, or as part of, an artwork. An assemblage creates a three-dimensional sculpture from these objects.

The first readymade was created by Marcel Duchamp in 1913 and was called *Bicycle Wheel* (see page 21). The artist took a mass-produced bicycle wheel and attached it to a stool. In his view, art had no function. By putting these two objects together, he made them functionless, and therefore they became art.

There are many ways an artist can connect readymade or found objects to make a three-dimensional assemblage. For example, objects can be pulled apart and placed together in a different format than originally intended, creating unlikely combinations that are designed to surprise and disrupt the viewer's perception of normality.

Objects can also be cast in another material, painted to integrate them into a painting, or embedded within a sculpture or installation.

Deconstruction

Readymade objects can be deconstructed and rebuilt into something else or exhibited as the disassembled object. Metal objects, such as car parts, garden tools, and scrap, can be welded into animal or abstract forms. Nonmetal objects can be joined using wire, glue, and mechanical attachments. How an item is taken apart is integral to the process and meaning of the artwork: are the pieces disassembled carefully, cut, or broken?

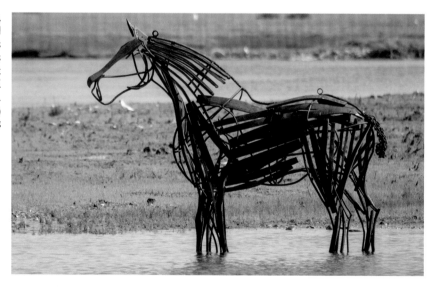

▷ **This 10-foot sculpture**, made from deconstructed steel bars and old barrels, was made to remember the horses that used to pull the lifeboat out to the sea in the UK town Wells-next-the-Sea.
The Lifeboat Horse (2018)
Rachel Long

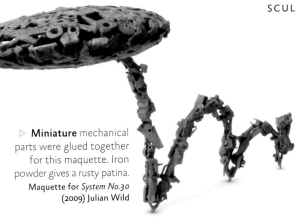

▷ **Miniature** mechanical parts were glued together for this maquette. Iron powder gives a rusty patina.
Maquette for *System No.30* (2009) Julian Wild

Integration

A readymade can be integrated into an artwork so that it is not instantly recognizable. This can be achieved by disguising it under more conventional art materials, such as plaster, or by painting the found elements. If the objects are painted, they should be prepared and primed carefully first, depending on their base materials (see page 56).

Combination

Multiple readymades can be assembled to create one sculpture, each object recognizably separate. They can be glued or joined together with screws, bolts, or string, according to the material and the artist's aim.

Alternatively, found objects can be collected, glued together, and painted a unifying color. Or they can be pressed into clay and cast in plaster; the cast might convey a theme, such as nature, with each object being a natural form.

△ **An assemblage** of thousands of plastic toys was created by this artist to comment on our disposable consumer society.
Magnet (1999) Wayne Chisnall

TYPES OF GLUE

The most obvious way to join objects together is to glue them. The glue you use will depend on the size of your sculpture, as well as on its component materials. Here are some of the most commonly used adhesives.

▪ **Cyanoacrylate adhesive**, known as super glue, crazy glue, or instant glue. This joins many different materials together but is relatively weak, especially with irregular surfaces. An accelerator or spray activator can hasten drying times.

▪ **Epoxy** attaches most dissimilar materials and is fairly strong and flexible. It needs mixing, then takes time to set, so items need to be held in place with tape or clamps.

▪ **Glue guns** join most materials quickly. A glue stick heats up inside, so care is needed, as the glue becomes very hot.

▪ **PVA** (polyvinyl acetate) is excellent for joining porous materials such as paper and cardstock. Some wood glues are made from the same substance. You will need to clamp, nail, or screw pieces together when gluing wood.

3D SOFTWARE AND 3D PRINTING

3D digital technology enables sculptors to design and visualize a piece, take accurate measurements for fabricating their work in many materials, and produce small-scale models or final sculptures using a 3D printer.

3D SOFTWARE

There are many 3D software programs available that allow sculptors to design their artworks. The software includes polygonal modeling, Computer Aided Design (CAD), solid modeling, wireframe modeling, and surface modeling. Each type of program has its own unique benefits. Some allow the user to simulate different materials, such as soft clay, wood, or metal, while others are more suited to precision design and engineering.

MODELING SOFTWARE

Here are a few of the free and commercial 3D modeling software options available.

- **AutoCAD®:** Purchasable CAD modeling package.

- **Blender™:** Free, downloadable, open-source 3D modeling software suite.

- **OpenSCAD:** Free, downloadable software; focuses more on the technical aspects.

- **Rhinoceros®:** Purchasable modeling suite; allows free-form modeling and different surface effects.

- **SketchUp:** Free online software; easy to use; popular with artists.

- **SolidWorks®:** Purchasable CAD modeling package; probably more suited to engineers than artists.

- **Tinkercad®:** Free online software for designing models specifically for 3D printing.

BASIC 3D MODELING

Experiment with some of the free software programs, creating simple shapes first. Once you have created your design, it can be exported to a .dxf or .dwg file, viewable in other 3D software programs, or to a .stl file for 3D printing.

1 **Start with an X and Y axis** and use the rectangle tool to draw a square.

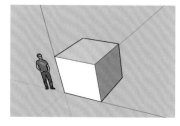

2 **Use the push/ pull tool** to pull the rectangle into a 3D cube.

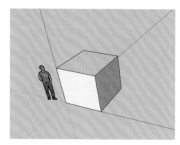

3 **Highlight the object** and make it a group. The model is now one unified component.

3D PRINTING

Load your file into the printer—either remotely or via a USB memory stick. 3D printers have "slicing" software to arrange your model on the build plate. Check regularly while printing to ensure the printer is working properly. Once printed, take your model off the plate and remove supports by hand or with a craft knife. Smooth imperfections with sandpaper.

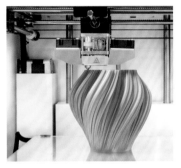

◁ **Filament 3D printers** are fairly low cost. Filaments come in different colors; some models can make multicolored prints.

3D PRINT MATERIALS

All 3D printers build the model up in layers, but there are three main types of 3D printer, using different processes:

- **Filament or Fused Deposition Modeling (FDM).** A thin, flexible filament is fed through a hot nozzle onto the plate. Machines are lower cost and no fume extraction is needed, but layers can be visible and detail less defined.

- **Powder or laser sintering (SLS).** A laser beam heats up the powder (layer by layer) into a solid mass. Great for detailed models and can make multicolored prints, but printers are expensive and require fume extraction.

- **Resin or photopolymer printing.** A laser beam heats up liquid resin into a solid mass according to the file model. It can deliver a good level of detail for a relatively low cost, but the model is slimy and needs washing in a solution. Always wear gloves and goggles.

FDM nylon filament

FROM 3D SCAN TO FINAL SCULPTURE

An object or person can be scanned for use in 3D modeling programs. Smaller objects can be scanned on a turntable, while larger objects and people require a specialist camera or smartphone and app. The scanning software records thousands of points on the surface and then stitches this data together into a 3D model that can be manipulated in most modeling software or 3D printed.

▷ **A small-scale model** can be produced by sending the software file to a 3D printer.

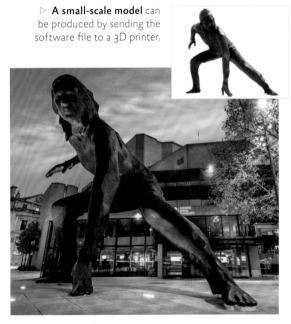

▷ **A large-scale sculpture** can then be created in any material. This 23ft (7m) tall sculpture is cast in bronze.
Messenger (2019) Joseph Hillier

PRINTMAKING

To print is to transfer information from one surface to another, and it takes many guises. From Stone Age handprints, through early Asian woodblock-printed fabrics, to Gutenberg's relief press and Damien Hirst's etchings, printmaking is a powerful art form.

INTAGLIO: ENGRAVING AND DRYPOINT

The technique of incising an image into a plate with lines and tones that hold the ink below the surface is known as intaglio. Metal engraving and drypoint are the most direct methods of making an intaglio plate.

There are various methods and approaches to engravings, from the fine details of traditional copperplate engraving to the softer lines of drypoint. To make an engraving, you need only a few tools and your choice of plate. Copper is considered to be the most superior metal plate to use, but your choice will depend on the amount of detail and tone that you wish to achieve. A specialist engraving tool known as a burin is used to incise lines with clean edges that can be filled with ink and printed onto dampened paper using the same method as an etching (see page 211).

Drypoint is a similarly direct but less long-winded method of inscribing a plate by using a

◁ **A burin** has a diamond-shaped tip that allows you to cut shallow, precise V-shaped grooves.

sharp, pointed steel tool to produce a soft line. It has been employed by many artists, such as the German expressionists Max Beckmann and Käthe Kollwitz and contemporary artists such as Jenny Robinson, shown opposite.

MEZZOTINT

This process, developed in the 18th century, is particularly suited to gradations of tone. The plate is prepared with a toothed metal tool that is rocked over the surface to make it pitted, which produces a solid black when inked. By burnishing away the rough surface to varying degrees, smooth transitions in tone are achieved.

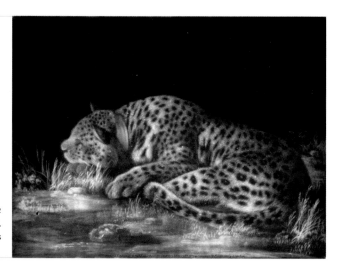

▷ **Soft gradations** of tone in the fur are beautifully rendered in mezzotint.
Cheetah Sleeping (1788) George Stubbs

TRADITIONAL METAL ENGRAVING

Copperplate engravings are made with highly polished copper plates, normally 16-gauge thickness. The edges are filed and the image is cut by hand using a burin tool (see left), which cuts the metal cleanly, producing crisp edges and fine lines. Occasionally, engravings are inked with a roller and stiff ink and printed in relief. Various texturing tools can be used to add tone and create a drawn effect.

△ **Albrecht Dürer**, a master of copperplate engraving, used expressive hatching to convey light and form.
Sea Monster (c.1498)
Albrecht Dürer

⎯ Delicate hatched lines

DRYPOINT

In drypoint printmaking, the burr that is created when pushing a point into the plate is left in place. The plate is then inked and printed using an etching press. It is extremely simple and makes a beautiful soft line, which can be delicate if inscribed lightly or dark and velvety if the point of the needle is pushed firmly into the plate. Suitable plates range from copper to plastic.

△ **Precise but soft** lines are achieved in drypoint, making it suited to graphic works with contrasts of tone.
Hangar 1 (2015) Jenny Robinson

Dark lines produced by ⎯ deeper incisions

INTAGLIO: ETCHING

An etching is created using a metal plate into which grooves are etched using a mordant (acid). These grooves are filled with ink. The plate and paper are then passed through a high-pressure press to produce an image.

In this process, the image is drawn onto a metal plate prepared with a thin wax or acrylic ground before being "bitten" with one of a number of mordants, which vary depending on the type of metal used (see page 114). Copper is the most traditional etching material; however, zinc, steel, and aluminum are also used.

The length of time a plate is exposed to the acid determines the depth of the etch and the amount of ink a groove will hold. Longer etches produce deeper and therefore darker lines.

△ **Atmospheric effects** can be achieved in etching by building up different weights of line.
The Three Trees (1643)
Rembrandt van Rijn

Cross-hatching

PREPARING THE PLATE

Take time to file, scrape, and burnish the edges of the plate. This is both to protect the soft press blankets from any sharp edges and to ease the process of wiping the plate.

Polishing and degreasing

Even if your plate is prepolished, polish it again with metal polish; it could mean the difference between having a light gray "plate tone" or a clear background. Work the polish firmly over the plate, wiping away any excess. It is important to degrease the plate: any amount of grease, even a fingerprint, between the plate and the ground may result in a "foul bite," or accidental etching.

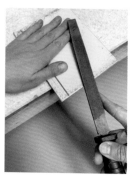

△ **File the edges** of the plate to create a smooth surface. Refine the edges by scraping and burnishing.

△ **To degrease**, wear PPE and mix diluted ammonia with chalk on the plate to form a paste. Work it in.

Hard-ground etching

Hard ground is a combination of beeswax, bitumen, and resin or "colophony," available as either a liquid or a solid ball. It is melted and rolled over the surface of the plate on a hotplate. If you don't have access to a hotplate, a liquid ground can be applied at this stage or an acrylic ground, such as B.I.G.™ ground, can be rolled onto the plate and baked.

Soot from a flame can be combined with the wax ground by "smoking" the plate, enabling the artist to see the line more easily. The plate should look dark and shiny. If it has been oversmoked, it will be opaque and the ground will come away slightly when touched, revealing pinpoint holes. If this happens, return the plate to the hotplate, carefully remove the wax with a clean rag, and reroll the ground.

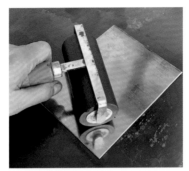

◁ **Heat the hotplate** to 176°F (80°C) to melt a little hard-ground wax onto your plate. Roll the ground evenly over the plate. It should be a dark honey color.

◁ **To smoke** the plate, hold it face down with a clamp and light a bunch of five or six wax tapers to create a sooty flame that just kisses the plate, softening the ground.

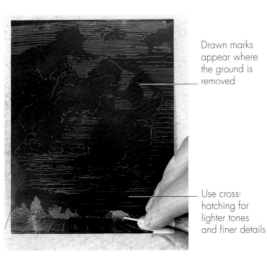

Drawn marks appear where the ground is removed

Use cross-hatching for lighter tones and finer details

△ **Once the plate** is cool, and remembering that the image will print in reverse, start to draw your design into the wax ground with an etching needle.

Drawing your design

Use an etching needle to draw your design in reverse into the wax. Wherever you remove the ground, the plate will be "bitten" when it is submerged in the acid and will corrode to form the grooves that will hold the ink. If you want to build up areas of tone using this process, use hatched or cross-hatched lines instead of removing large areas of ground, as the plate will corrode uniformly, leaving a shallow "open bite" with no "tooth" or roughness to hold the ink.

You need only remove the wax layer and not scratch the plate's surface. This way, if you change your mind and want to reground the plate and start again, you will not have marked it. If, after drawing, there are marks that you would prefer not to bite, cover them with stop-out varnish.

Soft-ground etching

This method uses a soft, waxy ground to create feathered edges and grainy textures by impressing drawn or textured marks through an overlaid sheet of paper. Soft ground is applied in the same way as hard ground (see page 207). Set the hotplate to 122°F (50°C) and roll the soft wax ground into a thin, even, light honey-colored layer.

Drawing on soft ground

When the plate has cooled, the ground remains soft, so avoid touching the surface other than for intentional marks. Impress your marks through paper onto the surface of the plate. The pressure of the pencil transfers the wax off the plate to reveal the plate's surface, which will be bitten by the acid.

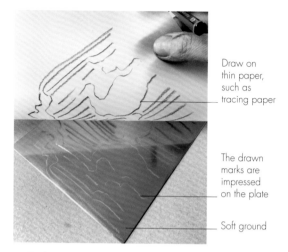

Draw on thin paper, such as tracing paper

The drawn marks are impressed on the plate

Soft ground

△ **To draw on soft ground**, lay a hinged piece of thin paper over the plate. You can lift it to check that your marks are transferring without losing registration.

AQUATINT

This is a tonal etching process whereby a prepared etching plate is placed inside an aquatint box, which creates a cloud of powdered resin, called "Colophony," that settles evenly on the plate. The plate is then heated to melt and adhere the dust to the surface. In the acid bath, the acid corrodes any exposed metal between each dot of resin, causing a rough surface that, when inked and printed, will translate as flat tone. The longer the plate is left to bite, the darker the tone will be. Always wear a dust mask with resin powder.

The Belly Pot (2012) Katherine Jones

Flat tone created using aquatint box

Drypoint lines are scratched into the plate

Lighter tones preserved with stop-out varnish

CONTROLLING TONES

For both soft- and hard-ground etchings, control the tones by covering areas you want to keep lighter before returning to the bath for a set time. Timings vary between acids and metals and should be worked out in advance; do a test piece first. Remove your plate from the acid, rinse, and let it air-dry thoroughly. For soft ground, use a soft lithography crayon or liquid ground to cover the areas you want to keep light. For hard ground, cover any lines you want to remain light with stop-out varnish. Return to the bath. Repeat so that exposed lines bite the deepest, creating the darkest tones.

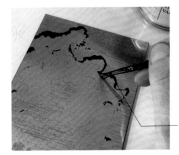

◁ **Stop-out varnish** can be used to protect any areas from the acid, beginning with your highlights.

— Use a soft brush to apply the varnish

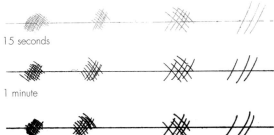

15 seconds

1 minute

6 minutes

▷ **To etch light to dark tones**, space the timings: begin with very short times, then roughly double for subsequent bites.

BITING THE PLATE

Once you have finished drawing, protect the back of your plate by covering it with a layer of varnish or packing tape. Use a longer piece of tape on one edge to hold onto the plate while it is biting.

EQUIPMENT

- Packing tape or varnish
- Acid bath
- Soft feather
- Water bath
- Turpentine
- Clean, dry rag

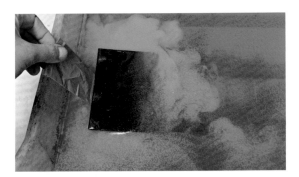

1 Lower the plate into the acid bath and gently remove any sediment or bubbles with a soft feather, as they may block lines and halt the bite.

2 Place in a water bath to stop the process. Remove the ground and any stop-out varnish with turpentine. Dry with a clean rag.

INTAGLIO: MAKING A PRINT

Inking and printing the plate is an exciting stage of the printmaking process when you see your artwork revealed in its final form. Inking the plate is a skilled process that ensures your work prints successfully.

It is advisable to take a "proof" or trial print of the plate after each process has been etched and you have thoroughly cleaned the plate. You'll be able to see how the image is printing and whether it needs adjusting. Choose a paper and ink that is suited to your work; medium-weight paper is generally used for intaglio, with heavier paper for deeply etched designs. Prepare the paper first.

Softening the paper

Soak the paper prior to printing to soften it, while you have clean hands. Do this in a water bath by carefully placing each sheet individually in the bath and leaving until ready. If you don't have a water bath, sponge the sheets liberally with water, wrap them in a plastic sheet, and leave to soak while you ink up. This process normally requires a minimum of 20–30 minutes.

Inking the plate

Squeeze out your etching ink. If it is very stiff, you can soften it by mixing in a little plate oil or by gently warming the plate on the hotplate before wiping. Once you have pushed the ink into the etched grooves using a dabber or strips of cardstock, your subsequent wipes using tarlatan are all about ensuring the ink stays in the lines while wiping away any surface ink. Form the clean piece of tarlatan into a firm, flat-bottomed ball that will pass over the plate but not affect the ink below the surface. Wipe away any remaining ink, then you are ready to print. Always have clean hands when handling paper and press blankets in the final stages.

◁ **Here, a fine, hard-ground** line has been expertly etched using multiple "bites" to create a wide range of tones.
Turning Point (2018) Marcelle Hanselaar

INKING AND PRINTING

To check the pressure of your press before you print, place a blank plate the same thickness as your plate and as wide as possible onto the press, cover with a damp printmaking paper, and run through. If a clear emboss is produced and both sides look even, you are ready to print. If not, adjust the press.

EQUIPMENT

- Etching ink
- Plate oil
- Dabber or squeegee strips (made of offcuts of cardstock or rubber)
- ½yd (0.5m) tarlatan
- Tissue paper and soft cloth
- Water tray or sponge and water
- Printmaking paper
- Press and blankets

Work over the plate with tarlatan, wiping away surface ink

Maintain the ink in the etched lines

1 Using a squeegee strip or piece of rigid cardstock, pick up a good amount of ink and apply to the plate, pulling a layer of ink all over in all directions.

2 Form the tarlatan into a soft pad and use it to push the ink firmly into the grooves on the plate. Continue wiping, removing surface ink.

Printed etching plate

Embossed edge

3 Use a firm, flat hand and a piece of tissue to remove any remaining ink. Clean any ink from the back and edges with a soft cloth, if necessary.

4 Place a piece of tissue on the press and drop your plate, face up, onto it, avoiding finger marks. Place damp printmaking paper over the plate.

5 Smooth the blankets and slowly turn the press wheel, and, once the plate and paper are through, your print will be complete.

MONOPRINTS

The term "monoprint" refers to any form of print that is a one-off or not editionable, in contrast to methods of relief or intaglio printmaking where multiple copies are printed.

This is the most spontaneous form of printmaking and incorporates many techniques that range from immediate and simple marks to highly complex, multilayered prints.

Indirect drawing

An indirect drawing or monoprint can be made with a few basic materials. By drawing or making marks onto paper laid over an inked base, you can produce one-off pieces that encompass a range of tones and soft and hard lines. The image will be transferred in reverse when you peel the paper back. It is a very good way to begin new projects or to get out of a rut, as it takes away a certain amount of control; the images can be made quickly and the surprises often generate new ideas.

Screen printing

A monoprint can also be made using a silkscreen. The design is quickly painted directly onto a screen using a brush and a liberal amount of screen-printing ink, then a squeegee is used to force the paint through the mesh before it dries. This printing method generates a painterly print that retains some of the bright, flat tones and graphic quality of a traditional screen print.

WATERCOLOR MONOPRINTS

This technique enables you to print using watercolor and water-soluble pastels or crayons. The paint is applied directly to a plate that has been degreased and sanded with very fine sandpaper. The slightly textured surface holds the paint in place. When finished, the watercolor is left to dry completely and then placed face up on the press with a piece of presoaked and blotted paper on top and rolled through. The watercolor will rehydrate against the damp paper when forced through the press and the image should transfer faithfully.

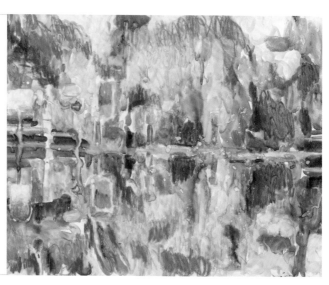

Green and Orange IV (2014) Tamsin Relly

MAKING AN INDIRECT DRAWING

This is a quick and immediate method of producing a one-off monoprint without a press. Ink can be rolled onto the surface and refreshed indefinitely to create a series of unique images on thin paper.

EQUIPMENT

- Ink roller
- Printmaking ink or oil paint
- Tape
- Glass or ceramic tile
- Paper
- Pencil

1 Use a roller to apply a small amount of stiff printmaking ink or oil paint very thinly onto a piece of glass or ceramic tile.

2 Tape a thin, dry sheet of paper on top and draw onto the back of the sheet. Remember, wherever you apply pressure will result in a tone.

3 When finished, lift the sheet. Your drawing will be mirrored on the reverse, often embellished with surprising tones and incidental marks.

MAKING A PLATE MONOPRINT

These prints are made using a rigid clear acrylic or metal plate thin enough to pass through an etching press, which can either be rolled or painted onto with a thin layer of ink. The ink is manipulated by removing it or adding to it using a rag or brush to produce a range of tonal, soft marks that are unique to this form of image making.

EQUIPMENT

- Clear acrylic or metal plate
- Printmaking ink and roller
- Clean rag
- Presoaked paper
- Press

1 Roll a thin layer of printmaking ink over the plate surface. Rub away the ink with a rag to draw your image.

2 Place the plate face up on the press with a piece of damp paper over the top and roll it through the press.

3 In the finished image, the smudged marks made by the rag contrast with darker marks painted prior to printing.

COLLAGRAPH

This method uses nonspecialist materials to create the printmaking surface, or matrix, using a range of textures that hold various shades of line or tone when inked and printed either as an intaglio or a relief print.

If using the intaglio method for printing, the more texture the collagraph plate has, the more ink it will hold and the darker the tone. The smoother the surface, the lighter the tone. Texture is often added by using carborundum grit (a fine, hard sand) mixed with wood glue or varnish. To print collagraphs in relief, roll a layer of ink over the surface.

◁ **In this two-plate collagraph**, areas of heavy, soft tone contrast with flat, hard-edged relief print.
Birds, Layered Sound and Aeroplane Noise (2018) Katherine Jones

MAKING THE PRINT

Use a plate that is thin enough to pass through an etching press. Add texture to create dark tones: use carborundum grit, handmade paper, or fabric. For lighter tones, make the surface smooth with wood glue or paint. You can also score the plate with a drypoint tool or add soft objects such as feathers.

△ **Add carborundum grit** to applied lines of glue or varnish to make dark areas that hold ink.

△ **Once dry**, ink the plate directly with loosened etching ink in the same way as an etching (see page 211).

△ **The pressure of the press** transfers the ink from the plate to dampened paper to create an impression.

RELIEF: WOODCUTS

Relief printing involves cutting away areas of a plate or block and rolling ink over the remaining surface to take a print. Japanese woodcut is the oldest form of relief printing, but there are many forms of this fine craft.

Originating in China in 220 CE, woodblock printing was first used for textiles. The image is carved out following the grain of the wood, leaving a raised design which is then inked and pressed onto paper using a relief printing press. Alternatively, paper is placed on the block and burnished with a Japanese tool (a baren) or wooden spoon to transfer the ink.

◁ **In this Japanese-style woodcut**, the wood grain enhances the light, fluid washes of ink.
Asemic Writing (2020) Carol Wilhide Justin

JAPANESE-STYLE WOODCUT

In contrast to European-style woodcuts that are inked with a roller, Japanese woodcuts use fluid ink or watercolor applied separately with brushes. Take your time and always cut away from your hands. Use an antislip mat or bench hook under the block while cutting to give more stability.

△ **Cut using a hangito tool**, first one way and then in the opposite direction, to make a trough around the shape.

△ **Apply diluted rice paste** to the damp block before brushing with color. Place paper on top and burnish.

△ **Reveal the ink** carefully. The light layer of ink will transfer a little of the wood grain pattern, too.

RELIEF: LINOCUTS

In this relief printing method, the image is cut from a linoleum block. It is a versatile print medium used by artists, graphic designers, and illustrators to print onto a variety of materials from paper to fabric.

After the invention of linoleum floor covering in the 19th century, the material soon found its way into artists' studios as an alternative to woodblock printing. Linocuts, or lino prints, were adopted by artists such as Henri Gaudier-Brzeska and Picasso in the early 20th century, becoming the primary material of artists such as Edward Bawden and the avant-garde printmakers of the Grosvenor School by the mid-20th century.

Lino comes in various forms. Traditional linoleum is backed with burlap and tends to be fairly hard to cut, but it can be softened by gently warming on a hotplate. Japanese relief printing vinyl is a double-sided, softer version of a lino block and tends to be easier to use. There is also a softer version known as "softcut," which enables easier cutting but is slightly more rubbery.

Cutting the design

Lino is easier to cut than wood and can be carved in any direction rather than following the grain. Use linocutting tools; large and small, V- and U-shaped gouges are the most useful. Make fairly shallow cuts, always holding the linoleum block with one hand and carving away from you with the other—never cut toward you, as you may slip.

USING SEVERAL COLORS

As you gain confidence, try using more than one color by only cutting the highlights for the first cut; inking and printing several copies in a light tone; then, using the same block, cutting the rest of the design and printing over the first color with a darker tone. This is called reduction linocut and can be made in as many stages with as many colors as you like. For a good print, wait for the layers of ink to dry before printing on top, checking registration is aligned.

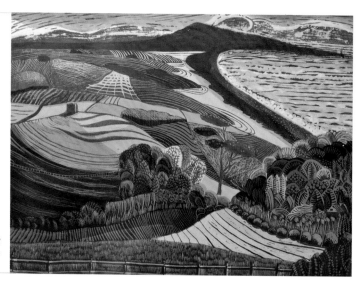

The Chapel on the Hill, version 18
(2018) Liz Somerville

MAKING A LINOCUT

You can either transfer your design with carbon paper or draw directly onto the lino. Remember the eventual print will be in reverse; make sure any writing is mirrored on the block. You can make registration marks from offcuts of lino or card of an equivalent thickness to help you align your lino block and paper before printing.

EQUIPMENT

- Pencil
- Lino or vinyl
- Chalk
- Masking tape
- Linocutting tools: V- and U-shaped gouges
- Roller
- Stiff relief printmaking ink
- Inking surface
- Smooth paper for printing
- Baren, wooden spoon, or relief-print press

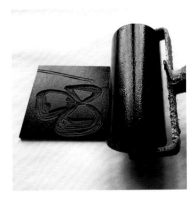

1 Draw your reversed image before you commit to carving. Shade in areas that are to be retained and which will hold the ink when printed.

2 To transfer the image, rub the back of the drawing with chalk, tape it on top of the block, and firmly go over the drawing again.

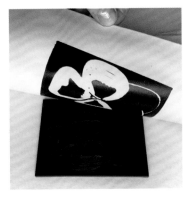

3 Concentrate on any edges or lines with the small V tool to begin. Cut away larger areas with the U-shaped tool. You can use a craft knife on vinyl.

4 Roll a very small amount of ink very thinly until there is an even layer all over your roller. Transfer the ink to the surface of your block.

5 Once inked, place your linocut into your registration marks and position a dry sheet of paper on top. Either burnish the paper or use a press.

6 On the finished print, the ink is transferred from the raised areas of the block. Light uncut marks add texture to recessed areas of the design.

LITHOGRAPHY

Lithography is a planographic, or flat, printmaking process based on the principle that oil and water don't mix. It is a direct way of printing graphic marks, from fine drawn tonal gradation to delicate washes.

TRADITIONAL LITHOGRAPHY

Invented in 1798 by Alois Senefelder in Bavaria for reproducing manuscripts, lithography was soon used by artists who were captivated by its capacity to reproduce marks close to original pencil or charcoal drawings. Traditionally, limestone, aluminum, or zinc plates are used, while the more recent Japanese invention, mokulito, uses plywood (see page 220).

Images are drawn using a greasy medium, such as tusche, then a gum arabic and nitric acid solution is applied to etch and protect the nonimage areas. To print, the plate is dampened with water and an oil-based ink is rolled over the surface.

△ **A range of tones** can be achieved by applying tusche washes and drawing fine details with lithographic pencils and crayons.
Quadern de Pedra 4 (2019) Danielle Creenaune

DIFFERENT EFFECTS

You can employ drawing and painting techniques when using lithographic media to create painterly effects that range from washes to shading.

◁ **Tusche mixed** with distilled water at varying strengths creates reticulated washes that are loose and fluid.

◁ **Graphic tonal** effects can be achieved using lithographic crayons in different ways similar to drawing.

◁ **Spray painted** effects can be achieved with a toothbrush or fine spray bottle containing tusche.

MAKING A LITHOGRAPHIC PRINT

Prepare the stone or plate by hand or use a preprepared plate. Draw directly with a selection of lithographic drawing materials before etching with a gum arabic/acid mix. Etch the stone at least twice to fix the image. To reuse the stone, you can grain the surface again to remove the image after printing.

EQUIPMENT

- Limestone or ball-grained aluminum plate
- Levigator
- Carborundum grit
- Lithographic crayons
- Tusche
- Rosin powder
- Talcum powder
- Gum arabic
- Nitric acid
- Muslin cloth
- White spirit
- Asphaltum
- Lithography inking roller
- Lithography ink
- Smooth printmaking paper
- Mylar® tympan sheet
- Direct lithography press

Rotate the levigator in a regular pattern

Add a border of gum arabic

1 Prepare the stone by hand using a levigator, water, and carborundum grit. Work in a circular motion to grain the stone. Aluminum ball-grained plates are sold ready prepared.

2 Draw your image directly onto the stone surface using lithographic crayons and tusche. Try to avoid touching the surface with bare hands, as you may leave finger marks.

The printed image

3 Dust the image with rosin and talc and apply a layer of gum arabic mixed with a few drops of nitric acid to around pH 3. Buff the surface with muslin and leave to dry for 1 hour.

4 Wash out the image with white spirit and rub in a thin layer of asphaltum. Keep the surface damp and roll up with ink. Once inked, leave the surface to dry and repeat step 3.

5 Wash the image out again following step 4. Keep the surface damp and roll up using lithography ink. Place paper on top, add Mylar® sheet, and run through the press.

MOKULITO

Mokulito is a form of printmaking based on the principles of lithography, but using plywood as the printing surface instead of limestone. The same lithographic principle that oil and water don't mix applies.

Mokulito is a relatively new form of lithography developed by Professor Seishi Ozaku in Japan in the 1970s, under the original name Mokurito.

Instead of stone, birch, maple, or marine-grade plywood is drawn on with drawing materials such as lithographic ink, or tusche, and paint markers. A thin layer of gum arabic is applied to protect the nonimage areas and left to dry. The gum arabic is washed off before printing and the plate can be printed immediately in a similar way to traditional lithography (see page 218). A unique characteristic of mokulito is that it creates a natural wood texture with each impression, producing slight variations within the edition.

◁ **Variations of texture** and tone are achieved in this mokulito print using tonal washes to accentuate the wood grain.
Blue Falls I (2021)
Danielle Creenaune

Undiluted liquid tusche creates the darkest tones

WOOD EFFECTS

Working with the wood grain leads to expressive marks, whether overlaying with a light wash, following lines in graphic strokes, or changing the surface texture.

◁ **Apply light tusche washes** to accentuate the wood grain, incorporating the patterns into your composition.

◁ **Use permanent paint markers** to add bold graphic marks or draw along the grain following the natural pattern.

◁ **Add gouged marks** with woodcutting tools to create sharp, contrasting linear effects.

MOKULITO PRINTMAKING

Variations in wood grain will offer different visual effects when using this method of lithography, so bear this in mind when drawing, as they will be part of the overall image and may guide your work as it progresses.

EQUIPMENT

- ¼in (4–6mm) birch, maple, or marine-grade plywood
- Fine sandpaper and dry cloth
- Tusche or permanent paint markers
- Talcum powder
- Gum arabic
- Sponge
- Foam paint roller or relief roller
- Lithography ink
- Smooth printmaking paper
- Etching press

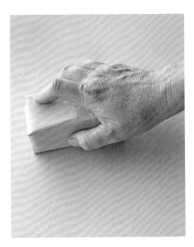

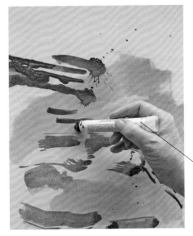

Start with a simple bold line image

1 Prepare the wooden plate surface by sanding it with fine sandpaper, then wipe away the dust with a clean, dry cloth to leave a smooth surface.

2 Draw your image onto the plate with paint markers or paint using tusche. Leave to dry fully.

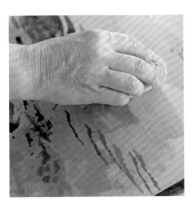

Foam paint rollers work well for rolling up mokulito plates

If your image darkens quickly, apply lots of water to wash off scum

3 Dust with talc and apply a thin layer of gum arabic with a sponge to the whole surface. Leave overnight or longer to dry fully.

4 Wash off the gum, keep the plate damp, and start rolling up the plate with lithography ink, ensuring that all drawn marks are covered.

5 Place paper on top of the inked plate and run through the press. Re-ink for each impression. The wood grain becomes more visible in each edition.

SCREEN PRINTING

This printmaking technique involves applying and then pressing ink or paint through a stenciled mesh screen to transfer the image onto the surface beneath, usually paper or fabric.

Traditionally, screens were made of silk; today, they are usually synthetic and come with different mesh "counts" for different printing needs. A mesh count is defined by the number of threads per inch (or per centimeter in the UK). The higher the thread count (T), the finer the mesh. For paper, it's best to use a 90T mesh; fabric requires more ink, so a 43T mesh is ideal, which allows more ink to be pushed through.

Inks, paints, and stencils

You can use premixed screen-printing ink or acrylic mixed one part paint to one part print medium. The medium stops paint from drying quickly and makes colors translucent. Stencils can be made from various materials. You can also draw on a screen with screen-drawing fluid or create a stencil using light-sensitive photo emulsion (see right).

USING A PAPER STENCIL

Ideally, make your stencil with newsprint, as it is thin and strong, so it gives a sharper image. You will need to keep the screen still either by putting weights on the corners of the frame or asking someone to hold the screen. You can also buy specialized screen-printing beds or tables.

EQUIPMENT

- Paper
- Screen
- Masking tape
- Weight(s)
- Squeegee
- Premixed screen-printing ink
- Paper (or fabric)

1 Place the stencil over paper or fabric. Position the screen over the stencil, using tape to mark its position.

Use a squeegee wider than the stencil

2 Secure the frame with a weight. Place ink at the top of the screen. Pull it down firmly with a squeegee.

Registration marks

3 Gently lift the screen. Use the registration marks to reposition the paper and screen for subsequent layers.

CREATING A PHOTOGRAPHIC STENCIL

You can create a stencil by exposing an artwork directly onto a screen prepared with light-sensitive photo emulsion. Your artwork needs to be black and white—any gray will let light through. Try making marks using India ink or black pens on tracing paper. Experiment by mixing graphic and painterly marks.

EQUIPMENT

- Screen
- Photo emulsion
- Coating trough
- Squeegee
- UV light source (bulb or exposure unit)
- Packing tape

Stop just before the top of the screen

1 Place a clean, dry, standard screen-printing screen against a wall, flat side facing out, and fill up a coating trough with photo emulsion.

2 Hold the trough at the bottom of the screen and tilt it until the emulsion rolls down and is touching the screen. Pull the trough up in one confident stroke.

3 Dry the screen in a dark place or in an area with a "safe light" bulb, as it is now light-sensitive, until the photo emulsion is touch dry.

Exposure unit

4 Once dry, expose the screen. Secure your artwork to the front of the screen, facing toward the UV light source (a bulb or exposure unit).

5 After exposure to UV light, wash the whole screen. On areas of black artwork, the emulsion will wash off and the image will appear.

Packing tape

6 When the screen is dry, put packing tape around the edge so that the ink only goes through the image. You are now ready to screen print your artwork.

DIGITAL ART PRINTS

Advances in digital technology mean that digital images can be printed at a much higher standard. Using quality inks and paper and working with high-resolution images ensures that professional prints will last.

Any desktop printer can produce an image generated from a digital file. The difference between a digital artwork and an everyday print depends on whether the artist conceived of the work in digital form. Digital printmaking reflects the impact of computing on printmaking, from the manipulation of an image using software to controlling the ink applied by a printer.

Giclée prints

High-quality artworks can now be printed using inkjet printers. These prints are called "giclée," from the French "to spray," as the ink is sprayed onto the paper and bonded using a fluid fusing agent or heat. There are several factors that can differentiate a giclée print from a standard print, the quality and lightfastness of the ink being the most significant.

Instead of dye, quality pigment inks are used for digital prints. These are fade-resistant, and the printer should ideally have at least eight different colors instead of the four used in the CMYK process (see page 247).

◁ **This giclée print** was printed onto 140lb (300gsm) Hahnemühle paper to give it a matte, watercolorlike finish.
Half Empty Half Full (2013) Tansy Spinks

The resolution of the printer (dots per inch) is also important. The higher the resolution of the image, the better the quality. When printing your own files, it is vital to carefully consider the scale of the final image, file format, and printer settings. Depending on the available software and hardware, the options you select can have a significant impact on the quality of your digital print (see pages 244–247).

In order for the print to have longevity, the paper it is printed on must be of archival quality. Different papers—matte, gloss, watercolor, handmade, or textured—can be used (see page 48).

Cost considerations

Digital art prints are relatively expensive. The materials involved require an initial outlay that exceeds that of standard printing. However, there are advantages to printing digitally and to owning a wide-format printer that is set up to print giclée works: you can print your pieces individually on demand, taking control over any color correction.

△ **A small inkjet edition** of 15 prints was made of this sublime interior space, initially made as a digital study for a photorealistic painting that was subsequently created. *Unseen Space* (2005) Ben Johnson

Digital C-type prints

A digital image created or processed by a computer can be exposed onto light-sensitive photographic paper and affixed with chemicals to produce a printed photograph, known as a C-type print. The image can be made from a digital file rather than a traditional film negative, and the exposure is controlled from the computer. These prints exhibit continuous tone.

◁ **Large inkjet printers** at professional print workshops may offer a bespoke service to artists who aren't able to print for themselves.

PHOTOGRAPHY AND FILMING

Photography and filming are dynamic, multidisciplinary art forms that can involve recording memories or providing an archive of the everyday. Equally, they can be fantastical and escapist or site-specific and experimental, encompassing photomontage, compositional or digital effects, and immersive experiences.

PHOTOGRAPHY: KEY ELEMENTS

For photographs, there are a few key elements that will help you take an image that holds the viewer's attention—from choosing subject matter and composing a shot to utilizing your camera settings.

Recently, photography has become a key visual element in other types of art, such as installation and site-specific practice, and is widely used on all social media platforms and commercial websites. Every photograph you take is influenced by your choice of subject matter and its composition, and as you become more confident, you will develop your own distinctive style and way of working.

Subject matter

As with many other art forms, photography is split into three major types or genres: people, places, and objects. Your choice of subject matter is the first decision to be made. The choices are limitless, and therefore some time spent considering what to photograph and how to photograph the subject is vital; images should be '"about" something and not just "of" something. Explore and research these subjects, studying the way in which others have treated similar themes (see page 18).

Developing ideas

Keep a sketchbook in which you make notes and add examples of images that have a powerful effect on you (see page 22). It is a useful habit and a key part of the artistic decision-making process.

△ **People can feature** in many ways in your photographs, from intimate portraits to modeling or street photography and reportage.

△ **Places provide infinite** subject matter and inspiration, from landscapes to cityscapes, outdoor settings to indoor spaces.

△ **You can use objects** in similar ways to still life paintings, or as a focal point in your composition, making use of shape and color.

COMPOSITION

How the various elements in an image are arranged within the frame will enhance the subject matter and influence the viewer. There are a number of compositional techniques to choose from.

Center frame

Filling the frame with your subject is a powerful and positive method of drawing the viewer's attention to exactly the theme or subject you want them to consider. Beware of zooming in too closely on your subject, as you will lose the defining negative space. Shoot various angles and positions; you can choose the composition you prefer later.

Subject fills the frame

Close-up crop

Rule of thirds

In its simplest description, the rule of thirds divides the image into thirds—both horizontally and vertically—to create nine equal squares, and intersections within the frame where you can place focal points. Some cameras have the option to turn this grid on or to provide other guidelines.

Compositional grid

Keep it simple and declutter

When considering the subject matter, think about the necessity of the composition and what it is possible to leave out of the frame. The reduced composition does not make it any less powerful as a photograph. By decluttering for a product shot or portrait, you ensure that you draw attention to the subject matter.

Simplified composition

Frame within a frame

A compositional device that is often used in landscapes but can be applied to any subject is to use an existing feature as a natural "frame" for the focus of the photograph. Sweeping branches, the span of a bridge, or a train window can all be employed in this way to create pleasing images.

Landscape framed in arches

Leading lines to direct the eye

The success of an image often relies on guiding the viewer to a point of interest, and you can control this by including leading lines in your composition: vertical, horizontal, or diagonal. These can be literal guides, such as a road or pathway, or more subtle lines that all converge at the focal point.

Diagonal leading line

Depth of field

It is possible to control the amount of the subject that is in focus by using depth of field. This setting controls the amount of light entering the camera, so you can choose between the foreground subject being sharp with a blurred background by using a small aperture with less light, or a wider depth of field with more light for landscapes where the whole image is in focus.

Subject with shallow depth of field

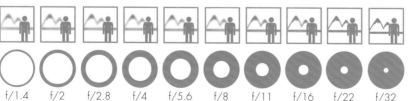

f/1.4 f/2 f/2.8 f/4 f/5.6 f/8 f/11 f/16 f/22 f/32

◁ **Aperture settings** range from f/1.4 to f/32 or higher, with "f-stops" in between, which affect the transition between the sharpness of the foreground and background.

Shutter speed

This is the action of the camera shutter, which is closed but allows light into the camera for more or less time when the shutter button is pressed. Shutter speed is vital in determining the type of image you create; by varying exposure time, fast-moving objects can be frozen in motion with fast shutter speeds of 1/4000 of a second. At slow shutter speeds of a minute or more, a moving object is blurred along the direction of motion. A tripod is required to hold the camera steady.

Slow shutter speed blurs moving water

More light to sensor; "silky" water effect; night shots

Less light reaches sensor; sharper shots

1 1/8 1/15 1/30 1/60 1/125 1/250 1/500 1/1000 1/2000 1/4000

◁ **Shutter speed** controls exposure time, from 1 minute to 1/4000 of a second.

ISO

This denotes the light sensitivity of the camera sensor (digital) or film (analog). It can be used to perfect images where using an f-stop and shutter speed aren't enough. By increasing the ISO number, you will be able to take images in low-light environments or to capture images in motion. The higher the ISO number, the grainier the image.

ISO 100 ISO 3200

Best-quality photos, daytime

Best for night or low light

100 200 400 800 1600 3200

◁ **Starting at 100**, each stop halves the amount of light gathered by the sensor or film.

PHOTOMONTAGE

**Photomontage uses two or more photographs to create a new image.
Original and "found" photographs, as well as printed or handwritten texts,
are cut, arranged, overlapped, and put together in provocative combinations.**

Photomontage came to prominence with the
Dadaists as a form of political protest during
World War I and was later adopted by the
Surrealists to show dreams, nightmares, and the
unconscious mind, while Pop artists from the 1960s
onward used it to draw attention to the process
of mass consumption.

"Cut and paste" montage is a simple process
that traditionally used scissors and glue to create a
composite image. It had a deliberate "do-it-yourself"
feel and was visually crude, often leaving torn,

ripped, and shredded edges in the final image in
order to draw attention to the process used.
Modern artists still employ this method, and further
additions of drawing, text, paint, or other mixed
media may be used to cover up or draw attention to
aspects of the image (see page 158). Once finished,
the montage can then either be rephotographed or
photocopied in color or black and white. Three-
dimensional objects may also be added as long as
they can be rendered effectively by the photocopier
or photographed to create a flat image.

◁ **Installed** on the floor of Union Street Station,
Washington, DC, in 2020, this 110y² (92m²)
photomontage marked the centenary of the 19th
amendment, giving women the right to vote.
Ida B. Wells (2020) Helen Marshall and University
of Chicago Library

Small photographs and
texts make up the image

Early use of negatives

Photography from its inception has regularly used more than one negative and image in landscape pictures to add a favorite sky to a particular scene, for example. In such instances, the artist would blend the two images seamlessly to obtain a smoother aesthetic. Surrealist artists, such as Man Ray, took this one step further, often using double exposure and overexposure of a negative to light or placing objects onto photo-sensitive paper to create visually disturbing photomontages.

▷ **Double or multiple exposure** works well with black and white photographs. The photographer simply takes another shot (or several) without winding the analog film on to the next frame.
Untitled (1924) El Lissitzky

USING DIGITAL TOOLS

As with the analog method of photomontage, cut-and-paste techniques in computer software make the blending of images seamless and may also be used to create strange but natural-looking images that disrupt our relationship with the real (see page 254). By combining images digitally, the digital montage produces an unnaturally finished image that appears to be real or like our expectation, a photograph, but in impossible combinations. These elements stimulate interpretation.

◁ **Searching for intrinsic beauty.** In this digital photomontage, the artist translates the forces of nature, in this case flowers, into human form.
Die Blume (2019) Antonio Mora

233

FILMING: KEY ELEMENTS

Film is an art form that artists use both to make art and to document their practice. To bring images and sound together often requires a cast of people and a range of skills both behind and in front of the camera.

Before starting to roll the camera, plan how your concept will translate to moving images. Careful planning ensures a smooth shoot and involves coordinating many elements. In addition to equipment, you may need to organize props, costumes, hair and makeup, transportation, sets, locations, and catering.

Developing ideas

The next stage is to develop the concept further using visuals such as a storyboard (see page 236) alongside any dialogue and designs for sets and costumes. Working from a storyboard helps

plan timings, the equipment you need, which actors are required, the location, and the need for any additional effects. Rough sketches for set designs visualize a setting and pinpoint any construction needed or props required before the shoot.

Working with a script

Apart from when characters are required to ad-lib, all dialogue needs to be carefully scripted in a screenplay. The dialogue of a screenplay may sound different when spoken, and it is useful to hear it out loud in rehearsals and make changes as different rhythms and timings are explored.

◁ **Hand-drawn sketches** of a set design (left) are developed in collaboration with the director to bring to life the setting for each scene (below).
Doc Martin Surf Shack (2019) Anthony Ainsworth

Cinematography

A director's approach to filming is what defines the style and genre of the film. In order to bring this vision to the screen, the director will set up shots in a particular way, often using several cameras.

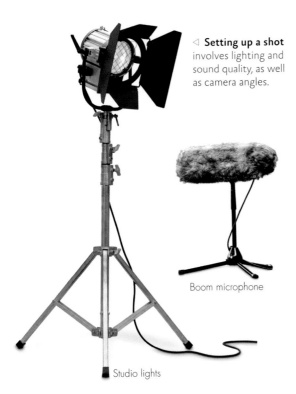

◁ **Setting up a shot** involves lighting and sound quality, as well as camera angles.

Boom microphone

Studio lights

CONSIDER YOUR AUDIENCE

Artists often use film to challenge traditional audience participation. In installations, for example, the audience may view the film in a dark space or with virtual reality headsets for a totally immersive experience. Alternatively, film can be used to capture events as they happen, or become part of live or performance art (see page 284).

The Airport (2016) John Akomfrah

Sound and vision

A musical score is a composed piece of music that is either written or adapted for a film. The score can often be as memorable as the film, and there are some unforgettable musical moments in films, such as the low, rhythmic strings in *Jaws*.

Making the cut

There are thousands of reasons why films are shot out of sequence and not in a linear order. These can be as simple as availability of actors or locations, the weather, and lighting. In essence, editing puts the footage in the correct sequence, using cuts and effects to add to the storytelling. Software programs make this a straightforward task, but editing is still a creative part of the process that requires the director's input and vision.

▷ **The screeching**, percussive strings in the shower scene of *Psycho* help build tension and create terror.

PREPRODUCTION

Planning each scene, frame by frame, is an essential part of the filming process to help with the development of the story and characters and to iron out any creative issues prior to shooting.

Before committing time and money to filming, it pays to plan every aspect of your film carefully; there is rarely time to "create" on the set—usually just "execute." Take the opportunity to try out ideas and review the production issues. There are many variables when shooting the film, so brainstorm and research every aspect in detail beforehand, using plans and animatics to finalize details and timings.

Storyboards

A storyboard is a sequence of hand-drawn sketches or visual images that are supported by script notes or dialogue and placed in a sequence. Each individual frame in a storyboard represents a type of camera shot, angle, action, or special effect, where the pace and timings of shots and the duration of the sequences can be measured. Add notes for camera angles and whether the camera is static or tracked, hand-held or steadycam, so you know what equipment is required.

The storyboard helps the filmmaker visualize each frame before production, testing the script or concept. It directly connects the imaginative process (the drawings) and the mechanical processes of the camera (the border around the drawings). Storyboards are useful in disseminating ideas and information and ensuring that the crew and production team are all on the same page.

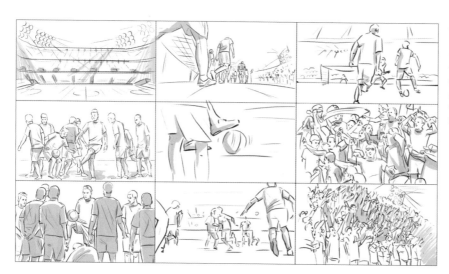

◁ **A storyboard** can be shown in different formats. Premade templates with panels or "frames" can be downloaded and filled with hand-drawn images or photos.

Planning and logistics

In addition to the visual process, some films require sound and dialogue input. Planning a script alongside the storyboard will entail script writers, and you will need to make a dialogue plan that corresponds with the storyboard. Locations, costumes, props, actors, or interviewees will all need to be organized and coordinated before filming.

Animatics

The next stage is to create an animatic where you cut and paste the storyboards together into a basic animation. You can do this manually by filming each drawing, or create it digitally with specialist animatic software such as Boords. You can add subtitles and vary the frame lengths to give pace to each scene, with the option to add audio or a soundtrack. This reveals a clear narrative and the tempo and cadence of the film and is a way to edit the film before you have shot it. This means that everyone involved knows their role and what is expected at this early stage of production.

CHARACTER PROFILES

Keep a simple record of each character to ensure continuity in appearance and note their backstory and how the character develops through the film.

- **Name and personal details:** Age, gender, ethnicity, hair, height, weight, accent, costume and styles

- **Relationships:** Marital status, children, parents, siblings, friends, work acquaintances

- **Character:** Strengths or weaknesses, secrets, dreams

▷ **Use an animatic** to assess every aspect of a film or animation before filming or finalizing content. *The Witch's Mask* (2017) Laura N-Tamara

FILMING TECHNIQUES

Whether you are making a single shot art film or a complex movie, shooting translates your preproduction concepts and plans into reality. How you compose, frame, and shoot the film adds to its artistic integrity.

Setting up

Before the shoot, ensure that you have all the necessary equipment, with spare batteries or memory cards. Use the storyboard to plan the type of shot and equipment required, such as a hand-held camera for tracking or a tripod for an establishing shot.

Plan the shoot carefully, following a timetable and using running times for each sequence as a guide. The running times give the time required to deliver the words in the screenplay and include any movements, actions, and expressions.

Composing a shot

Different shots used in filmmaking describe how you frame your subject within the camera. You can vary the distance to establish a setting or focus in on an expression or action and change camera

◁ **Establishing shots** set up the context, often as an overview.

◁ **A long or wide shot** shows the whole view of a character.

◁ **A medium shot** focuses in closer, with the figure filling the frame.

◁ **In a close-up**, the subject fills the screen, sometimes entirely.

ONE-TAKE APPROACH

Many art films use a single shot and a one-take approach to filmmaking, where the film lasts for the length of the recording. In these cases, when shooting an art film, you will be "shooting to edit" and will have in-camera continuity and narrative pace. Real time recording is made in a similar way, where one-shot smartphone or drone recordings of an event are uploaded directly to social media.

angles to shift viewpoints. The main shots break down into long, medium, and close-up. Unconventional angles, extreme close-ups, and aerial shots are just a few of the options available to the director and cinematographer when it comes to using the camera to convey an emotion or progress the narrative.

How you frame your subject can also be used to great effect in terms of storytelling. Consider symmetrical framing, used by directors such as Wes Anderson, or how partially obscuring a character can create the tension of being observed, which is a technique often used in the horror genre.

Continuity is the practice of ensuring that details and narrative are consistent from shot to shot in the logical order of the film. This order can be restored in the editing process (see pages 240–241). It is important to watch the continuity in terms of lighting, color, and frame content when filming to make this process easier.

Recording sound

A straightforward way to record dialogue is to use built-in camera microphones. However, sound quality may be poor and you may need to consider off-camera microphones such as a shotgun microphone, which is highly directional. Try to avoid excessive external noise, unbalanced levels, and unwanted sound, which is hard to edit.

◁ **A clapper** or slate board is used to synchronize audio and video recordings.

EDITING FILM

After shooting, editing is the process of assessing all the options and working with the director to find the best version of the narrative—directing attention using images, dialogue, and the soundtrack.

During the editing process, you are not only reestablishing the linear sequence of the film, but also having a creative input that directs attention to the drama. The selection of shots should help realize the most effective version of each scene, assessing how it contributes to the overall arc of the narrative. Consider sound effects and a soundtrack, working alongside the dialogue and visuals as a whole. Editing is also the stage where the final pass is given on the script.

Using the right edits and adding sound

Edit your footage using film-editing software. There are many techniques that can be employed in the editing suite to enhance the filmic effect (see below and box, opposite).

A soundtrack is an audio recording created separately from the images but by design integrated into the viewing experience. It comprises various sounds that include the dialogue, ambient sound, sound effects, and music on separate tracks that

△ **Fade in or fade out** signals the beginning or end of a scene, where the image is faded up from black or neutral to reveal the shot.

△ **Cross dissolve** is a simple transition where images simply fade into one another. As the first clip is fading out, getting lighter, the second clip starts fading in.

are mixed together to create the composite track. The soundtrack is integral to making memorable film sequences by setting the tone and mood, heightening tension, or creating an emotional response in the audience.

On a technical level, it is important to edit sound to ensure levels are balanced and any unwanted sounds or external noise are removed. Dialogue should be clear and synchronized with the video. This is where sound effects are also added. Software programs are available that enable you to cut, copy, paste, delete, insert, trim, and amplify sound in order to edit audio tracks and then export them to interface with video content.

Always check whether the music or sound effect that you are using is royalty free, or clear copyright permission for its use if your film will be viewed by anyone else but yourself.

JARGON BUSTER

- **Continuity error** Where visual or sound elements don't match across shots—for example, a character is wearing a tie in one shot but not in the next.
- **Cross cutting** Involves cutting rapidly from one scene to another to show two parallel storylines.
- **Cut** A transition where one shot is instantly followed by another.
- **Dissolve** When one shot gradually transitions to the next.
- **Establishing shot** An overall view separate from the action to set the location of a scene.
- **Eyeline match** A technique that cuts to a subject that is the focus of an on-screen character.
- **J cut** Where audio from a scene is heard before the visual is shown.

Interview

Cutaway

Back to interview

△ **A cutaway** is used when moving from one shot or piece of action to another. It literally "cuts away" from the main scene, for example, to show a moment that's being recounted in a story.

DIGITAL MEDIA

The use of digital technology is now so ubiquitous that artists often don't even consider that they are working digitally. It's just another set of tools that allows them to create art or convert and manipulate files for many purposes.

WORKING DIGITALLY

Digital tools, in the form of hardware and software, provide artists with many techniques for creating artwork. An existing image can be modified or extended, or work can be originated directly in software.

DIGITAL WORKFLOW

The process of working digitally follows a similar method whether you are digitizing an original artwork or creating directly into an application. The type of software you choose will depend on how the artwork is to be used, displayed, and exported for print, or used in other art media. Software choices offer a huge range of tools and techniques that allow for images to be easily extended in form, color, and material limitations. Your work can be viewed in traditional ways or used to create other art forms, from textile designs to 3D sculptures. Digital technology is now at the heart of an enormous range of manufacturing techniques, too.

△ **The process** of creating this artwork started with converting a pen and ink drawing to vectors for embroidery software.

▷ **The final piece** was machine embroidered in black and gold thread using the digital file created from the drawing.
London Panorama (2017)
Rob Pepper

INITIAL IDEA

As with any act of creation, start by planning and sketching your ideas, ideally on paper, so that you have a strategy to work from. Working digitally allows for infinite change, so it can be easy to lose sight of your original intention.

USING EXISTING MATERIAL

You may have an existing drawing or painting that you intend to use to form the basis of an artwork, in which case the picture will need to be digitized (transformed into pixels) to allow for computer manipulation by scanning it in. Upload photographic material from a digital camera or smartphone.

CREATING NEW MATERIAL

Once the idea for the artwork has been formulated, you can choose to draw or paint directly onto a tablet or computer using digital software and a stylus or drawing tablet. Many famous artists—David Hockney, for instance—work this way.

RASTER IMAGE

Rasters are digital files, made from pixels, which are discrete (separate) blocks of solid color. These can be digital photos, scanned drawings, or pixel drawings made directly into software.

VECTOR IMAGE

Vectors are made from mathematical paths and anchor points. These file types are ideal for logos, diagrams, large-scale artworks, and architectural drawings. Vectors are found in all CAD drawing packages, sound editing, animation, and video-editing software.

EXPORT TO PRINT

Print your work on a desktop printer or send to an external print workshop depending on the scale, quality, and type of print you want. Check color settings are compatible with the printer.

DIGITAL OUTPUT

Artworks intended to be viewed on a screen, website, or projected should be saved in the most compatible color mode for that device, usually RGB.

OTHER USES

There are many uses for digital files: your work could be cut or embossed into cardstock; woven into a carpet; embroidered; cut into metal or plastic; etched into wood, metal, or vinyl; or screen printed onto fabric.

COLOR MODELS: RGB AND CMYK

When you work with digital color, you use constructed models that approximate the color of the world we live in—seen in RGB, the color of light. The model used for print is CMYK, based on four ink colors.

RGB: SCREEN COLOR

White light can be refracted into three base colors: red, green, and blue light, known as RGB. This is the color seen on any screen, projector, or multimedia device and is also how we see the world around us. RGB colors are bright and vibrant, and more colors can be displayed on any light-emitting or projecting device than can be mixed in traditional drawing and painting media or printed. If millions of bright, vibrant colors are crucial for your artwork, you should consider a light-based medium for your work's final form.

COLOR SETTINGS

On screen, your work is always in RGB. However, the color profiles in your software program allow you to set up your file for different outputs.

- **RGB**—For images that will only be viewed on screen, for example, on websites or social media; the images remain the same on any screen. Most software programs are set up to RGB as a default. An RGB file can be converted to CMYK settings to match the output device.

- **CMYK**—Use CMYK settings from the start if your work is going to be commercially printed.

- **HEX**—A combination of numbers and letters that define RGB colors for websites (as code for HTML).

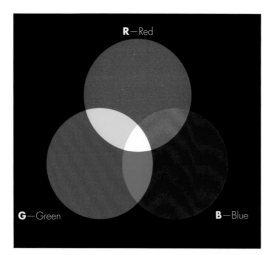

△ **In RGB color**, where colors overlap, they get increasingly brighter. Imagine two lights shining on a wall; where the lights overlap, they get twice as light, so when all three overlap, you get white.

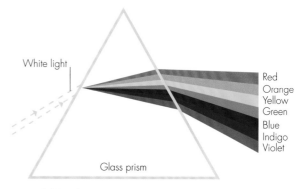

△ **RGB colors** are revealed when white light is refracted through a prism. The three colors can then be recombined to create millions of hues in between, and where they totally overlap, they remake white light.

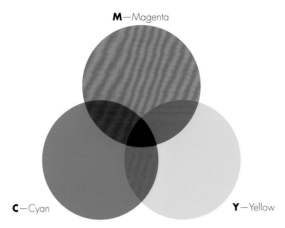

△ **The color model of print** is based on subtractive color: ink has to be taken away to create the impression of white, and where the inks overlap, colors get darker.

C = Cyan **M** = Magenta **Y** = Yellow **K** = Black

CMYK: COLOR FOR PRINT

When it comes to printing your work, how the final colors print will differ to the on-screen image. Print uses CMYK to create thousands of colors that can only approximate the millions created on RGB devices. Other differences occur, because you are changing media. CMYK is dependent on the type of ink-set and paper used. Ink-sets, the actual colors of the CMYK inks, differ from printer to printer, and paper stock also influences how colors appear; a glossy paper creates brighter colors than a matte paper.

It is possible to calibrate your screen to match the print profile of a specific printer so that what you see on screen will be much closer to what you see on paper. This is a very technical process; for most artists, it's easiest to do test prints to get the final colors as you want them (see pages 224–225).

◁ **The CMYK print process** is used for most commercial or machine printing. Images are split into four color plates based on three primary colors—cyan, magenta, yellow—and black. When viewed from a distance, colors mix to create a specific color.

When enlarged, it is possible to see the separate color plates

IMAGE TYPES: PIXELS AND VECTORS

There are two types of digital image to work with: raster files, which are
made from pixels, or vector files, which are made from mathematical
paths. Each is suited to different working methods and outcomes.

A QUICK GUIDE TO IMAGE TYPES

Your choice of working method will depend on many things: What is the
image for? Will it be printed or seen on a screen? What type of image does
your final technology require? Will you need to rescale the image?

Raster images
- Rasters are digital photographs, digital images,
or scans of drawings made up of pixels.
- Pixel-based software can seem more intuitive and
closer to traditional drawing and painting.
- Files can end up large and take longer to process.

Vector images
- Vector files use mathematical equations
to describe shapes and result in small files.
- Vector colors are created as a block,
limiting transitions between colors.
- Files can be printed at high quality.

△ **Raster images** are made from separate blocks
called pixels, which are visible when the image is
enlarged, creating a loss of quality.

△ **Vector files** can be scaled up and down
without any damage to the file or to the quality
of the image, which retains crisp edges.

A QUICK GUIDE TO FILE FORMATS

The format you choose to save your digital image depends on your intended use and whether you need to export it. Consider file size and compatibility with other programs.

Raster file formats

- **PSD** (.psd) All layers, paths, and alpha channels are saved within the file. Specific to Adobe® Creative Suite; files need converting for use in other programs.
- **TIFF** (.tif) Use to send an image to a high-quality printer and file storage. Usable in all image-editing software. Nondestructive compression. Large files.
- **JPEG** (.jpg or .jpeg) For uploading to websites and image storage on digital cameras. Small saved-file sizes. Each time a file is saved, it is damaged.
- **PNG** (.png) Used for publishing images online. Larger than jpeg files, but not damaged when saved.
- **GIF** (.gif) For online logos and simple animations with areas of flat, solid color.

Vector file formats

- **EPS** (.eps) Used for exporting a line drawing for cutting or engraving and for high-resolution printing. Saves vector and raster data nondestructively.
- **PDF** (.pdf) For "read only" documents and to send high-resolution files to a printer. Can be read on most devices. Images are compressed via jpeg, so can be a damaging format. Not very editable.
- **AI** (.ai) Mostly for work in progress. Small file sizes. Fully editable, but specific to Adobe® Creative Suite.
- **SVG** (.svg) To display vector graphics and drawings online. Can be scaled up and down without loss of quality to look smooth at whatever size. Only appropriate for web use, not for printing.

SOFTWARE CHOICES

Software for working in both pixel or vector images can be bought outright, paid for on a monthly basis, or used for free. Some examples are below:

RASTER SOFTWARE:

- Adobe® Photoshop®
- Affinity Photo
- Corel Painter®
- GIMP (free)
- Pixelmator (free)
- Darktable (free)

VECTOR SOFTWARE:

- Adobe® Illustrator®
- Affinity Designer
- CorelDRAW®
- Gravit Designer (free and purchasable versions)
- SVG-Edit (free)

△ **Grayson Perry** is here modifying a scanned drawing in Adobe® Photoshop® that will then be woven into a tapestry.

WORKING WITH VECTORS

Vectors are less intuitive to work with than pixels but have a far greater range of uses for the artist and can be read by many software packages or technologies.

CREATING VECTOR SHAPES

Vector-based files use mathematical equations to describe shapes made from anchor points and mathematical curves, known as Bézier curves. Each vector object and its properties (fill or stroke) is described by an algorithm, which is why vector images result in very small files. To work with vectors, you need specific software (see page 249) and to learn how to use the tools; once learned, these skills can be transferred to other packages.

▷ **Here, text** has been made into vector outlines, sandblasted into stone, and painted gold to form part of a permanent woodland installation. *Stone Voices* (2007) Suky Best

Path

Anchor point

Active anchor point

Use handle to alter Bézier curve

Duplicate and flip vector

Fill with color

1 To draw an object, select the pen tool and click at different points to create a path. Close the shape by joining corner points.

2 A curved line can be created from the original shape by selecting the convert direction point tool and dragging the handle.

3 To duplicate the shape, select all the anchor points and copy and paste. Here, the shape has been flipped to create a mirrored image.

4 The two vector shapes can be treated separately to be modified or changed. Strokes or fills can be endlessly modified.

CONVERTING PIXELS TO VECTORS

Artists often draw on paper or right onto the computer using a raster software. The resulting pixels can then be converted into vectors or objects, which can be modified if needed, scaled up or down, or converted to outlines. This allows for a range of output options. The conversion to vector outlines means that image resolution is no longer an issue, as the vectors can now be scaled up and down with no loss of quality.

Hand-drawn image

Anchor points

Live path around outline

Stroke outline

1 Scan or input an original artwork—such as a painting, drawing, or sketch, or an analog or digital photograph—and save as a raster file format.

2 Use vector software, such as Adobe® Illustrator®, to trace the outlines of the original image either manually or automatically.

3 The finished outline has been converted to a vector file and can be adapted further with additional effects and color.

4 Fill the whole outline with color, using different effects such as graded tints and adding to the design with drawn strokes.

5 The finished image can be used as part of web or screen design or sent as a file to be printed or output to another media.

VECTORS TO PIXELS

Vector files can also be converted into pixels for a number of reasons: the output technology can only work from pixels or the image is going to be projected or shown on screen and needs to be saved as a pixel-based file format. During the conversion, the resolution of an image can be defined: a small file for a website or a large file if the image is to be printed at quality.

WORKING WITH PIXELS

Working digitally allows for the indefinite editing of an image: any element can be altered, moved, transformed, removed, colored, or repainted, allowing total creative freedom.

Digital technology makes the collage of different images or reproduction of parts of images easier. Images from different sources are cut out and recomposited to create a new image. This can be a technique to enhance or extend an existing image, as in the case of the artist Debbie Loftus (right), or it can be used to create a photomontage where meaning is created by the juxtaposition of images from differing sources (see page 232).

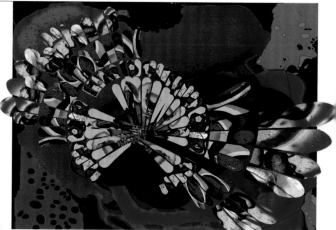

King's Vault (2019) Debbie Loftus

CREATING SELECTIONS

In order to isolate part of an image, it needs to be selected. The imagery within the selection can be copied and pasted from one document to another to create a collage, or modified further.

1 Use any selection tool to select part of the image. The active edge is visible as a dotted black and white line.

2 Enter a mask mode; the selection is shown as a hole. Paint with black to add to the mask and white to remove areas.

3 Exit the mask to see the active selection and continue working. Here, the dog has been pasted to a new file.

PIXELS AND RESOLUTION

Each raster file is an image created out of separate, tiny blocks of information—pixels (short for picture elements). The resolution of a raster image is usually measured in ppi (see right) or ppcm (pixels per centimeter). The more pixels there are in an image, the greater the potential for detail and the greater the size of the image file.

Resolution

Resolution is the number of pixels in a digital image. The greater the resolution, the larger the image. If your image is for print, the resolution you need will depend on the size of your final print and the type of print technology. Some large printers need 150ppi files, while other types of printers need 300ppi or 400ppi to get the maximum quality.

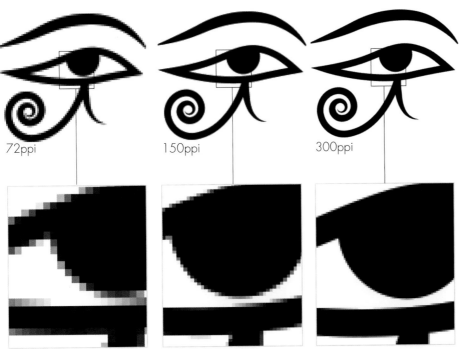

72ppi 150ppi 300ppi

◁ **Zooming in on** raster images reveals the importance of pixel counts. On screen, a 72ppi image looks clear, but try to print it large and it will pixelate. To print larger images, 150ppi or 300ppi is needed.

WORKING WITH LAYERS

Layers are an important part of working in almost all visual software, in both pixel- and vector-based applications. Each layer is separate, allowing you to build up complexity and control your image (and change your mind).

Any digital image is scanned or created as one background layer. You can select part of this image, copy it and make it into a separate layer, or copy part of an image from a separate document. You can make a new empty layer and draw directly onto this without touching your original image data.

Layers can be endlessly duplicated, moved, rotated, linked, or unlinked, and each layer can be modified without affecting any other part of the image. If you make a change you don't like, you can reverse it. A layer can have its own transparency or vector mask, and there are many adjustment layers that change the appearance of a file as a whole or just parts of the image. Layers can also have their own effects and filters, again without affecting another part of the image. More complex types of layers reference external files and stop any damage caused when rotating or rescaling an image.

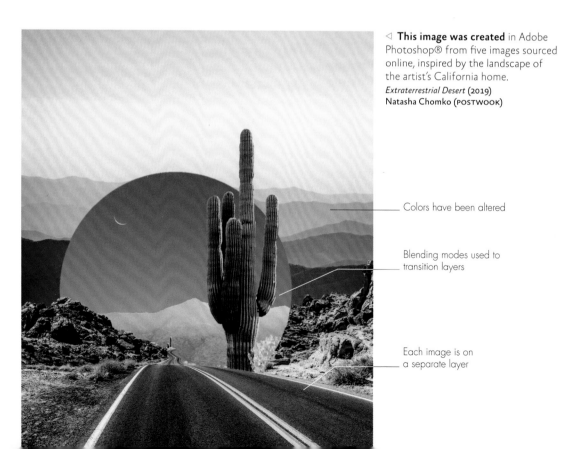

◁ **This image was created** in Adobe Photoshop® from five images sourced online, inspired by the landscape of the artist's California home.
Extraterrestrial Desert (2019)
Natasha Chomko (POSTWOOK)

Colors have been altered

Blending modes used to transition layers

Each image is on a separate layer

Understanding layer structure

A digital image can be thought of as a three-dimensional object. By separating the parts of the image into separate layers, each component can be worked on independently. In the image below of hand-drawn apples painted and placed onto a photo, each part has specific layers which, when viewed from above, looks seamless. Only when the layer structure is shown is its complexity revealed.

Each layer is separate to any other layer above or below it. Once you have a few layers, you can change the stacking order and the uppermost layer will always be visible first. This layer order can be endlessly changed.

A layer can have transparent areas and opacity settings, and each layer can have a separate blending mode, which will modify how it interacts with parts of the image below it.

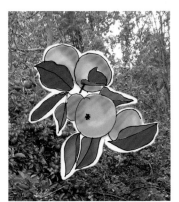

◁ **The image shows** a drawing that was scanned, enhanced, selected, and masked, then layered on top of a photograph of an orchard. The color has been added on top of the drawing in separate layers.

▽ **Seen as a stack**, the structure of the finished image is explained in individual layers. Each layer has been modified with a blending mode, a different opacity, and a mask added to the original drawing.

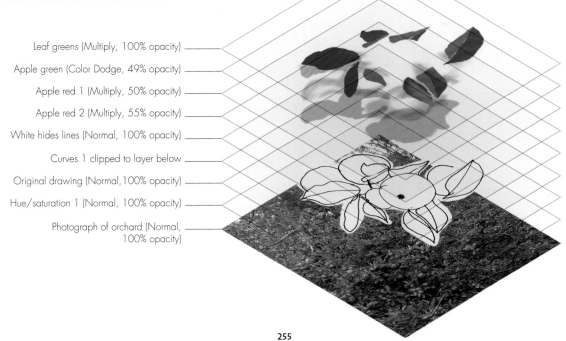

Leaf greens (Multiply, 100% opacity)
Apple green (Color Dodge, 49% opacity)
Apple red 1 (Multiply, 50% opacity)
Apple red 2 (Multiply, 55% opacity)
White hides lines (Normal, 100% opacity)
Curves 1 clipped to layer below
Original drawing (Normal, 100% opacity)
Hue/saturation 1 (Normal, 100% opacity)
Photograph of orchard (Normal, 100% opacity)

DIGITAL PAINTING TOOLS

Painting with digital tools allows for an infinite range of options and the ability to endlessly paint and repaint. Both pixel and vector painting tools have a wide range of brush types, and these are constantly expanding and changing.

RASTER PAINTING AND DRAWING TOOLS

All raster and a lot of vector software have brushes and pens of many types that can be modified. Many artists draw right into their software, which will have its own brushes or pencils that can be customized to suit your chosen style. There are also brushes that mimic oil painting techniques and can mix several colors at once, as well as pencil brushes and airbrushes.

Brushes can also be modified to change opacity and size along a brush stroke, especially if using a pressure-sensitive drawing tablet.

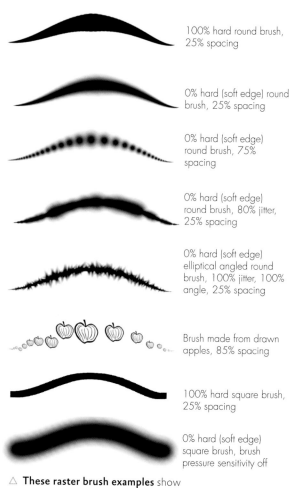

100% hard round brush, 25% spacing

0% hard (soft edge) round brush, 25% spacing

0% hard (soft edge) round brush, 75% spacing

0% hard (soft edge) round brush, 80% jitter, 25% spacing

0% hard (soft edge) elliptical angled round brush, 100% jitter, 100% angle, 25% spacing

Brush made from drawn apples, 85% spacing

100% hard square brush, 25% spacing

0% hard (soft edge) square brush, brush pressure sensitivity off

△ **Drawn from life in Autodesk® SketchBook**, the color in this image was built in eight layers using a Soft Light brush in maximum size.
Beach, Crete (2018) Michelle Salamon

△ **These raster brush examples** show how much variety can be created from a simple round brush by modifying a couple of settings, such as hardness and spacing.

VECTOR BRUSHES AND PENS

Vector brushes are used in many applications and, although initially harder to work with than raster brushes, they are ideal for detailed architectural drawings or fashion designs, as well as for drawing. You can create vector brushes from other elements, like art and scatter brushes, or from pattern tiles. Brushes can be modified, recolored, and rescaled.

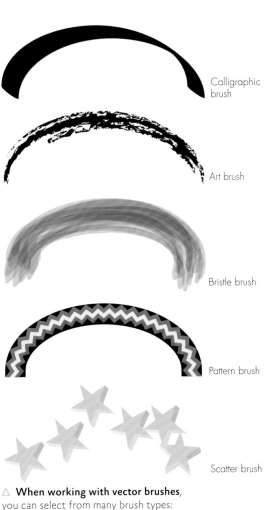

Calligraphic brush

Art brush

Bristle brush

Pattern brush

Scatter brush

△ **When working with vector brushes**, you can select from many brush types: those that mimic paintbrush and ink pens to brushes made from pattern tiles.

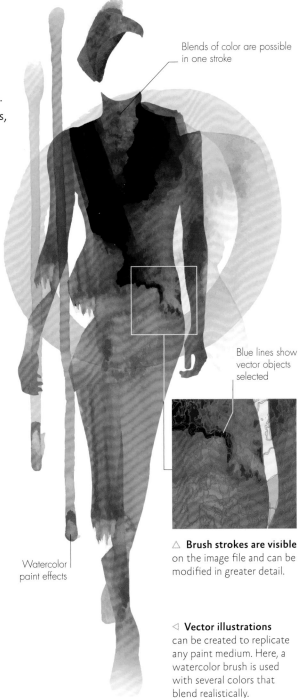

Blends of color are possible in one stroke

Blue lines show vector objects selected

Watercolor paint effects

△ **Brush strokes are visible** on the image file and can be modified in greater detail.

◁ **Vector illustrations** can be created to replicate any paint medium. Here, a watercolor brush is used with several colors that blend realistically.

IMAGE CORRECTION

Instead of radically remaking an image, you may simply wish to correct or modify it—resizing, adjusting contrast, or retouching. Software allows for editing raster images in all these ways and more.

Adjusting brightness and contrast

Use the Levels or Curves tools to brighten or add contrast. Levels gives you a graph from black to white showing you the amount of pixels and their brightness. You can also use Curves to change black, white, and mid-gray points. The curve works differently on a CMYK to an RGB image.

Adjusting the crop

You can crop your image with various tools, which allow you to recompose and keep part of an image and discard the remainder. Some cropping functions resize an image (change the number of pixels) and

this, along with other transformations (flips or rotations), interpolate the data and potentially damages a file. Images can be cropped, rotated, straightened, or flipped horizontally or vertically. They can be distorted to adjust the perspective, or they can have a perspective applied to them.

Correcting color

Software will often have a dedicated color balance tool that allows you to adjust an image by adding or taking away a hue to get rid of a color cast, or enhance colors. For more precise adjustments, use individual color channels in Levels or Curves.

Before

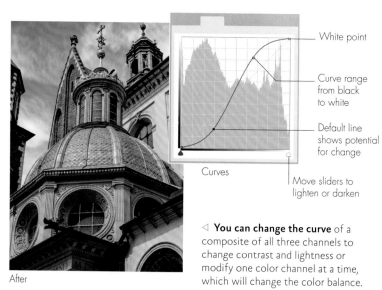

After

White point

Curve range from black to white

Default line shows potential for change

Curves

Move sliders to lighten or darken

◁ **You can change the curve** of a composite of all three channels to change contrast and lightness or modify one color channel at a time, which will change the color balance.

Before

After

◁ **Levels have been applied** on this image of an old engraving, specifically to set the black and white areas of the drawing. This makes it ready to be recolored or changed in other ways.

Ink has been set to black; yellow paper set to white

Before

After

◁ **Both cropping and color adjustments** have been applied to this image to change the composition and make the colors more saturated to create more drama.

The horizon has also been straightened

Retouching

When retouching (if the software allows it), make all your changes on layers above your original data to allow nondestructive editing. This way, if you do something you don't like, you can erase or modify it.

There are many types of retouching tools. To clone, parts of the image are copied using a brush and painted over damaged parts to create seamless repairs. Healing tools sample detail from one area and blend it with the color of another.

Before

After

◁ **Areas of fire damage and aging** on this photograph were retouched with cloning and healing tools, such as a spot healing brush. Small adjustments were made using Curves.

Large areas fixed using patch tools or content filling functions

Base of the dress has been filled in using cloning

2D ANIMATION

By working with animation, motion graphics, or video editing software, you can introduce duration to your project. Imagery from different sources can be combined and shown as moving images.

Source materials and software choices

Software allows you to import from different sources and work with raster or vector images—such as an artwork, video, or photograph—and combine them in frames or a timeline that produces the effect of motion, or a still image can be shown for a specific duration. Source materials are combined in layers, so you can adjust them to create effects (see page 254), even adding sound.

Ideally, you already have a motion graphics program. There are many to choose from, either as a subscription or free, such as Adobe® After Effects®, FilmoraPro, Synfig, Moho®, and many that can be used on phones and tablets.

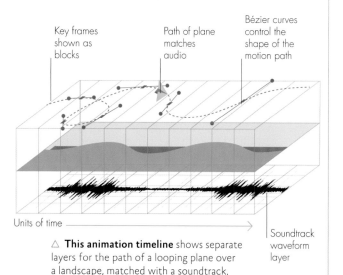

Key frames shown as blocks

Path of plane matches audio

Bézier curves control the shape of the motion path

Units of time

Soundtrack waveform layer

△ **This animation timeline** shows separate layers for the path of a looping plane over a landscape, matched with a soundtrack.

ANIMATING A DRAWING

In the example shown opposite, an animation is created from a series of illustrations that were hand-drawn directly into a computer. These are set against video footage of sea, overlaid with a scan of a watercolor painting and shown as a sequence, all set to an audio soundtrack.

◁ **Hand-drawn images** of the boy and his shadow become animated in the sequence.

◁ **Video footage** in black and white of the sea provides a moving background beneath the color layer.

◁ **A watercolor background** was created by hand and scanned in as a separate layer.

Independent layers

A digital animation may be built in layers in a stacking order; the layer that is uppermost is seen first. Each layer is separate and independent but can interact with the imagery below via opacity or blending modes. Footage can be edited in a video editing program and imported in its modified form. Adding a layer of sound to match the frames of your animation is possible within the software.

Individually drawn still images become animated

△ **The action** is constructed from individual drawings of a boy playing in moving, shallow waves added from imported video footage.
Still from *Beach Studies (Kerala)* **(2020) Suky Best**

Still from animated sequence

Uppermost layer is visible first

Units of time

◁ **The different layers** in this animation work together over time to create a moving sequence with an audio soundtrack.

A still image can be set to be visible for a certain number of units of time.

Video footage of the sea was overlaid with a mask to reveal only a section of the image.

The watercolor background is a still layer that is extended through time.

The lowest layer is recorded sound, mixed in sound software and shown as an audio waveform.

APPLIED ARTS

Sometimes described as the "decorative arts," the methods within this section are about how art, design, and expertise combine to create objects and ideas that are beautiful but also often useful, whether that's a textile playground or a gilded tile.

GILDING

Gilding is the decorative technique of applying gold or other metals as a leaf or paint onto a prepared surface. There are two main methods of hand gilding: water- or oil-based, according to the type of glue (size) used.

Oil gilding is the easier technique for beginners. Water gilding is more sophisticated and requires a water-based glue, making it inappropriate for outdoor artworks, as the glue reactivates in water. In oil gilding, metal leaf is applied using an oil-based glue, which makes it suitable for external use. However, it cannot be burnished to such a high luster as water-based gilding.

Loose and transfer leaf

Gilding leaf can be bought either loose on a roll or mounted on transfer paper in books. It comes in a variety of metals, including gold, silver, platinum, bronze, imitation, and variegated. Gold leaf ranges in purity, measured in carats, from 7 to 24ct. Silver purity is measured in grams. Transfer leaf is easier to handle than loose leaf, so it is better for beginners.

GILDING TEXTURED SURFACES

Objects with irregular surfaces can be challenging to gild, as the metal leaf does not easily stick to the recessed parts. Applying the leaf gradually will prevent air bubbles and avoid breakages.

EQUIPMENT

- Item with textured surface
- Oil-based gilding glue
- Wide, flat brush
- Transfer leaf (variegated used here)
- Gilder's mop
- Spray varnish

Glue drying time varies from 1 to 24 hours

Use your mop to smooth the surface

1 Wipe the surface with warm water to prepare it. Apply the glue with a flat brush and wait until it feels tacky.

2 Gently smooth the transfer onto the glue, leaf-side down. Lift the paper and brush off excess leaf with a mop.

3 Once the glue has set completely, spray the finished item with varnish to protect your work.

GILDING FINE DETAILS

To gild details, you need to mask off the bordering areas before applying the glue. Once the glue is tacky, remove the tape and place the leaf. Varnish the gold leaf afterward to prevent it from tarnishing.

A gilder's knife cuts the leaf without tearing

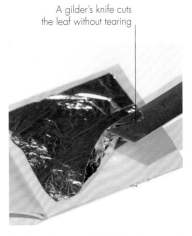

1 Cut the transfer leaf to the size of the area being covered. Do this on the transfer paper in the book. Avoid touching the leaf with your fingers.

2 Apply masking tape over the areas to be gilded, then cut out their shapes with a craft knife to form a stencil. Apply the glue to the cut-out areas.

3 When the glue is tacky, remove the masking tape. Use a gilder's tip to pick up pieces of leaf and gently lay them on the glued areas.

4 Brush away any excess leaf with a gilder's mop once the glue has dried completely. Touch up any missed areas with more glue and leaf. Once dry, spray the surface with varnish.

GILDING METAL

The key to all gilding is to prepare the surface carefully. For metal objects, sand down imperfections, then clean the surface with acetone. The leaf will stick immediately to the adhesive, so apply the glue section by section instead of all in one go. Finish by using a damp cotton ball or a cotton-tipped applicator to smooth the gilded surface.

TEXTILE ART

Encompassing a broad range of techniques, textile art includes any work that uses animal, plant, or synthetic fibers to make an object. Your options range from small-scale embroidery to large-scale sculptures.

△ **This crocheted work** is a site-specific art installation and interactive playground, taking nearly three years to complete and almost architectural in nature and scale.
Crochet Playground (2012) Toshiko Horiuchi MacAdam

The interaction between the form the textile takes and the function it has means that a textile can be seen as art, as well as a utilitarian object. There are many forms textile art can take: hand-made, machine-made, large or small scale, or a way of making political commentary. Tapestries were used by nobility and the Christian church as statements of wealth and to keep drafty houses and churches warm. Textiles have been used in the performing arts for hundreds of years, but they are now a truly diverse field of art and culture.

Textile installations

The colors and textures that can be created with textiles lend themselves to large-scale installations and interactive experiences. Wool yarn is a strong and flexible fiber, which easily transforms into a fabric that can be shaped and joined to produce very tactile surfaces. Textile artists, such as Sheila Hicks and Toshiko Horiuchi MacAdam, use it to create huge, site-specific installations of cascading, woven yarn or crocheted playgrounds.

Sculptural works

Fabric and fiber can be manipulated in many ways to produce sculptural works. Leather can be shaped and colored, and knitted or crocheted yarn turned into 3D forms. Felted fabrics and shapes are created by compressing or matting the fibers.

Key image board in first stages

Moodboard with developed ideas

PLANNING AND DESIGN

When planning a textile, you need to consider your thread choice, color palette, stitch selection, and any embellishments or additional materials. Software programs are available to help plan a design, especially for techniques that require a gridded template, such as tapestry or cross stitch. Many textile artists also employ moodboards to help develop a concept. Start with images and color swatches that inspire you, adding stitch samples; yarns; and details, such as beads, to build the idea. Refer back to your moodboard as your work takes shape to help keep you on track.

◁ **Moodboards** for Ngan Lok Spring/ Summer 2019 (top) and Winter 2018 (left) fashion collections.
Aimée McWilliams

Small-scale pieces

Working with a needle and thread produces often delicate and precise pieces. Hand-sewn works include textiles that are pieced together in quilts or appliquéd, or embellished with embroidery (see page 268). Knitted or crocheted textiles are created with yarn. Lacework and beading are techniques used in different cultures and adopted in fashion but also utilized by the artist.

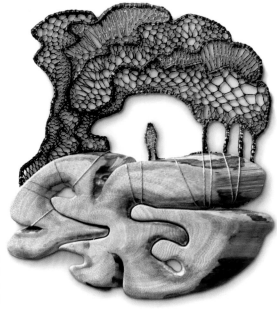

▷ **Here, needle lace** is worked on wire, then dyed and combined with found wood to create a picture.
Untitled (2021) Ágnes Herczeg

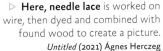

EMBROIDERY

To embroider means to embellish fabric with designs using a needle and thread. Contemporary artists are embracing this traditional craft, creating hand-stitched or machined pieces and exciting mixed-media artworks.

Traditionally seen as a pastime for women, there was a fair amount of unconscious bias against embroidery as an art form. However, in recent years, with the use of many formal artistic elements such as composition, color, and line, it has become a recognized part of artistic practice.

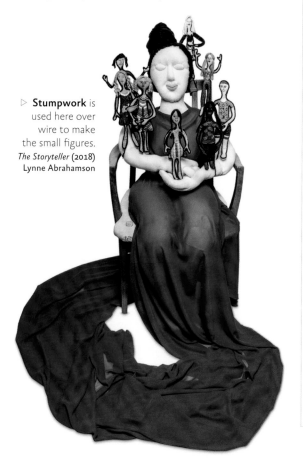

▷ **Stumpwork** is used here over wire to make the small figures.
The Storyteller (2018)
Lynne Abrahamson

EMBROIDERY STITCHES

There are hundreds of stitches to learn, but a few can be easily mastered and will have you creating your own work quickly. Stitch types fall into several categories: for outlining a design, filling it, or creating texture and color.

◁ **Outline stitches** such as backstitch or stem stitch can create solid, straight, or curved lines.

◁ **Straight stitches** form a line as evenly spaced running stitch, or individual stitches used to add detail.

◁ **Filling stitches** can be used for areas of solid color. Padded satin stitch, used here, creates a raised effect.

◁ **Chain stitches** can be worked in a line, individually, feathered, or placed in groupings to form a pattern.

Embroidery styles

There are many types of embroidery derived from different cultures and historical periods, from the Zardozi in India using gold thread, the silk work of China, and blackwork introduced in Britain in the 1500s. Embroidery falls into two broad categories: counted thread, where there is a predetermined amount of stitches over all parts of the fabric, such as cross stitch; and freestyle, or surface embroidery, where many stitches can be used to create any design with as much or as little of the underlying fabric covered as desired by hand or machine.

Materials and equipment

A basic embroidery kit consists of a needle, thread, fabric, and scissors. Use a frame or hoop to keep the fabric taut when hand-sewing. You will need a sewing machine with a free-motion foot for machine embroidery.

Work out your composition, then transfer your image onto the fabric. This can be done directly by drawing with a pencil or with special pens where the marks fade or can be removed. You can use a lightbox or dressmaker's carbon paper to trace the design, too.

▽ **Any fabric** can be embroidered; however, it's better to use one that won't stretch—cotton and linen work best. Artists continue to explore new surfaces, such as paper and cardstock.

△ **Made using blackwork**, each square of this embroidered chessboard is an individual stitch sample.
The Queen's Sacrifice (2018)
Katie Hughes

Embroidery needles

Cross stitch

▷ **Silk, cotton, and wool threads** can be used, and it is advisable to buy good quality for intense, permanent color. Threads with multiple strands can be separated.

Linen

Cotton

Silk

COLLAGE

Collage—the practice of making an artwork from various materials or elements—can create exciting and unexpected results. A collage can be a standalone piece or used to develop ideas for a final artwork.

COLLAGE WITH "FOUND" IMAGES

Creating collages from "found" images is a fabulous way to explore how images function visually and to make images, both contemporary and historical, collide. You can use images from a range of sources—from magazines; sourced from the internet; and from pieces of old wallpaper. Or seek out old photographs from a thrift store to add archival material.

You might want to incorporate thematic interest into your collage, such as political images or photos from a particular era, combining them to see what visual questions or similarities emerge. Collage is a playful activity, even when done with serious intent. Once you've selected your images, arrange and rearrange them to see what visually clicks. Then attach them to your chosen surface, whether cartridge paper, board, canvas, or other found materials with their own history. Simple adhesives such as spray mount can be used, or use archival double-sided clear tape (which is acid-free and long-lasting) or acid-free glue.

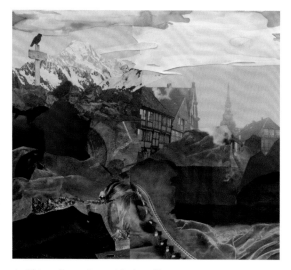

△ **This collage** plays with the effects of light and carefully places images to create an evocative abstract landscape.
Remaining (2012) Michelle Jezierski

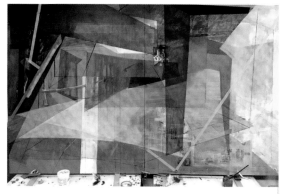

SKETCHING WITH COLLAGE

Collages can be a helpful way to test out compositions for future works. By layering unexpected images together, you can respond to them with your own drawing or painting, which can help you work out complex compositions for a piece in a quick and dynamic way.

COLLAGE USING 3D OBJECTS

You can use objects in your collage, working elements together to create hybrid sculptural or "relief" pieces, which sit between two and three dimensions. Look out for discarded objects in trash or in the street and notice when you respond to a particular object. You can work with its meaning and choose images or other objects to combine with it. You can also find interesting objects, such as vintage china or ornaments, in thrift stores. These can be smashed and applied to a surface and then worked into with paint, or used with additional objects, paint, or flexible materials such as black iron wire or wool to assemble a collage.

▷ **Layering a 3D object** onto this 2D photo results in a startling and challenging image. *Eye of the Beholder* (2017) Kate Murdoch

COLLAGE WITH MIXED MEDIA

Textiles are excellent for collage. You can photo transfer onto textiles (see page 159), which is a good way to fix the collaged image. Or try sewing together sections of textiles, images, and other unusual household materials.

Sheets of acetate also work well. Paint and permanent marker pens can be applied, and the transparent sheets can be layered with paintings, abstract geometry, or painterly gestures on each one. Collages can also move between digital and analog. A mixed-media piece can be photographed, adjusted digitally, and then added to physically.

◁ **The artist's photos** plus acrylics, charcoal, pastel, black pen, and tape have been used here, then photographed and digitally adjusted. *Pink City* (2019) Gail Seres-Woolfson

PAPER ARTS

Paper arts are numerous and have a long history in both Eastern and Western cultures. The art can be either two- or three-dimensional, but it is the paper that forms the work rather than it being a support.

Paper and fine card stock are ideal materials for creating art, because their flexibility, lightness, and relative thinness make them perfect for making flat or three-dimensional objects by cutting, folding, bending, and forming. Paper arts fall into three main areas: papier mâché, paper cutting, and paper folding. Specialist papers can be used, or make your own. Handmade paper can be really beautiful and an art form in itself. You can buy special kits or improvise at home by using two old picture frames for your mold and deckle.

PAPIER MÂCHÉ

Possibly originating in East Asia, France was pioneering in the making of papier mâché objects in the 1700s, and Victorian Britons employed it for items such as furniture and decorative boxes. Today, fine artists are reinventing it again to create extraordinary sculptural works, with virtually no limits to size and scale.

Meaning "chewed paper" in French, papier mâché involves using wet, gluey paper and either layering it onto surfaces or wire structures or creating a paper "clay" and molding it into shapes. Both forms are left to dry and harden before applying other media and usually a glaze to protect the final artwork.

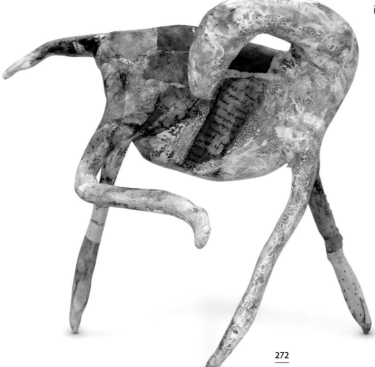

◁ **Carefully balanced forms** can be created in papier mâché, layering torn paper over a sculpted wire structure. Horse (2008–2010) Berit Othman

PAPER CUTTING

This method involves cutting solid paper shapes or piercing paper sheets into patterns. In China, where many believe paper first appeared, paper cutting has centuries of history and is still a major folk art today. In Switzerland and Germany, *Scherenschnitte* ("scissor cuts") are paper-cut pieces whose story dates back to around the 1500s. In the 1700s and 1800s, paper-cut pictures ("shades") and silhouette portraits ("profiles") were popular. Recently, very elaborate works have taken the art form further.

▷ **Japanese artist** Masayo Fukuda created this graceful, monochromatic octopus from a single sheet of paper. Her delicate and precise work is like a 3D pencil drawing.
Octopus (2018) Masayo Fukuda

△ **Using almost translucent** paper handmade by the artist, this piece incorporates sculpted abacá pulp, pigment, and pastels to convey the delicate form.
Stumble Upon (2020) Jocelyn Châteauvert

PAPER FOLDING

Origami is the art of paper folding. Its history is much debated, but Eastern Asia seems to have played a major role, in particular Japan, where it was originally used for ceremonial purposes but later became a recognized art form with standardized shapes and folds. Traditionally, an origami piece is made from a single sheet, although multiple pieces can be joined to create complex works. Many artists nowadays use paper folding to create sculptures.

Another recent development in paper art involves the creation of 3D handmade paper art forms. Used alone or in combination with other paper arts, they fall under the heading of paper sculpture. These works often combine the artist-made paper with other media or techniques in their construction.

NONTRADITIONAL ART FORMS

Nontraditional art forms are frequently where creativity meets political or cultural commentary, whether that's by seeking to democratize public art, highlight a social injustice or environmental concern, or emphasize the moment of artistic creation over the commercial value of an artwork.

INSTALLATION ART

Installation art describes the arrangement of objects in a specific site.
The space the art inhabits is central to its interpretation, and the
experience of the viewer is part of the creative process.

This type of art takes the creative practice beyond the artist's studio, as installations often exist in public places. Ephemeral in nature, an installation can be architectural in scale and form or a collection of small objects arranged with meaning.

Integral to the space

Most artworks can be moved from a gallery and reinstalled elsewhere without losing their meaning. Installation art is different. The art is not explicit in the actual objects, but in their arrangement and in their relationship to each other and to the space.

The arrangement of each element in an installation is integral to the work and is therefore decided on by the artist (see page 294). An installation is the whole work and its placement and arrangement can be used partly to question the traditional conventions of the display and status of objects within a gallery.

The audience is an important part of installation art—the immersion of the viewer is part of the creative process. This aspect of the experience, whereby the audience completes the art, has its roots in performance art.

◁ **Pictured here** at the Whitworth, Manchester, in 2015, this sculptural installation of a blown-up garden shed has been shown in several locations. Each piece is suspended in midair, the shadows from the bulb adding drama. By arranging the pieces midexplosion, Parker was taking away the idea of the shed as a place of refuge.
Cold Dark Matter: An Exploded View (1991) Cornelia Parker

A particular setting

Often, installation art begins with the site. The history and significance of a particular place can give context and meaning to a work. The site may suggest the use of certain materials, or the installation may have a connection to its previous use. The artwork exists in this unique site only (it is site-specific)—whether for a few hours or days or for several months—and won't retain its meaning in another place. The site becomes not a setting, but an integral part of the work.

▷ **The scale and space** of the turbine hall in Tate Modern, London, was integral to this immersive installation, where monofrequency light and haze suggested the sun rising from a mist.
The Weather Project (2003) Olafur Eliasson

A REIMAGINED SPACE

Installations can also be located in galleries, and many artists play with the form of the gallery by mimicking another place, changing the viewer's experience of this particular space. In this section of a gallery installation by Mike Nelson, a series of visual reflections and illusions creates a landscape mirrored into infinity, challenging the viewer's perception of time and their personal experience.

Sensory Spaces 8: Amnesiac Shrine (2016)
Mike Nelson

LIGHT ART

Light art is work that uses light as its primary medium, either sculpturally or as an immersive installation, whereby participation is encouraged. Technology, such as sensors, is often used so the work reacts to stimuli.

Artists started to use light as a medium when artificial lighting became commonplace in architectural spaces. The advancement of technology and its integration into our lives was a key concept for Modernists and, as a result, light art was adopted by the Constructivist and Bauhaus art movements. The first light sculpture was *Light-Space Modulator*, created by the Hungarian Bauhaus artist László Moholy-Nagy in 1922.

Altering perceptions

In the 1960s, light art became an increasingly popular and well-recognized form of art. The Light and Space Movement, formed in California at this time, was concerned with geometric abstraction and how the use of light could alter one's perception of the environment. Artists such as James Turrell, Robert Irwin, and Bruce Nauman were part of this movement and are all still active today.

SAFETY AND MAINTENANCE

If creating your own custom circuit, always consult a qualified electrician and obtain a PAT certificate to show that it is safe before it leaves your studio. Some galleries and museums won't exhibit your work without one.

It is likely that the work you create will require maintenance in its lifetime. To mitigate the risks:

▪ **Make sure** the light source is easily accessible for replacements.

▪ **Always keep** a box of spare parts for a work so that the gallery can repair it if needed.

▪ **Make the client aware** at point of sale that your work may need maintenance and agree to a servicing plan together.

◁ **Many contemporary artists**, such as Yayoi Kusama, create light sculpture and immersive installations. Here, her infinity room uses mirrors and soft lit-up sculptures combined with a poetry recording to spread a message of love.
Love Is Calling (2013) Yayoi Kusama

LIGHT ART MATERIALS

There are two kinds of light that can be used in light art: natural light, such as daylight or candles; and electric light, which includes incandescent and LED bulbs, LED tape, and fluorescent or neon lights.

Light artists may use ready-made sources of light, such as fluorescent strip lighting, as an integral part of a work. Or they may project light inside a space or sculpture. Some also use mirrors to bounce light in a space and create reflections or devices such as smoke machines and projected images to diffuse light.

▷ **In this light installation**, the artist uses projected light to create a structural work without the physical restraints of sculpture.
08019 (2013) David Ogle

INTERACTIVE LIGHT ART

Advances such as the emergence of programmable microcontrollers—small-scale computers—have allowed artists to create artwork that interacts with the viewer or space around them. These devices can be expensive, but an "open-source" community of software contributors has invented low-cost versions, such as the Arduino microcontroller and Raspberry Pi computer. These, combined with custom-made circuits, programming, and sensors, provide artists with a less costly way of creating interactive light art.

▷ **Distance sensors** make this light sculpture interactive—the more visitors there are around it, the more the piece pulses like a heartbeat.
Heart Beats of Cristal (2016) Aphra Shemza. Commissioned by Champagne Louis Roederer

△ **LED tape** and mirrored acrylic create an infinite reflection inside the sculpture.

STREET ART

Street art is the term for graffiti, murals, and other artworks that appear in public spaces, often without permission. Starting in the mid-20th century, it began to be taken seriously as an art form later in the 1980s.

Street art is an urban art form associated with the inner city—the art is always located outside, in public areas; it is rarely commissioned and not for sale; and the often representational images have a clear message.

Although street art is still illegal in most cities, many artists accept the risks, because they want their work to be seen by those who don't normally visit a gallery, making art accessible to all. Many artists enjoy the direct communication with an audience. Rivalry can exist between street artists, and they may paint over or comment directly on each other's work.

Political murals

In the 1970s in Northern Ireland, during the period known as "the troubles," many murals were painted in Catholic areas of Derry by local artists to make political statements, visible to all. This type of street art was intended as a form of protest to make a point of view conspicuous. Around the world, other murals in South Africa, in the US, or on the West Bank wall in Bethlehem, Israel, carry a message that is often more important than the artists' methods or the merit of the images.

▷ **This mural**, made to commemorate George Floyd, who was murdered by a police officer in 2020 in Minneapolis, aims to make a political statement about racism and to encourage viewers to reflect on the excessive force used against black people by white authorities.
George Floyd Mural (2020) Thomas "Detour" Evans and Hiero Veiga

Graffiti

In the 1960s in New York, Philadelphia, and other inner-city areas in the US, often beset with poverty and deprivation, artists began to spray-paint images and names (tags) around the subway systems and their local area.

These artists started to paint in collaborative groups. Some would act as lookouts while others painted, or they would seek out locations that allowed for more privacy so that images could be painted with more consideration. Subway trains in many towns became increasingly policed and protected, so artists started to work on subway tunnel walls, which led to an even more sophisticated art form. Over the past few decades, measures such as making it illegal for those under 18 to buy spray paint have been introduced in an effort to stop graffiti. However, determined street artists often find ways to navigate around the law.

△ **Known as the Leake Street Arches**, this wall near Waterloo station, London, has been granted legal status as a graffiti wall, providing a democratic art venue that has become a colorful and vibrant canvas for street artists.

CELEBRATED ART

Over the years, people have emerged from street art to become successful gallery artists. Jean-Michel Basquiat and Keith Haring rose to prominence in the 1980s in New York, and Banksy emerged in the UK. Banksy's actual identity remains a secret, like many street artists whose practice is illegal. Despite this, street art images are often protected now. Some have been removed and auctioned; others are tourist attractions. The political murals of Northern Ireland, for example, are floodlit at night by the council as part of the Northern Irish tourist trail.

West Bank Guard (2007) Banksy

TEXT ART

Incorporating words, letters, numbers, and punctuation in an artwork, or using them *as* an artwork, is an art form whose history can be traced from the ancient art of calligraphy via the collages of Picasso to the present day.

Using text in art can encompass any discipline or media, from print to film, stencils, and performance art. Words may be real or made up, and the text may be significant to the piece's meaning or have no meaning at all. An artwork may feature individual characters or use a poem or story as the whole piece or a component part. Text may appear alone or with images. Traditional Chinese landscapes, for instance, often juxtaposed images and poems.

Lettering and calligraphy
The term lettering describes the one-off creation of letters and words freehand or digitally. Calligraphy, thought to have originated in China around the 3rd century BCE, is the art of handwritten letters and words. It was also very important in Islamic art.

Text within collage
The 20th century saw a radical shift in what was considered art. In 1912, Georges Braque and Pablo Picasso stuck paper items, such as newspaper cuttings, together to create artworks called "papiers collés" —pasted paper—giving rise to collage (see page 270). Modern collage uses letters shaped from paper, fabric, or natural objects such as leaves, embroidered, hand-sewn, and stenciled.

TYPOGRAPHY

Typeface and font are often used interchangeably, although each is distinct. A typeface is a collection of characters—letters, numbers, punctuation, and signs—that share a design. A font is the size, weight, and style of those characters, such as bold or italic. Typography is the art of selecting and arranging typeface and font into a successful composition for use in any media.

Africa (2005) Alan Kitching

New meanings

Incorporating the written word into visual art allowed artists to liberate text from language. The Dadaists integrated the written and spoken word into their work, creating "sound poems," and Pop Art in the 1950s and '60s used text within comic book–style speech bubbles.

Conceptual art (see page 21) prioritizes ideas over a physical work, and words are a perfect vehicle. Installation art places words on gallery walls and floors, and from the 1970s, artists began using text in new ways, such as in neon light.

▷ **The iconic LOVE artwork** became an emblem for 1960s idealism and has been reproduced in many forms, such as this sculpture in Malaysia.
LOVE (1966–) Robert Indiana

Cultural commentary

Street artists (see page 280) began to use graffiti and images in public spaces to tackle art world hierarchy and promote cultural democracy.

So by the end of the 20th century, text-based works had become a common means to address social and political issues. Lorna Simpson used text, photos, and film to question ideas around gender and race; Jenny Holzer projected text-based light pieces; and Tracey Emin embroidered words to convey vulnerability.

◁ **A poem** forms the basis of this abstract piece, painted using Arabic calligraphy.
"Two Strangers" A Poem by Mahmoud Darwish (2021) Khalid Shahin

LIVE AND PERFORMANCE ART

Live art is a fluid way of thinking and working that aligns artist, artwork, and audience in a set place and time. It may include performance art, where the artist uses human actions or the body as a vehicle for the art.

LIVE ART

Live and performance art are often talked about collectively, but live art differs from performance in that it embraces any live practice and live audience interaction—from an online drawing workshop to a communal picnic or a conversation. The point of encounter is vital to the existence of a live art piece.

Live art is created to be fully experienced, and is therefore ephemeral in nature; the "present" place and time are crucial, and once the experience is over, memory becomes an intrinsic part. It often tackles political, environmental, or social issues. Some live art promotes the concept of "cultural democracy," whereby everyone present or choosing to participate can decide what counts as art and culture.

Collaborative and participatory art

This type of art involves an artist working alongside others, often outside of the traditional art space. The audience become active participants, resulting in empowerment and a degree of co-ownership. It can involve other art forms, such as a performance artist or sculptor working with nursing home residents.

Community art

Artists may collaborate with a community of a specific location and/or culture. The process of dialogue and relationship building is usually as important as any piece that is made. This socially and politically aware type of art aims to challenge art world hierarchies.

Socially Engaged Art

Contemporary Socially Engaged Art (SEA) is historically rooted in avant-garde movements such as Dada; its philosophy to blur the line between life and art. It doesn't follow a set style or method, but takes the form best suited to challenge a political or social issue—via research, collaboration, and activism—for a definite outcome.

◁ **This image**, used as a promo for the Od Arts Festival, documents a live art piece commenting on the importance of human and digital connection.
And a Vital Connection is Made (2021) Zoe Toolan
Photograph by Simon Lee Dicker

PERFORMANCE ART

Actions performed by the artist or others can create powerful art with the body. Such performances might be spontaneous and improvised, scripted, live, or filmed. They may simply be certain actions, or they might constitute "happenings," events, or guerrilla interventions. The "Guerrilla Girls" are a group of female artists who hide their identities by wearing monkey masks as they protest in public about issues including gender inequality and racism.

Like live art, performance art has its origins in art movements such as Dadaism and Futurism and 1960s–1970s countercultures fueled by artists such as Joseph Beuys and John Cage. In her iconic *Cut Piece* (1964), Yoko Ono encouraged the audience to approach her and cut off small pieces of her suit. Other notable works include Bruce Nauman's films of himself walking in confined spaces (1968–1969).

△ **Painted in multicolored metallic powder,** Gilbert & George appeared as living sculptures and sang along repeatedly to a classic 1930s vaudeville song, moving in a robotic way.
Underneath the Arches (1969) Gilbert & George

BODY ART

Using the body as a kind of canvas—for example, tattoos, piercings, and henna painting—is a form of cultural and artistic expression stretching back thousands of years. These designs are often filled with spiritual and cultural meanings. Polynesian tattoo motifs, for example, include images representing the ocean. Some artists, such as Yves Klein, have modified the concept of body art by using the body as a tool, or "human brush," to paint on canvas.

▷ **In a reversal** of representational art, here the artist has "painted" the human model, which plays with ideas of reality, art, and two- and three-dimensionality.
Risen Behind the Scenes (2012) Alexa Meade

BOOK ART

Books have a special place as treasured objects, which makes book art both powerful and thought-provoking. From medieval illuminated manuscripts through pop-up books, book sculpture, and artists' books, the book has proved a stimulating artistic medium for centuries.

FINE PRESS PRINTING

Books created with significantly high standards of materials, design, general aesthetics, decoration, or production—often published in limited editions—redefine the book as an art form. They have been a constant thread in cultures around the world for centuries, including in the world of contemporary art, and are often of great artistic merit. William Morris's Arts and Crafts Kelmscott Press is a leading example, where he returned to handmade techniques such as finely wrought wood-engraving for illustrations.

◁ **The complete works** of Geoffrey Chaucer, printed by the Kelmscott Press in 1896, used wood-cut illustrations by Edward Burne-Jones.

The book contains 87 hand-printed illustrations

ARTISTS' BOOKS

This loose term applies to artworks that take book form. They may be produced in small editions or made as one-of-a-kind objects. Artistic experiments of the 1960s and '70s were very influential, and the term "artists' books" is often said to have been coined by Dianne Vanderlip, who organized the *Artists Books* exhibition in 1967.

◁ **In this one-off edition**, silkscreen prints on silk and Japanese paper are bound in a hardback cover and presented in book form.
Tracé Transitoire (2014)
Krassimira Drenska

BOOK SCULPTURE

Small-scale sculptural effects are crafted from existing books by using techniques such as folding the pages or carving shapes from them. With just a few tools, including scissors, a craft knife, and glue, it is possible to sculpt the pages into many forms, from portraits and natural forms that spring from the surface, to hollowed-out organic shapes. For many book sculptors, the aim is to bring a beloved book to life by visualizing its story or meaning.

△ **Book sculpture artists** often take the themes of the books they are working with to create magical, miniature 3D forms.
Thumbelina (2014) Karine Diot

ALTERED BOOKS

Books themselves can be altered in all kinds of ways to become art objects. Many pieces Pstill resemble the original book or keep certain features, such as the original text or illustrations. Others use the book or books to produce a totally different object, possibly a mixed-media piece that adds other materials. Piles of books have been used to create large sculptures, while smaller-scale sculptural effects are achieved by carving or folding the pages (see above).

◁ **In this alternative form**, the artist has rearranged the expected format of a book using assembled books and bookmarks combined with paint and burnished ink.
Anthologia (Devotion Series) (2007) Jacqueline Rush Lee

ENVIRONMENTAL AND LAND ART

Environmental art is work that uses the land and nature as its material or addresses social and political concerns regarding ecology and the relationship of humans with their natural and urban spaces.

The environment has been a source of inspiration for artists, from the first cave painters through to modern ecological artists who work with the land itself. Environmental art as a term emerged in the late 1960s with "land art" created by artists such as Jeanne-Claude and Christo, who worked large-scale with the land, wrapping whole islands in pink fabric in *Surrounded Islands* in 1983, for example. Robert Smithson created his *Earthworks* series, where he shaped the earth itself with heavy machinery. The movement grew out of a desire to break the boundaries of the traditional art market.

Social sculpture

In the 1970s, Joseph Beuys coined the term "Social Sculpture," which united Utopian ideas with artistic practice. His 1982 artwork *7000 Oaks* promoted urban renewal through inner-city tree planting.

More recently, there has been a movement to highlight the impact of global warming. In 2018, Olafur Eliasson installed 24 icebergs outside Tate Modern in London, in a work called *Ice Watch*, to bring the reality of melting ice caps to the public. The documentation or recording of these works is vital to this type of ephemeral art.

Andres Amador
at work

◁ **Celebrating impermanent art,** these earthworks are created at low tide along the California coast using just a rake. *Prayer Flower II* (2015) Andres Amador

Creating environmental art

Head outside and take a camera to document your work. Find some natural materials to work with, such as leaves, stones, shells, branches, or flowers (these materials should be found and not cut down, as you do not want to negatively impact the environment), and arrange them in a pattern or on top of one another to create a sculptural work.

Take images—play with the daylight and shadows that the environment creates in your photographs. Once you have finished documenting the work, return the materials and present or display the images in a finished piece of art.

▷ **This woodland installation** was inspired by fallen leaves at Hawarden Woods, North Wales. The artist cut the leaves into colorful squares.
Beech Leaf Grid (2017) Tim Pugh

SUSTAINABLE ART

As an artist, it is important to consider the environmental impact of your materials. Ask yourself these questions at the point of creation to try and be more mindful of where your material comes from, what it's made of, and how long it will last.

- **Are your materials natural** or manufactured?
- **How far have they traveled**, and could you use a local supplier?
- **Could you use recycled** or reclaimed materials?
- **Does your work** need to be large?
- **What will you do** with the waste you create when making your work?
- **How will you transport** your work to its site?

▷ **This giant sculpture** was made from discarded consumer waste materials collected from the sea by environmental awareness artist Bordalo II.
Giant Egyptian Vulture Bird (2019) Bordalo II

PRESENTING
& PRESERVING
YOUR WORK

SELLING YOUR WORK

Making great art can be difficult enough, but selling it, especially if you want to start to live off the proceeds, is a whole new challenge. It calls for planning, patience, networking, and promotional skills.

There are now many ways to sell your art; you don't have to have an agent in order to be a career artist. However, you need to realize that when you start selling work, you are running a small business, which involves dedication and hard work. If you're serious about selling work, then the first major challenge is marketing. As a basic rule, in the first few years, you could spend 50 percent of your time making art and the other 50 percent promoting it.

Copyright

You own the copyright to all the artwork you make unless you specifically sell it as part of a contract. If you sell a physical artwork, you can still license the copyright of that work for other uses, such as in a book or on a physical object like a plate.

Building a portfolio

Build a digital portfolio of images that represents you as an artist. If you work small, then invest in a quality flatbed scanner or take quality photos from all angles of 3D art such as sculpture or ceramics. Your portfolio should be edited regularly and exported as a pdf. You can use it to introduce your work to curators, galleries, and art consultants, who buy or hire work for private clients or businesses.

Biography and artist's statement

Create a biography, just one paragraph, with your contact details, educational background, current projects, awards, and commissions. Then write an artist's statement—about two or three paragraphs long and written in the third person. It describes what you make and why, the medium you work in, and how your work has evolved to this point.

◁ **Invest in a high-resolution camera**, studio lights, and a tripod and create a clear space where you can easily photograph your work, then save the digital file.

Online presence

Spend time researching the various online platforms and follow artists that you love. Develop your own profile and use it to show your work and process, and share and comment on other artists' work, too. A website is an online calling card and can be simple or complex, but it should represent you as an artist. Keep it simple to start; a site that shows the best examples of your work can be more useful than a catalog of every single work you've ever made. There are also online platforms where you can upload work to sell. They allow you to see how other artists have priced their work, too.

△ **A website is an online portfolio**, which you can keep regularly updated with news and current pieces, details of exhibitions, your contact details, and your artist's statement.

△ **Social media platforms**, such as Instagram, can help you build up a network of useful contacts and potential clients.

Creating an income

There are many paths to selling your work—either pieces you have already made or ones you create as a commission. Building a client base takes time, and many artists start by creating a database of friends and family who will support you as you expand (see page 294). Commissions happen once a client has seen a work and wants a new piece made to their specifications. Keep a database of people you meet and send out regular email newsletters.

Financial decisions

Some artists price by calculating an hourly rate and add in their material costs; others go by the size of the work. Try to benchmark yourself against artists with a similar amount of experience or at the same career stage. If you are represented by a gallery or agent, you will need to include their commission or fee into your pricing. When creating work for a commission, agree on a contract stating the payment plan and the key dates for making the piece.

EXHIBITING AND CURATION

Exhibiting your art is not just about selling it—there are many other benefits, too. The exhibition process also involves curation, which is the selection, arrangement, and organization of your works in a chosen space, whether this is done by you or by someone else.

The first benefit of showing your art is that it forces you to finish your work and think about how it will sit in a space or on a wall. Showing your work will also allow you to get some separation from it and to see the pieces differently.

Your artwork will take on its own identity by being in a public space for people to see. The response and interpretation of your art by other people provides invaluable feedback and ideas to

shape your further work. It is also an ideal way to build a network or following, as well as a place to meet the clients in your database.

Museum or gallery exhibitions

If your exhibition is being held in a museum or gallery, then the curation will be done by a professional curator. Curation has become a creative process where the curator's vision unites works of individual artists. They will have a theme or concept that the exhibition will explore and illustrate, and your work will have been chosen because of this.

▽ **Your work may** be selected as part of a large public exhibition, potentially exposing your art to many visitors.

◁ **A private view** at the start or end of an exhibition gives you a chance to meet and cultivate an audience.

Initially, you will be contacted by the curator, who may want to do a studio visit and see other works that you have made. A work or series will then be selected. The curator may discuss the selection with you and how the work should be installed, but you may not necessarily be part of this process. If you're exhibiting as a solo artist, you have more control over the work selected than if you are in a group show. As the solo artist, you can discuss the final selection and how the work is to be arranged and ordered in the space.

Open studio and self-curation

Another option is to open your studio to the public, in which case you can arrange and select the work for view. You may want to show current work in progress, or older works with a view to selling them.

Alternatively, you can participate in a self-curated group exhibition, where several artists find a space and curate the exhibition themselves. This gives each artist more control over how their work is conceptualized and seen and is a great learning experience. You need to find a group of artists to exhibit with and agree on a theme, concept, or rationale for exhibiting together. Once you have

decided to host a show together, you need to work collectively, with all decisions and choices discussed at every stage, including costs of promotion, transport, and any publications.

EXHIBITION CHECKLIST

For self-curated shows, you will need to consider the following:

■ **Promotion:** Will you use social media, your website, press, TV, radio, leaflets, posters, invitations?

■ **Opening night:** Will there be an opening event or private view? Do you need to update your mailing list?

■ **Events during the exhibition:** Will you arrange talks, screenings, performances?

■ **Invigilators:** You will need people to be at the exhibition during open hours to protect the work and be on hand to answer visitors' questions about the pieces.

■ **Insurance:** You may need to insure the works against theft or damage; you will definitely need public liability insurance in case of accident to the visiting public.

■ **Titles:** Each work will need a label with the name of the work, media, date, artist.

■ **Catalog:** Printed with details of each work or with a map of the space.

Exhibition invitation

FRAMING AND HANGING

Making frames for your artworks is integral to the creative process, as the right frame will enhance the piece without detracting from its beauty. A well-presented painting gives a final, professional touch.

TYPES OF FRAMES

Christianity and architecture played an important role in the development of framing. Traditionally, religious paintings were surrounded within wooden carved enclosures, simulating the architecture of the church. As societies became more secular and socioeconomics more diverse, different styles and approaches to framing emerged.

The intention has always been to enhance the artwork by "framing" it, but there are some key things to think about for each item to be framed:

- **Perspective:** Is space/depth needed around and inside the frame, and if so, how much?
- **Framing style:** Does the artwork need to be raised within a mount, sewn, or stretched?
- **Frame profile:** Is a slim and simple or a chunky and elaborate frame required?
- **Frame color:** Does the frame color match or complement colors within the piece, or would a contrast be preferable?

Adding glass and mounts

Whether you need to glaze your work will help you decide on the depth and style of frame you need. Oils and acrylics can be left unglazed, whereas watercolors and drawings benefit from a mount and glass. Mounts come in different colors and thicknesses and can be rectangular or oval with single, double, or triple windows cut into them.

◁ **A box frame** style can be used to add depth to 2D artworks, either with Pa window or float mount. Use deeper frames for 3D objects.

◁ **A tray frame** style is used when a stretched canvas needs a frame either to hide the edges or to enhance the artwork.

◁ **A window mount** is normally used when a focus on the image is required. The mountboard is cut to create an aperture.

◁ **A float mount** creates a floating effect with the work raised on a mountboard. Use when the edges are part of the image, such as a deckle-edge.

MAKING A FRAME

The internal size of the frame is determined by the size of the artwork. The glass, mountboard, barrier board, and backboard all need to match the artwork size, referred to as "glass size." Moldings can be wood, aluminum, or polymer, in various depths.

EQUIPMENT

- Artwork
- Mountboard
- Mount cutter and ruler
- Barrier board
- Backboard
- Glazing

- Molding
- Miter saw
- Wood glue and clamps
- Sandpaper and paint
- Gummed tape
- Hanging hardware

Cut four miters at 45-degree angles

1 Prepare your artwork, window mount, barrier board, and backboard and order a piece of glass or acrylic to be cut to the same size by a glazier.

2 Measure and cut the molding sides, using the glass as reference. Add ⅛in (3mm) to allow a gap between the contents and the inside of the frame.

3 Lightly glue and clamp or pin your corners. Once set, sand and paint the frame, fit the contents, seal the back with tape, and attach hanging hardware.

TYPES OF HANGINGS

Choose the correct hanging for the artwork and the wall where it is going to hang. Ideally, attach the hanging onto the side bars at the back. Remember that hangings and hardware have a maximum load capacity.

▷ **Hanging fittings** are screwed to the frame and either have rings for attaching picture wire or use brackets to support heavy works.

Strap hanger

Keyhole bracket

J-hook

Mirror plate

Flush mount

Brass picture wire

D-rings

Split batten

STORAGE AND CATALOGING

Creating art is essential, but recording and storing it correctly is equally vital if it is to stay safe and be accessible for exhibitions and sale or for reviewing your artistic practices and creative journey at a later date.

Cuneiform tablets, papyrus, parchment, paper, photography, filming, and the internet: all these have been used in the process of keeping a record of artistic accounts. They are the traces of history left to us to decipher—knowledge, experiences, and tales that are delivered to us in a variety of formats.

Today, records are a crucial part of artwork storage and documentation. Most artists are prolific in their output and express their creativity in many mediums, so organizing art systematically allows it to be divided into themes for exhibitions, promoted via a website, and records to be kept of the techniques and materials used in any one collection.

Making a record

Create a detailed information sheet, recording: type of artwork, technique, medium, creation date, any damage/repairs, location, assembling/disassembling method, type of hanging, number of exhibitions, and value. Develop an easy-to-follow, successive numbering system and allocate one to each record sheet. This forms the basics of cataloging.

Software choices

Nowadays, Collections Management Systems (CMS) are widely used by artists, curators, registrars, and librarians. These are licensed software that can be purchased and installed on a computer. Alternatively, there are web-based CMS options offered by many companies, which do not require installation and can be accessed via an online account. Pricing is available as yearly or monthly subscriptions or on a pay-as-you-go basis. Both types provide the user with templates to create and manage records, divide artworks into themes or techniques, and allocate ID numbers.

Another factor to consider is whether you want certificates of authentication and tagging of your artworks, especially if they are unique or part of a limited edition. There are online services that offer such features, which may reassure buyers.

△ **Use photo documentation** to record your work. Take photos in either physical or digital format on a neutral background. Take high-resolution images in case they are required for exhibition publications.

Storing and labeling

Accessibility is part of the cataloging and record-keeping process. Collections that are stored and handled effectively and the location properly recorded are easier to preserve. Labeling objects with their ID number can be done by discreetly writing on the verso of paintings (on the wooden frame, not the canvas) and on the bottom of sculptures. Apply a small strip of correction fluid, then write the ID number on top with a pen.

◁ **Archive-grade** paper or Tyvek® labels can be tied or attached to objects.

PROTECT YOUR ART

Raise art off the floor to avoid flood damage, and store artworks back-to-back with medium-density foam sheets between them. Shelves and drawers can also be lined with foam for storage.

Separate each frame with foam

Use wooden risers to raise frames

TYPES OF STORAGE

For small objects, store in resealable bags, archival polyester sleeves, and archive boxes padded with acid-free tissue. Large works require space to stack vertically, and consider an environment where light and moisture levels can be controlled.

▷ **Choose a storage** method to match your medium; drawings can be laid flat in chests or rolled in a tube for ease of transport.

Art tube

Plan chest

△ **Constructing custom-made** shelving means you can accommodate several canvas sizes in one space. Always stack vertically, not flat or piled on top of each other.

INDEX

Page numbers in *italic* indicate artworks.

2D animation 260–261
3D modeling 200, 201
3D paper art 273
3D printing 200, 201
3D software 22, 200

A

Abrahamson, Lynne *268*
abstract art 21
acrylic ink 71
acrylics 80–81
 blending 152
 color mixing 148–150
 combining oil and acrylic paints 158
 eco-friendly and non-VOC paints 81
 fabrication 193
 glazes 149
 grounds 154
 impasto 157
 masking 153
 mediums 80, 95
 storage 81
 textural effects 156, 157
 types of paint 81
 underpainting 155
Ainsworth, Anthony *234*
airbrush 87
Akomfrah, John *235*
Alade, Adebanji 16, *22*, *128*, *173*
alcohol-based ink 71
alkyd impasto medium 94
alla prima 151
aluminum 57, 104, 105
Amador, Andres *288*

animatics 237
aquatint 114, 208
archival paper 48
armatures 98, 99, 180–181, 184
art markers 69
artist's portfolio 292, 293
artists' books 286
Artswati *33*
assemblage 199
Ast, Balthasar van der *162*
Auerbach, Frank *166*
Aycock, Alice *196*

B

back irons 180–181
balanced images 39, 125
ballpoint pens 69
Banksy *281*
Basquiat, Jean-Michel 281
beeswax 93, 144
Benson, Tim *54*, *151*
Beuys, Joseph 285, 288
black light paint 88, 89
blotting 135
boards 54–55
body art 285
book art 286–287
Bordalo II *289*
Bourgeois, Louise *37*
bronze 104, 105, 106, 187
 patina 105
Brown, Paul S. *163*
brush pens 69
brushes 78–79
 cleaning 95
 digital painting tools 256–257
 types of brushes 78–79

 watercolor 134–135
burin 204
Burne-Jones, Edward 286

C

Calder, Alexander 196, 197
calligraphy 282
 ink 71
 pens 68
cameras 22
 analog 116
 aperture settings 230
 digital 116, 117, 118, 119
 flashes 117
 ISO 231
 lenses and filters 117
 shutter speed 231
 single lens reflex (SLR) 117
 smartphones 116
 tripods 116, 117
Canaletto *172*
canvas 51–53
 boards 54
 cotton 51
 linen 51
 priming 53
 sizing 53
 stretching 52
 unstretched 53
carborundum grit 214
cartoon strips and comics 168–169
carving 188–189
 relief carving 189
 tools 102
casting 104, 187
cataloging 298
cave paintings 76, 78

ceramics, sculptural 98, 190–191
chalk 65
charcoal 64–65, 158
 colored 65
 compressed 65
 natural 64
 pencils 65
 powder 64
 water-soluble 65
Châteauvert, Jocelyn *273*
Chinese ink 70, 71
chipboard 55, 193
Chisnall, Wayne *199*
Chomko, Natasha *254*
Christo 288
cityscapes 172–173
clay 98–101, 106
 air-dry clay 98, 100
 ceramics 190–191
 coarse and fine 98
 epoxy 99
 modeling 100–101, 182–185
 modeling tools 101
 molding 186
 oil-based 99, 100
 polymer 99, 100, 101
 water-based 98, 100
 wax-based 100
cleaners 95
CMYK color 31, 247
collaborative and participatory art
 284
collage 144, 156, 270–271, 282
 with 3D objects 271
 with "found" images 270
 with mixed media 271
 text within 282

collagraphs 115, 214
color 30–35, 130–131
 attributes 34–35
 blending and burnishing 130,
 131, 141
 color wheel 30, 32–33
 complementary 32, 33
 contrast 32–33
 harmony 33
 hues 35
 interactions 32–33
 mixing 148–150
 optical color mixing 150
 optical illusions 33
 primary, secondary, and tertiary
 colors 30, 148
 saturation 35
 tints 34
 tonal range and values 34–35
 value 35
 warm and cool colors 31
 see also pigments
community art 284
composite boards 55, 193
composition 38, 125, 229–230
conceptual art 21, 283
copper
 copperplate engraving 114,
 115, 204, 205
 supports 57
copyright 292
corten 104, 105, 106
Courbet, Gustave *90*
Cragg, Tony *193*
crank 190
crank automata 196
crayons 158

lithographic 113
watercolor 85
wax 93, 145
Creenaune, Danielle *218, 220*
Crivelli, Carlo *146*
Crumpler, Kate *23*

D

Dada 21, 232, 283, 284, 285
damar resin 144
Davidson, Nadia *144*
design, key principles of 39
digital cameras 118
digital images 22, 23
 2D animation 260–261
 color models 31, 246–247
 digital painting tools 256–257
 image correction 258–259
 layers 254–255, 261
 pixels 248, 249, 251, 252–253
 raster images 245, 248, 249, 253, 256
 vector images 245, 248, 249,
 250–251, 257
digital media 242–261
 working digitally 244–245
digital photomontage 233, 252
digital printmaking 110, 224–225
 C-type prints 225
 giclée prints 224–225
 printers 111
Dillon, Alexandra *56*
Diot, Karine *287*
dip pens 68, 70, 71
dipper pots 91
drawing 124–131
 cartoons 169
 documenting the everyday 125

figure drawing 164–165
hand-eye connection 124
line drawings 28–29
mark making 126–127
with opposite hand 124
paring back 124
portraits 167
shading 125, 126, 128
subtractive drawing 72
tonal drawings 72, 128–129
on top of paint 158
using color 130–131
drawing gum 92
Drenska, Krassimira *286*
drypoint 115, 204, 205
Duchamp, Marcel 21, *21*, 196,
197, 198
Dürer, Albrecht *205*

E

egg tempera 146–147
Egger-Lienz, Albin *166*
Eliasson, Olafur *193*, *277*, 288
embroidery 268–269
emulsion paint 88
enamel paint 89
encaustic wax painting 93, 144
engraving 204–205
copperplate 114, 115, 204, 205
environmental art 288–289
ephemeral art 276, 284, 288
epoxy clay 99
epoxy glue 100, 199
epoxy resins 107
erasable pens 69
erasers 72
etching 114–115, 206–209

aquatint 114, 208
common metals 115
etching press 110, 111
etching solutions 114
hard-ground etching 207, 209
soft-ground etching 208, 209
tools 115
Euwens, Egon von *89*
Evans, Thomas "Detour" *280*
exhibiting and curating art 294–295
experimentation 19

F

fabrication 192–195
acrylic 193
metal 104, 192, 194
plinth 195
wood and composite 193
workspace issues 192
feathering 131
fiberglass 107
Fibonacci's sequence 38
figurative art *see* representational art
figure drawing 164–165
from photo or sculpture 164
life drawing 164
filming 118–119, 234–241
film editing 240–241
jargon 241
key elements 234–235
preproduction 236–237
recording equipment 118, 239
sound and lighting equipment 119
storing images 119
techniques 238–239
fine press printing 286
fineliners 68, 158

fixatives 73
gloss/matte 73
permanent 73
workable 73
form 37
"found" objects 60, 198
fountain pens 68, 70
framing and hangings 296–297
Fukuda, Masayo *273*
Futurism 285

G

Gabo, Naum 196
Gaudier-Brzeska, Henri *188*, 216
gel pens 68
giclée prints 224–225
Gilbert & George *285*
gilding 264–265
fine details 265
gilding leaf 264
metal objects 265
oil gilding 265
textured surfaces 264
water gilding 265
glazes 136, 138, 149
gloss paint 88
glue guns 199
glues 199
Goez, Joseph Franz von *168*
Gogh, Vincent van *24*, *70*
Golden Mean 38
Golden Rectangle 38
Gormley, Antony *104*
Goshun, Matsumura *28*
gouache 81, 85
graffiti 281, 283
graphic novels 168, 169

graphic tablets 130
graphite
 blocks 61
 pencils 60–61
 powdered 61, 158
 sticks 61
grids 175
grounds 154
 opaque 154
 transparent 154
Guerrilla Girls 285
gum arabic 63, 92, 95, 218, 219, 220
gum erasers 78
gums 92

H

Hall, Robin-Lee *147*
Hand, Alison *86*, *157*
Hanselaar, Marcelle *210*
Harada, Kazuaki *196*
Haring, Keith 281
hatching and crosshatching 29, 125, 126, 129
henna painting 285
Herczeg, Agnes *267*
Hillier, Joseph *201*
Hiroaki, Takahashi *170*
Hiroshige *172*
honing technique and style 25
Howe, Anthony *197*
Hughes, Katie *269*

I

ideas, developing 22–23
illustration 176–177
impasto 153, 157
imprimatura 154

Indian ink 70
Indiana, Robert *283*
ink 70–71, 158
 acrylic 71
 alcohol-based 71
 calligraphy 71
 Chinese 70, 71
 dye-based 71
 etching 210
 Indian 70
 oil-based 71
 pigment-based 70, 224
 printing ink 112
 watercolor 71, 85
inkjet printers 224, 225
installation art 266, 276–277, 283
intaglio 110, 113, 114–115, 204–211
 drypoint 115, 204, 205
 engraving 204–205
 etching 114–115, 206–209
 inks 112
 making a print 210–211
iron 105
isometric drawing 41
isopropyl alcohol 57

J

Jeanne-Claude 288
Jezierski, Michelle 270
Johnson, Ben *225*
Jones, Katherine *208*, *214*
Justin, Carol Wilhide *215*
juxtaposition 39

K

kinetic art 196–197

Kitching, Alan *282*
Klein, Yves 285
knives
 painting 90
 palette 90
Kusama, Yayoi *278*

L

land art 170, 288
landscapes 170–171
Lee, Jacqueline Rush *287*
lettering 282
life drawing 164
Light and Space Movement 278
light art 278–279
line drawings 28–29
linocuts 216–217
 lino types 216
 reduction linocuts 216
 tools 112
linseed oil 94
Lipchitz, Jacques *37*
Lissitzky, El *233*
List, Caroline *36*
lithography 110, 112, 113, 218–221
 inks 112
 lithographic stone 113
 lithography press 110
 mokulito 220–221
live art 284
Loftus, Debbie *252*
Long, Rachel *198*
"lost wax" method 187

M

MacAdam, Toshiko Horiuchi *266*
McWilliams, Aimée *267*

Madden, Tamara Natalie *158*
Manga cartoons 169
maquettes 22, 23
mark making
 drawing 126–127
 painting 134–135
masking 153
materials 24
 sustainable 289
MDF 55, 193
Meade, Alexa *285*
mediums 80, 94–95
 acrylics 80, 95
 oils 83, 94, 149
 watercolor 85
Merian, Maria Sibylla *176*
Mersh, Rowan *43*
metal
 gilding 265
 panels 57
metal sculpture 104–105, 106
 casting 104, 187
 fabrication 104, 192, 194
 types of metal 105
 welding 105, 194
mezzotint 115, 204
Miller, Stan *136*
mixed media 158–159, 271
mobiles 197
modeling 182–185
 3D modeling 200, 201
 abstract 183
 realistic 182, 183, 184
Moholy-Nagy, László 196, 278
mokulito 113, 220–221
 wood effects 220

Monet, Claude *31*
monoprints 212–213
 watercolor monoprint 212
Mora, Antonio *233*
Mueck, Ron *25*
murals 280, 281
Murdoch, Kate *271*
museum and gallery exhibitions
 294–295

N
N-Tamara, Laura *237*
Nagle, Ron *107*
Nash, Will *106*
Nauman, Bruce *285*
Nelson, Mike *277*
neon paint 88, 89
Newton, Sir Isaac 30
nontraditional art paints
 88–89

O
O'Connor, John *185*
Ogle, David *279*
oil pastels 66, 67, 73, 131
oil-based ink 71
oils 82–83
 alla prima 151
 blending 152
 color mixing 148–150
 combining oil and acrylic paints
 158
 "fat-over-lean" 155
 glazes 149
 grounds 154
 impasto 153

masking 153
mediums 83, 94, 149
oil painting papers 50
paint quality 82
pigment properties 83
supports 83
textural effects 156, 157
underpainting 155
varnishes 94
Ono, Yoko *285*
Op Art 42
open studio 295
optical color mixing 150
optical illusions 33
oriented strandboard (OSB)
 193
origami 273
Othman, Berit *272*
Outcault, Richard *168*

P
painting
 from photographs 174–175
 grounds 154
 mark making 134–135
 mixed media 158–159
 supports 46–57
 textures 144–145, 156–157
 see also specific techniques and styles
 of painting
painting knives 90
palettes 91
 mixing paint on 148
 palette knives 90
 stay-wet palette 91
paper 48–50

preparing 50
printmaking paper 113
types and textures 48–49
weight 48
paper arts 272–273
paper cutting 273
paper folding 273
papier mâché 272
Parker, Cornelia *276*
Parmigianino *164*
Pascin, Jules *145*
pastels 66–67, 131
blending 67, 131
feathering and stippling 131
hard pastels 67
layering 131
oil pastels 66, 67, 73, 131
soft pastels 66
pattern 42
Pearse, Tamsin *93*
pencils 62–65
blending tools 62
charcoal 65
colored 62–63, 130
eraser pencils 72
grading system 60
graphite 60–61
oil-based 63
pastel 66
sharpening tools 63
watercolor 63
wax-based 62
pens 68–69
art markers 69
ballpoint 69
brush 69

calligraphy 68
dip 68, 70, 71
erasable 69
fineliners 68
fountain 68, 70
gel 68
rollerballs 68
technical 68
watercolor 84
Pepper, Rob *20, 23, 25, 36, 244*
performance art 284, 285, 320
Perry, Grayson *18*, 249
perspective 40–41
aerial 40, 171
foreshortening 165
isometric drawing 41
linear 40–41
one-point 40
three-point 41
two-point 41
vanishing points 40
pewter 104, 105, 187
photo documentation 298
photo emulsion 222, 223
photo transfer 159
photo-editing software 23
photographic stencils 223
photography 116–117, 228–233
composition 229–230
equipment 116–117
painting from photographs 43,
171, 174–175
photomontage 23, 232–233
subject matter 228
see also cameras
Picasso, Pablo 21, 162, 216, 282

pigments 31, 76–77
granulating 139
opacity rating 83
organic/inorganic 76–77
pigment-based inks 70, 224
pixels 252–253
pixel images 248, 249
resolution 253
vector conversion 251
plinths 195
plywood 55, 113, 193
pointillism 150
polymer clay 99, 100, 101
Popova, Lyubov *21*
porcelain 190
portraits 166–167
printmaking 110–115, 202–225
blocks, sheets, and plates 113
collagraphs 115, 214
digital 110, 224–225
etching 114–115, 206–209
inks 112
intaglio 114–115, 204–211
linocuts 112, 216–217
lithography 110, 112, 113, 218–221
monoprints 212–213
paper 113
presses 110–111
relief printing 110, 113, 215–217
screen printing 110, 222–223
tools 112
woodcuts 215
proportion 39, 165
Pugh, Tim *289*
putty erasers 72
PVA (wood glue) 199

R

raster images 245, 248, 249, 253
 painting and drawing tools 256
readymades 21, 198–199
 combination 199
 deconstruction 198
 integration 199
Reeves, Hazel *180*
Reilly, Tamsin *212*
relief carving 189
relief printing 110, 113, 215–217
 linocuts 112, 216–217
 relief press 111
 woodcuts 215
Rembrandt van Rijn *206*
representational art 20
research 18–19
resins 93, 106, 107, 144
RGB color 31, 246
Riley, Bridget *42*
Robinson, Chris *171*
Robinson, Jenny 204, *205*
rollerballs 69
rule of thirds 38, 229
Russell, Tanya *23, 182, 183, 185*

S

safety
 acrylics 81
 light art 278
 oils 83
 personal protective equipment
 (PPE) 104, 107
 pigments 77
 polymers and fiberglass 107
 printmaking 114

solvents 95
Salamon, Michelle *256*
Salim, Madeleine Hartley *67*
sand erasers 72
sandpaper block 65
scale 25
screen printing 110, 222–223
 inks 112
 monoprints 212
 screen mesh count 222
 screen printing bed 111, 222
 stencils 222–223
sculpture 178–201
 3D modeling and 3D printing 22,
 200–201
 armatures 98, 99, 180–181, 184
 book sculpture 287
 carving 188–189
 ceramic 98, 190–191
 clay 98–101, 106
 fabrication 192–195
 kinetic 196–197
 light sculpture 279
 maquettes 22, 23
 metal 104–105, 106
 modeling 182–185
 molding and casting 186–187
 outdoor 106
 plinths 195
 readymades and assemblage 21,
 198–199
 Social Sculpture 288
 stone 103, 106, 189
 synthetic materials 107
 textile art 266
 texture 43

wood 102–103, 106
scumbling 126, 127, 150
selling your art 292–295
Seres-Woolfson, Gail *40, 271*
Seurat, Georges-Pierre *38*, 150
shading 125, 126, 128
 contour shading 126
Shahin, Khalid *283*
shape 36
 organic 36
 positive and negative 36, 125
Shawa, Laila *80*
Shemza, Aphra *279*
Signac, Paul 150, *150*
silhouettes 29, 273
sizing 50, 53
sketching 22, 24, 163, 169, 173
 with collage 270
 sketchbooks 22
smartphones 22, 116, 118, 131
Smithson, Robert 288
Social Sculpture 288
Socially Engaged Art (SEA) 284
Somerville, Liz *216*
spattering 135
Spaull, Sue *51*
Speller, Mike *37*
Spinks, Tansy *224*
splattering 135
sponging 135, 156
spray painting 86–87, 218
 airbrush 87
stainless steel 105, 106, 187, 192
 tools 101
steel, mild 105, 106, 192
stencils, screen printing and 222–223

paper 222
photographic 223
still life 162–163
stippling 126, 131, 156
Stokes, Jayne *57*
stone sculpture 103, 106
carving 189
types of stone 103
stop-out varnish 209
storage 17, 298–299
storyboards 234, 236, 238
storybook illustrations 177
straw, mark making with a 135
street art 280–281, 283
Stubbs, George *43, 204*
studios 16–17
subtractive drawing 72
superglue (cyanoacrylate adhesive) 199
supports 46–57
sustainable art 289
Sutcliffe, Edward *174*
Suter, Vivian *53*
swanskin 110
synthetic polymers 107

T
tablets 22, 245, 256
tapestry 18, 266
tattooing 285
tempera 146–147
text art 282–283
textile art 18, 266–267, 271
texture 43, 144–145, 156–157
thumbnails 163, 171
tonal drawings 72, 128–129

tonal range and values 34–35, 128, 129, 155, 163
Toolan, Zoe *65, 67, 284*
Travljanin, Maša *156*
tusche 218, 220
typography 282

U
underpainting 155, 167
unity in an artwork 39

V
varnishes 88, 93, 94
vector images 245, 248, 249, 250–251
brushes and pens 257
Veiga, Hiero *280*
verisimilitude 43
video cameras and camcorders 118
vinyl erasers 72
visual motifs 42

W
washes 136–143
multilayering 136
paper types 136
strong and weak 136
types of wash 137–138
wet-in-wet 137, 139, 142–143
wet-on-dry 140–141
water brushes 63
watercolor 84–85, 134–143
brushes 79, 134–135
crayons 85
gouache 81, 85
inks and liquid watercolors 71, 85

mark making 134–135
mediums 85
monoprints 212
pans 84, 85
paper 49, 50, 134, 136
pencils 63
pens 84
textural effects 156
tubes 84
washes and glazes 136–143
wax bloom 62, 63, 73
wax resist 93, 145, 158
waxes
encaustic wax 93, 144
sticks, crayons, and candles 93, 145
welding 105, 194
wet-in-wet painting 137, 139, 142–143, 151
wet-on-dry painting 140–141
Wild, Julian *187, 190, 192, 199*
wind sculptures 197
wood sculpture 102–103, 106
carving 102, 188
fabrication 193
types of wood 103
wood supports 54–56
woodcuts 215
blocks 113
Japanese-style 215
tools 112
working environment 16–17
Wright, Cindy *162*

Z
Zhang Zeduan *41*

PICTURE CREDITS

(Key: a-above; b-below; c-center; l-left; r-right; t-top)

The publisher would like to thank the following for their kind permission to reproduce their photographs:

ACKNOWLEDGMENTS

CONSULTANT'S ACKNOWLEDGMENTS

All artists need help, and I'm grateful to my family: Aimie, Art, and Lowri for their never-ending support. Katie, Matt, Theo, Jonny, the Littlers, Tomlinsons, Darrel, Ross, and The Art Academy community, thank you for all your parts. The contributors for gifting their knowledge, Rona and Rebecca for making it happen, and Molly Doyle for inspiring me at the beginning.

DK ACKNOWLEDGMENTS

DK would like to thank John Friend for proofreading, Marie Lorimer for creating the index, and the following people in the DK Delhi team for image retouching: DTP Designers Rajdeep Singh, Tarun Sharma, Anurag Trivedi, and Satish Gaur and Pre-production Manager Sunil Sharma.

Irises (2019) Rob Pepper

Project Editor	Rebecca Fry
Project Designers	Emma Forge and Tom Forge
Editors	Claire Cross, Kiron Gill, Katie Hardwicke, Carol King, and Tia Sarkar
US Editor	Kayla Dugger
Designer	Tessa Bindloss
Picture Researcher	Jo Walton
Jacket Designer	Amy Cox
Jackets Coordinator	Lucy Philpott
Production Editor	David Almond
Senior Producer	Luca Bazzoli
Creative Technical Support	Sonia Charbonnier
Senior Editor	Rona Skene
Senior Designer	Barbara Zuniga
Managing Editor	Dawn Henderson
Managing Art Editor	Marianne Markham
Art Director	Maxine Pedliham
Publishing Director	Katie Cowan

First American Edition, 2021
Published in the United States by DK Publishing
1450 Broadway, Suite 801, New York, NY 10018

A catalog record for this book
is available from the Library of Congress.
ISBN 978-0-7440-3376-2

Printed and bound in China

For the curious
www.dk.com

This book was made with Forest Stewardship Council™
certified paper—one small step in DK's
commitment to a sustainable future.
For more information go to www.dk.com/our-green-pledge